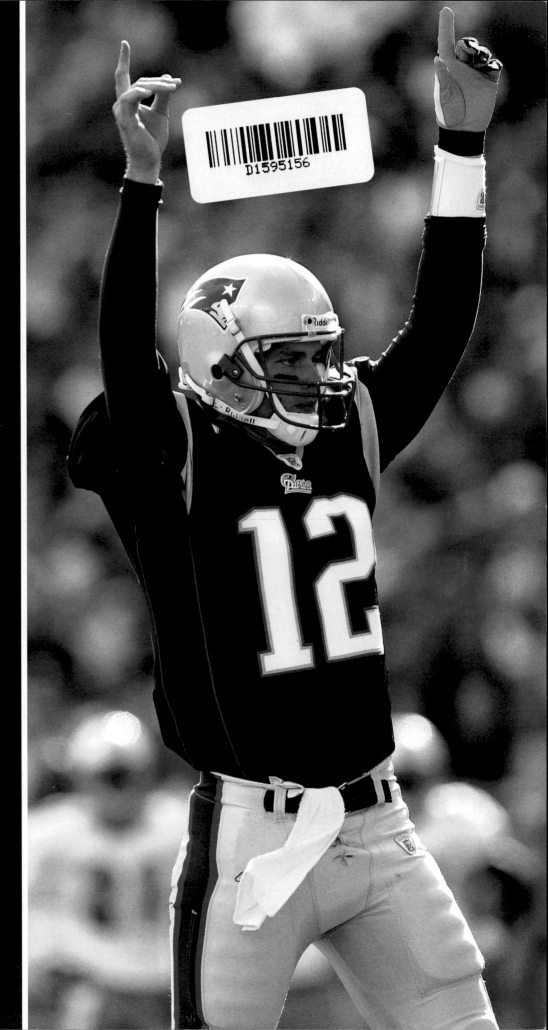

The Boston Globe

GOAT

THE LEGEND AND LEGACY OF TOM BRADY

This book is available in quantity at special discounts for your group or organization.
For further information, contact:

Triumph Books LLC
814 North Franklin Street
Chicago, Illinois 60610
Phone: (312) 337-0747
www.triumphbooks.com

Printed in U.S.A.
ISBN: 978-1-63727-181-0

Book Contributors
Rachel G. Bowers, Nick Cafardo, Kim Chapin, Frank Dell'Apa, Daigo Fujiwara, Christopher L. Gasper, Bill Greene, John
Hancock, Bob Hohler, Ryan Huddle, Jackie MacMullan, Jeremiah Manion, Jim McBride, Will McDonough,
Ira Napoliello, Matt Pepin, Christopher Price, Bob Ryan, Dan Shaughnessy, Tara Sullivan, Ben Volin, Nicole Yang

Boston Globe Photographs
Nick Antaya, 99, 103; Barry Chin, 81, 93, 143-144; Jim Davis, Front Cover, 9, 23, 55, 57, 83, 101, 109, 127, 133; Bill Greene,
137; Stan Grossfeld, Back Cover, 113, 139, 141; Matthew J. Lee, 2-3, 7, 43, 111; Jessica Rinaldi, 8; Lane Turner, 91

Additional Photographs
AP Images, 1, 5, 11, 13-14, 17, 19, 21, 25-26, 29-30, 33-34, 37, 39, 41, 45, 47, 49, 51, 53, 58, 60-61, 63, 65, 67, 69, 71, 73, 75,
77-78, 85, 87, 89, 95, 97, 104, 107, 115, 117, 119, 121, 123, 131, 135

Content packaged by Mojo Media, Inc.
Joe Funk: Editor
Jason Hinman: Creative Director

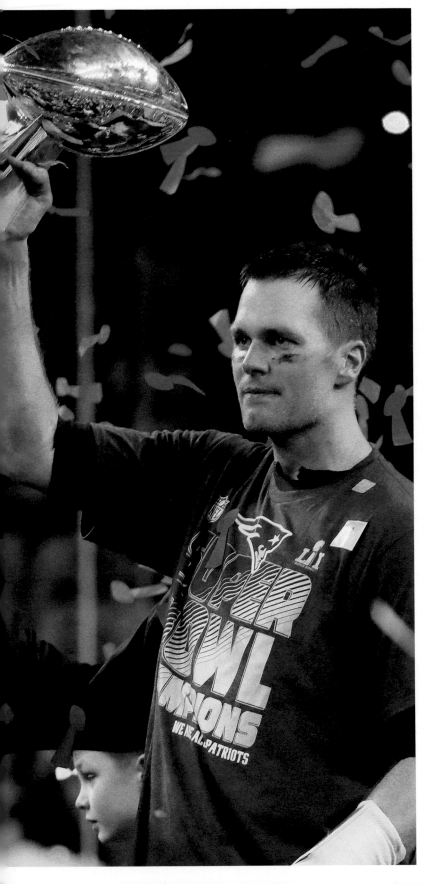

CONTENTS

Tom Brady proved his value time and again in his 20 years with the Patriots, leading the franchise to six Super Bowl titles and redefining the quarterback position.

INTRODUCTION

By Christopher Price, Globe Staff

On April 16, 2000, Patriots coach Bill Belichick was wrapping up his post-draft press conference, running down a list of picks, when he came to the quarterback they took in the sixth round, Tom Brady.

"The value board at that point really clearly put him as the top value. Brady is a guy that has obviously played at a high level of competition in front of a lot of people and he's been in a lot of pressure situations. We felt that this year his decision-making was improved from his junior year after he took over for Brian Griese. He cut his interceptions down. He's a good, tough, competitive, smart quarterback that is a good value and how he does and what he'll be able to do, we'll just put him out there with everybody else and let him compete and see what happens."

Two things stand out about that passage: One, Belichick uses the word "value" three times. (The more things change, the more they stay the same.) And two, his closing quote: *We'll just put him out there with everybody else and let him compete and see what happens.* It's the perfect place to start when you are talking about one of the most impressive chapters in New England sports history.

So what *did* happen? Eighteen months later, after one of the unlikeliest Super Bowl runs in NFL history, he was one of the most well-known athletes on the planet, and stayed that way for 20 years, winning six Super Bowls (and a seventh after he left New England with Tampa Bay).

In New England, Brady was always fascinating theatre, and while he didn't always provide the greatest quotes, the philosophy of many who covered the team in those early days was simple: *When it doubt, write about the quarterback.* Starting in the fall of 2001, he routinely made the impossible possible, and turned fiction into reality. With Brady, you always had a chance. There was always another comeback, another connection, another championship. People couldn't get enough.

You can argue that Brady wasn't the only Boston athlete with a long list of transcendent achievements. So why him, over the likes of Russell, Bird, Orr, Ted, or Yaz? The truth of the matter is that he separated himself from the pack as a bona fide sports celebrity, a 21st century athlete with boatloads of charisma who blossomed in the digital age. Combine that with the glamour of a supermodel wife and a track record of on-field success, and it's no wonder why he was just as likely to show up on TMZ as the sports pages of the Globe, just as comfortable talking to People Magazine as Sports Illustrated. The Super Bowl or the Met Gala; it didn't matter. He did it all.

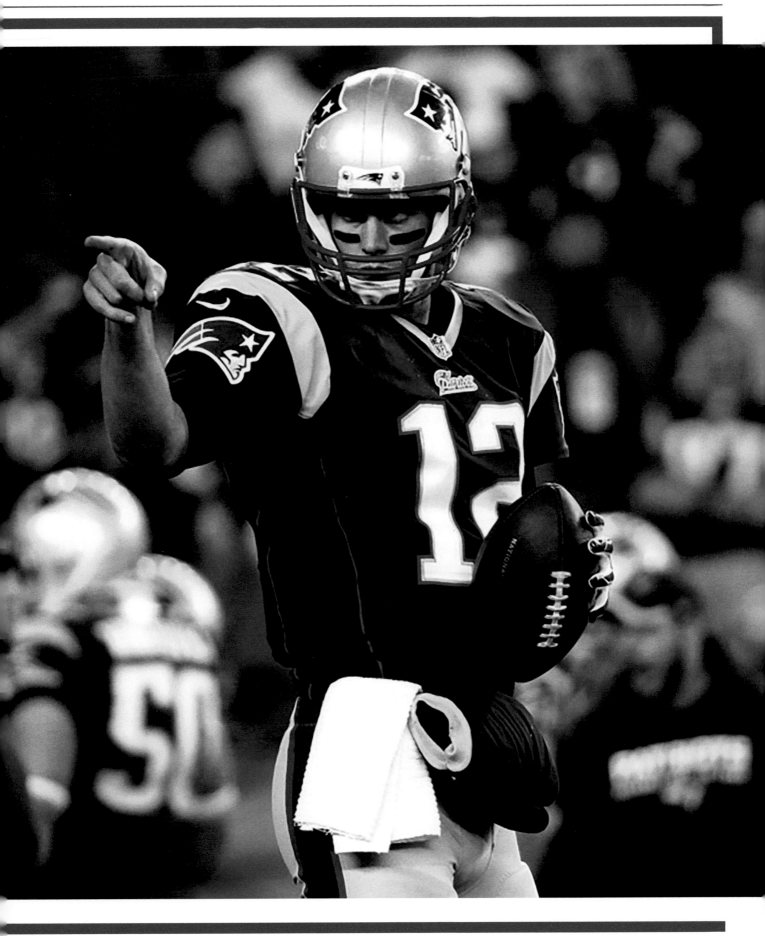

Below: Tom Brady may not have finished his storied career with the Patriots, but he'll remain the embodiment of the Patriots Way through the test of time. Opposite: Once upon a time an afterthought in the draft in the sixth round, Tom Brady did it all during his illustrious NFL career.

What made it all the more amazing was that — an occasional playoff loss aside — when it came to on-field production, he stayed at that same level for the better part of 20 years. He found the balance between grit and glamour, between on-field sacrifice and long-term success. In an era of unrivaled success for all four of Boston sports major sports teams, it was Brady who set the standard.

In the end, Brady's larger-than-life legacy is wrapped up in unprecedented on-field success: Nine conference championships, seven Super Bowl titles, and a knack for consistently clutch performances. Twenty remarkable years. Not bad value for a sixth-round pick. ■

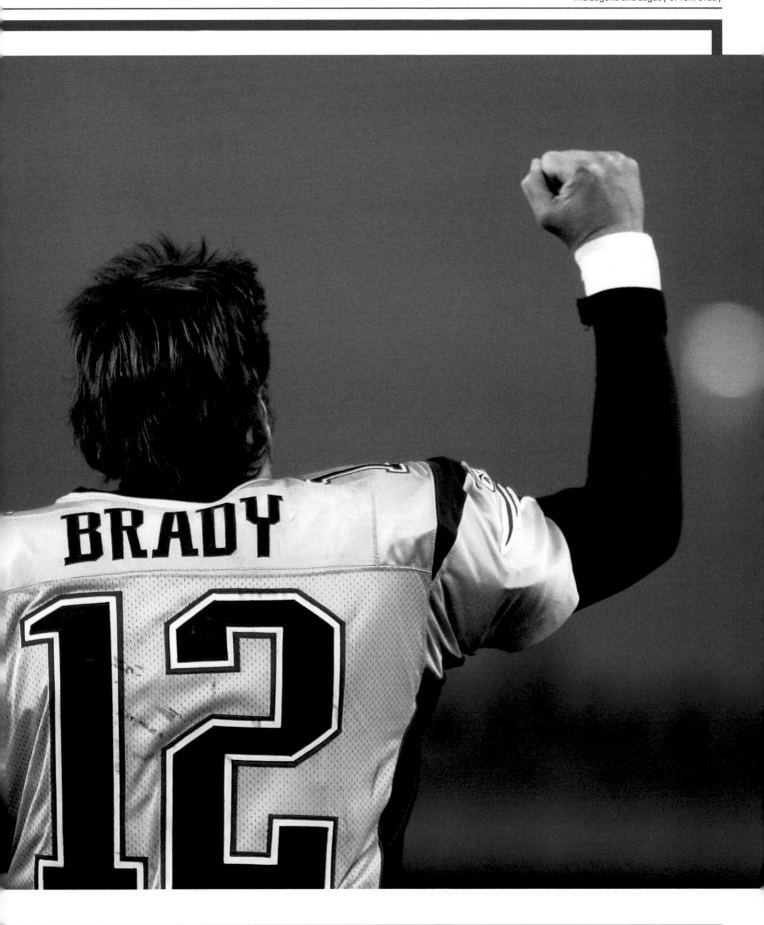

Tom Brady had a strong career at the University of Michigan, going 20-5 and winning the Citrus Bowl and Orange Bowl, but as a sixth-round pick of the Patriots in the 2000 NFL Draft, few expected great things out of him on the pro level.

"I don't think disappointment is the word. Whether it's the second or sixth round, I think everyone starts on the same level."

— Tom Brady

THE BOSTON GLOBE ● MONDAY, APRIL 17, 2000 E15

The NFL Draft 2000

PATRIOTS PICKS AT A GLANCE

Rd. 4, No. 127 – Greg Robinson-Randall, OT, Mich. St.
Considered an intense, physical pass protector who has excellent arm extension that helps him seal off the outside rush . . . 6 feet 5 inches, 320 pounds . . . Keeps his legs churning on contact and knows how to get low to deliver his strikes . . . Timed at 5.61 in the 40-yard dash . . . Carries his weight well, hitting with authority to create movement off the snap . . . Has the range to lead the way on sweeps . . . More of a right tackle . . . Claims he's a better run blocker than pass blocker, but that remains to be seen . . . A kinesiology major, he was raised in Hitchcock, Texas, and was a top lineman at Coffeyville (Kan.) Community College . . . Blocked for former Michigan State All-American Sedrick Irvin.

5, 141 – Dave Stachelski, TE, Boise State
The 6-3, 250-pound native of Marysville, Wash., is considered a strong blocker . . . Caught 31 passes for 453 yards and six touchdowns last season, a breakthrough campaign as a receiver (he had only four receptions before 1999) . . . A former defensive end, he was credited with 14 sacks and 11 tackles in 1997 . . . Considered a good route-runner . . . Runs a 4.87 40 . . . The strongest player on the Boise State team, he bench-presses 415 pounds . . . Has a 40.5-inch vertical jump . . . He's a former Seattle Post-Intelligencer all-state player at tight end and defensive end . . . A business management major.

5, 161 – Jeff Marriott, DT, Missouri
The son of a Missouri logger, he didn't appear on the radar screen of many scouts. But at 6-5, 305 pounds, some believe he could develop . . . The defensive MVP in the Insight.com Bowl with three tackles behind the line of scrimmage, a sack, and a blocked field goal . . . A former prep wrestler, he often caused disruptions in the opponent's backfield . . . Scouted by the pros as an offensive lineman because of his size, he only played on the OL in high school . . . Runs a 5.1 40, decent for a big man . . . A hard worker who doesn't take days off . . . Weighed only 220 pounds when he signed with Missouri but has been a weight room warrior.

6, 187 – Melvin "Antwan" Harris, CB, Virginia
A multi-purpose defensive back who is a shade under 5-10, and 186 pounds . . . Runs a 4.41 40 . . . Displayed good recovery speed last season . . . Battled hamstring problems and missed four games, but when he did play, he started at free safety, finishing with 35 tackles and two pass deflections . . . Played left cornerback in 1998 and also has been on special teams coverage . . . A probable special-teamer in the NFL and possibly a backup at safety and corner . . . A good tackler who can finish a play . . . Played running back at Raleigh (N.C.) HS . . . A psychology major.

6, 199 – Tom Brady, QB, Michigan
A pocket passer who will compete for a practice squad spot with the Patriots . . . Drafted as a catcher by the Montreal Expos in 1995 out of Serra (San Mateo, Calif.) HS . . . Completed 62.8 percent of his passes with 20 TDs and six interceptions. Only Elvis Grbac had more TD tosses in a season for the Wolverines . . . Throws a great spiral . . . At almost 6-4, 214 pounds, has some mobility . . . Platooned with sophomore Drew Henson . . . Was projected to go in the third round, but dropped quickly.

6, 201 – David Nugent, DT, Purdue
Played for Patriots defensive line coach Randy Melvin with the Boilermakers . . . Has a powerful initial step to avoid the low block . . . At 6-4, 301 pounds, has a low center of gravity for a big guy . . . Came to Purdue as a tight end, which had some teams considering him as an offensive lineman . . . In 1999 recorded 46 tackles with two sacks . . . Received Purdue's "Pit Bull Award" for exemplifying the most tenacity and intensity . . . A native of Collierville, Tenn., who lettered in baseball and track at Germantown (Tenn.) Houston HS . . . An exercise and fitness major.

7, 226 – Casey Tisdale, LB, New Mexico
An outside 'backer . . . At 6-4, 258 pounds, has played defensive end, and ran a 4.71 40 as a junior, the fastest time ever for a DL at New Mexico . . . Played in 11 games last season and had 74 tackles, 6½ sacks, and 8 pass deflections . . . Spent two seasons at San Diego Mesa JC, where he was first-team all-Mission Conference for coach Dave Fager with 64 tackles, 4 sacks, and 6 pass deflections . . . Born in Oakland, Calif., but lived in Adak, Alaska, for two years . . . Lived most of his life in San Diego but didn't play football in high school there until his senior year, when he was first-team all-conference . . . A general management major.

7, 239 – Patrick Pass, RB, Georgia
A Florida Marlins farmhand (outfielder) for the Utica Blue Sox of the New York-Penn League . . . A good friend of Patriots RB Robert Edwards . . . Solidly built (5-10, 208), runs hard, and lowers his head to make yardage after initial contact . . . A skilled receiver with soft hands who often lines up in the slot . . . Runs a 4.44 40 . . . Shared ball-carrying duties with Robert Arnaud and Jasper Sanks . . . Ran for 335 yards on 62 carries (5.4 yard average) and hauled in 19 passes for 250 yards . . . Returned 15 punts for 136 yards and 10 kickoffs for 217 yards . . . Averaged 85.3 all-purpose yards per game . . . Played four years for the Bulldogs.

Compiled by Nick Cafardo

Peace in the war room

By Nick Cafardo
GLOBE STAFF

FOXBOROUGH – Not that they would report any chaos in the war room, but coach Bill Belichick and vice president **Jonathan Kraft** reported a smooth two days of decision-making.

Kraft made his comments on the Patriots' Internet radio show, indicating the organization was the "best it's been in the last five years." Belichick said all went well, except early in the seventh round when "we had a bunch of players where we were having trouble distinguishing one." That's when the Patriots traded the spot to the 49ers for a third-round pick next season.

Kraft reported that the interaction between vice president of player personnel **Bobby Grier** and Belichick was smooth.

With the draft over, Grier's role with the team again becomes an issue.

For the first time, the Patriots used two draft rooms. There was the main room which contained the top decision-makers – Belichick, the Krafts, Grier, scouting staff heads **Dave Uyrus** and **Larry Cook**, vice president **Andy Wasynczuk** – and an overflow room with the assistant coaches, locker room staff, and medical staff.

Off and running

Belichick believes all of his running backs will be on even footing. "We have three running backs who have never carried the ball in a game for the New England Patriots," said Belichick.

The Patriots will head into next week's minicamps with third-round pick **J.R. Redmond, Kevin Faulk, Raymont Harris,** and **Derrick Cullors** competing for playing time. Seventh-round pick **Patrick Pass**, a 5-foot-10-inch, 208-pounder from Georgia should also be in the mix.

Asked why he thinks Redmond can be an every-down back, Belichick said, "because he's done it. He's carried the ball on first and second down. He's a good inside runner, he can block, pick up the blitz." Belichick thinks Faulk is more of a third-down back, but "maybe he'll be able to do it here. I might be wrong about him."

Belichick said every back will get enough reps during the five exhibition games to get an accurate measure on everyone's role.

Redmond, Faulk, Cullors, Pass, and cornerback **Antwan Harris,** a sixth-round selection, are the potential kick returners.

Playing long ball

The Patriots had a baseball theme to yesterday's picks. Pass has played parts of four seasons in the Florida Marlins' system, no higher than the Single A New York-Penn League. His best season came with Melbourne (Fla.) in the rookie Gulf Coast League when he hit .244 in 1997. Michigan quarterback **Tom Brady**, the team's second sixth-round pick, was taken by the Montreal Expos in the 18th round of the 1995 amateur draft as a catcher. Pass plans to stick with football.

They didn't catch on

The receiving crop was the best in years but the Patriots passed. Belichick said there were many good receivers on the board, but none was considered the top player available at selection time. This is a break for **Sean Morey,** who is playing in NFL Europe . . . Belichick said he wouldn't rule out carrying four quarterbacks . . . **Adrian Klemm** and **Greg Robinson-Randall** join the mix of tackles that includes **Max Lane, Ed Ellis,** and **Grant Williams.** The Patriots haven't ruled out Klemm as a guard. The team has **Todd Rucci, Derrick Fletcher, Lance Scott,** and **Jason Andersen** in that group.

Some choice picks by Patriots?

■ PATRIOTS
Continued from Page E1

and a cornerback.

"I think we did draft some big guys, but we thought if we had a game on the 14th we could have put a team out there on paper [with players already on the roster]," Belichick said. "We had opportunities to select players at positions where we could continue to get stronger and we'll continue to make moves to do that. We tried to value the board at some of the positions we were hoping to get. It wasn't anything we could have predicted."

Without a first-round pick, the Patriots could have used some players who could step in and play now, but they may not have gotten that. Klemm will need time, and Redmond didn't appeal to the other teams looking for a running back.

Robinson-Randall, who may have problems getting his name on a Patriots jersey, is another big man (he is 6 feet 5 inches and is currently 320 pounds) who has played right tackle for a big college program. An obvious project, he blocked for Sedrick Irvin for the Spartans and came to the Patriots at the recommendation of Michigan State coach Nick Saban, who worked with Belichick with the Browns. Though Robinson-Randall considers himself a decent run blocker, he's touted more for his pass blocking.

"I think I need a little bit more work at pass blocking because I need to get my knees a little bit more and stay low," said Robinson-Randall.

The native of Hitchcock, Texas, worked out for the Cincinnati Bengals and named Tony Boselli as his favorite player.

In the fifth round, the Patriots took tight end Dave Stachelski from Boise State. He is a native of Marysville, Wash., a Seattle suburb, and said he grew up watching Patriots quarterback Drew Bledsoe (Washington State).

Stachelski is a converted defensive end who came on as a receiver. Last season he caught 31 passes for 453 yards.

The brass was excited to get Stachelski because of the obvious need for a big tight end who may be able to help

Missouri's Jeff Marriott, closing in on a sack, is a weight room warrior.

Michigan QB Tom Brady slipped to the Patriots in the sixth round.

make up for the loss of Ben Coates, a five-time Pro Bowler.

With their second selection in the fifth, the Patriots took Marriott, who wasn't on the radar screen of most scouts. At 6-5, 305 pounds, Marriott scored some points with Patriots secondary coach Rob Ryan, who was the defensive coordinator at Oklahoma State last year. Ryan was alerted to Marriott by an area scout.

The son of a logger, Marriott, whose specialty is blocking kicks, never has traveled north of Ohio. He was worked out by some teams as an offensive lineman, but Marriott said the Patriots told him they regarded him as a tackle.

A native of Chillicothe, Md., Marriott has a high motor and the Patriots believe he can become a good player. He can bench-press 515 pounds.

The Patriots took a defensive back, Melvin "Antwan" Harris of Virginia with their first of three picks in the sixth round. Harris doesn't have a pure position; he has started at cornerback, free safety, and strong safety. The Raleigh, N.C., native is considered quick and can return kicks and punts, but he battled hamstring problems last season, which kept him out of four games.

With a quarterback in mind, the Patriots passed on the athletic Joe Hamilton of Georgia Tech to go for Tom Brady of Michigan with their next pick. Brady, projected as a third-rounder, said he wasn't upset at slipping. "I don't think disappointment is the word," he said. "Whether it's the second or sixth round, I think everyone starts on the same level."

Brady's selection should not affect backup quarterbacks John Friesz or Michael Bishop.

The Patriots then grabbed defensive lineman Dave Nugent from Purdue. He's 6-4, 301 pounds, and played for New England defensive line coach Randy Melvin, who was the Boilermakers' defensive coordinator last season.

The Patriots took Marriott and Nugent for depth on the line, but Belichick thought they were a good value because other teams who don't play the "2-gap" system were not interested in those players.

In the seventh round, the Patriots selected Casey Tisdale, a linebacker from New Mexico.

Then came an intriguing pick – Patrick Pass, a running back from Georgia. If he comes anywhere close to the likes of other Bulldogs such as Herschel Walker, Terrell Davis, Olandis Gary, Robert Edwards, and Garrison Hearst in the pros, the team will be happy.

Pass has been in the Florida Marlins' system as an outfielder for the past three seasons, but said that his first love is football. He thinks the Patriots are a good fit for him especially after Edwards, a close friend of his, went down to a career threatening injury.

TEAM-BY-TEAM SELECTIONS

ARIZONA CARDINALS
1, Thomas Jones, rb, Virginia (7); 2, Raynoch Thompson, lb, Tennessee (41); 3, Darwin Walker, dt, Tennessee (71); 4, David Barrett, db, Arkansas (102); 5, Mao Tosi, dt, Idaho (133); 6, Jay Tant, te, Northwestern (164); 6, Jabari Issa, dt, Washington (176); 7, Sekou Sanyika, lb, California (215).

ATLANTA FALCONS
2, Travis Claridge, ot, Southern California (37); 3, Mark Simoneau, lb, Kansas St. (67); 4, Michael Thompson, dt, Tennessee St. (100); 5, Anthony Midget, db, Virginia Tech (134); 6, Maceo Phillipcas, wr, Troy St. (172); 7, Darrick Vaughn, db, Southwest Texas St. (211).

BALTIMORE RAVENS
1, Jamal Lewis, rb, Tennessee (5); 1, Travis Taylor, wr, Florida (10); 3, Chris Redmon, qb, Louisville (75); 5, Richard Mercier, g, Miami (148); 6, Adalius Thomas, de, Southern Mississippi (186); 6, Cedric Woodard, dt, Texas (191).

BUFFALO BILLS
1, Erik Flowers, de, Arizona St. (26); 2, Travares Tillman, s, Georgia Tech (58); 3, Corey Moore, lb, Virginia Tech (89); 4, Avion Black, wr, Tennessee St. (121); 5, Sammy Morris, rb, Texas Tech (156); 6, Leif Larson, dt, Utah St. (189); 6, Jonas Jennings, ot, Georgia (205); 7, Deshon Polk, LB, Georgia (221).

CAROLINA PANTHERS
1, Rashard Anderson, db, Jackson St. (23); 2, Deon Grant, s, Tennessee (57); 3, Leander Jordan, g, Indiana, Pa (92); 4, Mike Wahle, ot, Mississippi S. (120); 5, Gillis Wilson, dt, Southern (147); 6, Jeno James, ot, Auburn (182); 7, Lester Towns, lb, Washington (221).

CHICAGO BEARS
1, Brian Urlacher, lb, New Mexico (9); 2, Mike Brown, s, Nebraska (39); 3, Dez White, wr, Georgia Tech (69); 3, Dustin Lyman, te, Wake Forest (87); 4, Reggie Austin, db, Wake Forest (125); 6, Frank Murphy, rb, Kansas St. (170); 6, Paul Edinger, pk, Michigan State (174); 7, James Cotton, db, Ohio St. (232); 7, Mike Green, db, Northwestern St. (254).

CINCINNATI BENGALS
1, Peter Warrick, wr, Florida St. (4); 2, Mark Roman, cb, LSU (34); 3, Ron Dugans, wr, Florida St. (66); 4, Curtis Keaton, rb, James Madison (97); 5, Robert Bean, db, Mississippi St. (133); 6, Neil Rackers, pk, Illinois (169); 7, Brad St. Louis, te, Southwest Missouri St. (210).

CLEVELAND BROWNS
1, Courtney Brown, de, Penn St. (1); 2, Dennis Northcutt, wr, Arizona (32); 3, Travis Prentice, rb, Miami, Ohio (63); 3, JaJuan Dawson, wr, Tulane (79); 4, Lewis Sanders, cb, Maryland (95); 4, Aaron Shea, te, Michigan (110); 5, Anthony Malbrough, db, Texas Tech (130); 5, Lamar Chapman, db, Kansas St. (146); 6, Spergon Wynn, qb, Southwest Texas St. (183); 6, Brad Bedell, g, Colorado (206); 7, Manuela Savea, g, Arizona (209); 7, Eric Chandler, de, Jackson St. (209); 7, Rashidi Barnes, db, Colorado (225).

DALLAS COWBOYS
2, Dwayne Goodrich, db, Tennessee (49); 4, Kareem Larrimore, db, West Texas A&M (109); 5, Michael Wiley, wr, Ohio St. (144); 6, Mario Edwards, db, Florida St. (180); 7, Orantes Grant, lb, Georgia (219).

DENVER BRONCOS
1, Deltha O'Neal, cb, California (15); 2, Ian Gold, lb, Michigan (45); 3, Kenny Kennedy, s, Arkansas (45); 3, Chris Cole, wr, Texas A&M (81); 4, Cooper Carlisle, ot, Florida (112); 5, Muneer Moore, wr, Richmond (154); 6, Mike Anderson, rb, Utah (189); 7, James Jackson, qb, Notre Dame (214); 7, Leroy Fields, wr, Jackson State (246).

DETROIT LIONS
1, Stockar McDougle, ot, Oklahoma (20); 2, Barrett Green, lb, West Virginia (50); 3, Reuben Droughns, rb, Oregon (81); 5, Todd Franz, db, Tulsa (145); 6, Quinton Reese, de, Auburn (181); 7, Alfonso Boone, dt, Mount San Antonio JC (253).

GREEN BAY PACKERS
1, Bubba Franks, te, Miami (14); 2, Chad Clifton, ot, Tennessee (44); 3, Steve Warren, dt, Nebraska (74); 4, Na'il Diggs, lb, Ohio St. (98); 4, Anthony Lucas, wr, Arkansas (114); 4, Gary Berry, db, Ohio St. (126); 5, Kabeer Gbaja-Biamila, de, San Diego St. (149); 5, Joey Jamison, kr, Texas Southern (151); 7, Mark Tauscher, ot, Wisconsin (224); 7, Ron Moore, db, Northwestern Oklahoma (229); 7, Charles Lee, wr, Central Florida (242); 7, Eugene McClain, lb, Florida (249); 7, Rondel Mealey, rb, LSU (252).

INDIANAPOLIS COLTS
1, Rob Morris, lb, Brigham Young (28); 2, Marcus Washington, de, Auburn (59); 3, David Macklin, db, Penn St. (91); 4, Josh Williams, dt, Michigan (122); 5, Matt Johnson, c, Brigham Young (186); 7, Rob Renes, dt, Michigan (235); 7, Rodregis Brooks, db, Alabama-Birmingham (238).

JACKSONVILLE JAGUARS
1, R. Jay Soward, wr, Southern California (29); 2, Brad Meester, c, Northern Iowa (60); 3, T.J. Slaughter, lb, Southern Mississippi (92); 4, Joey Chustz, ot, Louisiana Tech (133); 5, Kiwaukee Thomas, db, Georgia Southern (159); 6, Emanuel Smith, wr, Arkansas (196); 7, Erie Olsen, ob, Colorado St. (236); 7, Rob Meier, de, Washington St. (241); 7, Shyrone Stith, rb, Virginia Tech (243); 7, Damon Gibson, wr, Cincinnati (248).

KANSAS CITY CHIEFS
1, Sylvester Morris, wr, Jackson St. (21); 2, William Bartee, db, Oklahoma (54); 3, Gregory Wesley, db, Arkansas-Pine Bluff (85); 4, Frank Moreau, rb, Louisville (115); 5, Dante Hall, rb, Texas A&M (153); 5, Pat Dennis, db, Louisiana-Monroe (162); 6, Darnell Alford, ot, Boston College (188); 7, Desmond Kitchings, wr, Furman (208).

MIAMI DOLPHINS
1, Todd Wade, ot, Mississippi (53); 3, Ben Kelly, db, Colorado (84); 4, Deon Dyer, fb, North Carolina (117); 5, Arturo Freeman, db, South Carolina (152); 6, Earnest Grant, dt, Arkansas-Pine Bluff (167); 7, Jeff Harris, db, Georgia (232).

MINNESOTA VIKINGS
1, Chris Hovan, dt, Boston College (25); 2, Fred Robbins, dt, Wake Forest (59); 2, Michael Boireau, de, Miami (56); 3, Doug Chapman, rb, Marshall (96); 6, Jim Kleinsasser, te, North Dakota (107); 4, Anthony Wilson, lb, Texas A&M-Commerce (106); 4, Tyrone Carter, db, Minnesota (118); 5, Troy Walters, wr, Stanford (145); 7, Mike Malbrus, c, San Diego St. (247); 7, Giles Cole, te, Texas A&M Kingsville (244); 7, Lewis Kelly, g, South Carolina St. (248).

NEW ORLEANS SAINTS
3, Darren Howard, de, Kansas St. (33); 4, Terrelle Smith, rb, Arizona St. (96); 5, Chad Morton, rb, Southern California (156); 6, Marc Bulger, qb, West Virginia (168); 6, Michael Hawthorne, cb, Purdue (195); 6, Sherrod Gideon, wr, Southern Mississippi (200); 7, Kevin Houser, c, Ohio St. (209).

NEW YORK GIANTS
1, Ron Dayne, rb, Wisconsin (11); 2, Cornelius Griffin, dt, Alabama (42); 3, Ron Dixon, wr, Lambuth (73); 4, Brandon Short, lb, Penn St. (106); 5, Ralph Brown, db, Nebraska (140); 6, Dhani Jones, lb, Michigan (177); 7, Jeremiah Parker, de, California (217).

NEW YORK JETS
1, Shaun Ellis, de, Tennessee (12); 1, John Abraham, lb, South Carolina (13); 1, Chad Pennington, qb, Marshall (18); 1, Anthony Becht, te, West Virginia (27); 3, Laveranues Coles, wr, Florida St. (78); 5, Windrell Hayes, wr, Southern California (140); 6, Tony Scott, db, North Carolina St. (179); 7, Richard Seals, dt, Utah (218).

OAKLAND RAIDERS
1, Sebastian Janikowski, pk, Florida St. (17); 2, Jerry Porter, wr, West Virginia (47); 6, Junior Ioane, dt, Arizona St. (107); 5, Shane Lechler, p, Texas A&M (142); 7, Montrell Fulcher, te, Miami (227); 7, Clifton Black, db, Southwest Texas St. (231).

PHILADELPHIA EAGLES
1, Corey Simon, dt, Florida St. (6); 2, Todd Pinkston, wr, Southern Mississippi (36); 2, Bobby Williams, g, Arkansas (61); 4, Gari Scott, wr, Michigan St. (99); 6, Thomas Hamner, rb, Minnesota (171); 6, John Frank, de, Utah (178); 6, John Romero, c, California (192).

PITTSBURGH STEELERS
1, Plaxico Burress, wr, Michigan St. (8); 2, Marvel Smith, ot, Arizona St. (38); 3, Hank Poteat, db, Pittsburgh (77); 4, Danny Farmer, wr, UCLA (103); 5, Clark Haggans, lb, Colorado St. (137); 6, Tee Martin, qb, Tennessee (163); 6, Chris Combs, dt, Duke (173); 6, Jason Gavadza, te, Kent (204).

ST. LOUIS RAMS
3, Jacoby Shepherd, db, Oklahoma St. (62); 3, John St. Clair, c, Virginia (94); 4, Kaulana Noa, g, Hawaii (104); 5, Brian Young, dt, Texas-El Paso (139); 6, Matt Bowen, db, Iowa (195); 7, Andrew Kline, g, San Diego St. (225).

SAN DIEGO CHARGERS
2, Rogers Beckett, s, Marshall (43); 3, Damion McIntosh, ot, Kansas (65); 3, Trevor Gaylor, wr, Miami, Ohio (111); 4, Leonardo Carson, de, Auburn (116); 5, Shannon Taylor, lb, Virginia (184); 6, Darren Wheeler, db, Colorado St. (137); 6, Jerome Collins, db, Julian Seider, cb, Colorado A&M (205); 7, Jason Thomas, g, Hampton (222).

SAN FRANCISCO 49ERS
1, Julian Peterson, lb, Michigan St. (16); 1, Ahmed Plummer, db, Ohio St. (24); 2, John Engelberger, de, Virginia Tech (35); 2, Jason Webster, db, Texas A&M (48); 3, Giovanni Carmazzi, qb, Hofstra (65); 3, Jeff Ulbrich, lb, Hawaii (86); 5, Paul Smith, rb, Texas-El Paso (132); 5, John Milem, db, Lenoir-Rhyne (150); 7, Tim Rattay, qb, Louisiana Tech (212); 7, Brian Jennings, te, Arizona St. (230).

SEATTLE SEAHAWKS
1, Shaun Alexander, rb, Alabama (19); 1, Chris McIntosh, ot, Wisconsin (22); 2, Ike Charlton, db, Virginia Tech (52); 3, Darrell Jackson, wr, Florida (80); 4, Marcus Bell, lb, Arizona (116); 6, Anthony Derricks, db, Hampton (161); 6, James Williams, wr, Marshall (175); 6, Tim Watson, db, Rowan (185); 6, John Hilliard, dt, Mississippi St. (190).

TAMPA BAY BUCCANEERS
2, Cosey Coleman, g, Tennessee (51); 3, Nate Webster, lb, Miami (90); 5, James Whalen, te, Kentucky (157); 5, David Gibson, db, Southern California (193); 7, Joe Hamilton, qb, Georgia Tech (234).

TENNESSEE TITANS
1, Keith Bulluck, lb, Syracuse (30); 3, Erron Kinney, te, Florida (68); 3, Byron Frisch, de, Brigham Young (93); 4, Bobby Myers, s, Wisconsin (124); 4, Peter Sirmon, lb, Oregon (126); 5, Aric Morris, db, Michigan St. (159); 5, Frank Chamberlin, lb, Boston College (160); 6, Robaire Smith, de, Michigan St. (197); 7, Mike Green, rb, Houston (213); 7, Wes Shivers, g, Mississippi St. (237).

WASHINGTON REDSKINS
1, LaVar Arrington, lb, Penn St. (2); 1, Chris Samuels, ot, Alabama (3); 3, Lloyd Harrison, db, North Carolina St. (64); 4, Michael Moore, g, Troy St. (129); 5, Quincy Sanders, db, UNLV (155); 6, Todd Husak, qb, Stanford (202); 7, Delbert Cowsette, dt, Maryland (216); 7, Ethan Howell, wr, Oklahoma St. (250).

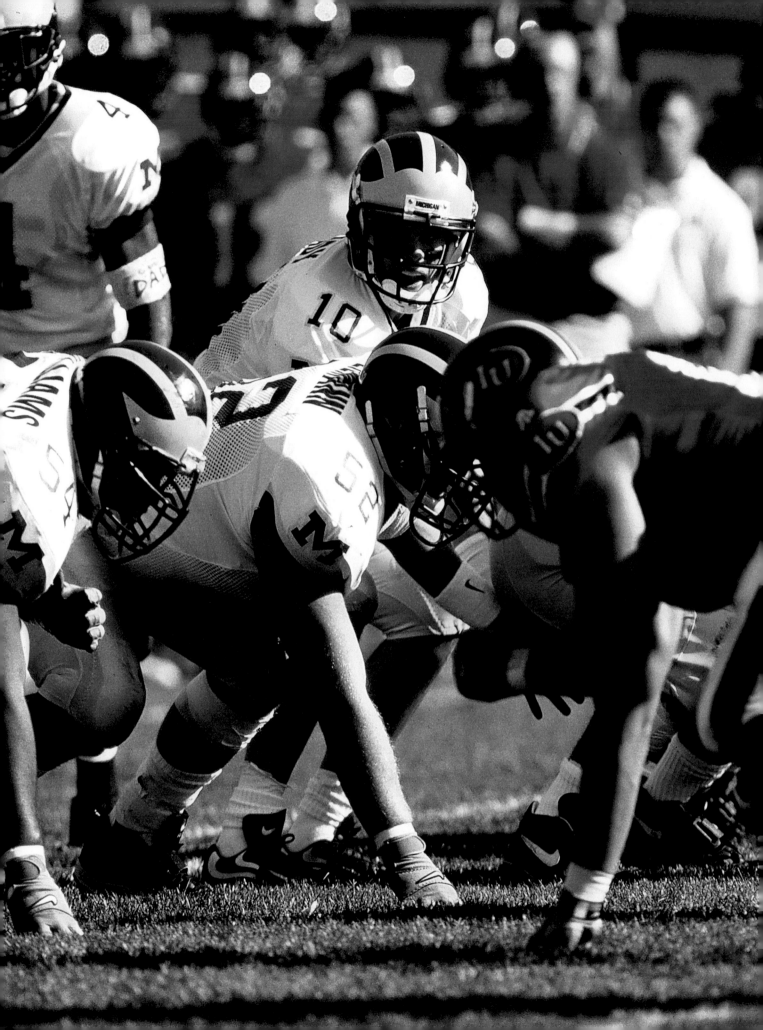

Tom Brady started seeing action for the Patriots during his second season, replacing an injured Drew Bledsoe and eventually taking over the starting job.

INTO THE FRAY

Tom Brady Shows Composure in Relief of Drew Bledsoe

By Frank Dell'Apa • September 24, 2001

The Patriots' quarterback ran out of the pocket toward the right sideline, where he was about to be confronted by a Jets linebacker yesterday. Tom Brady made a wise choice. He slid out of bounds at midfield.

Drew Bledsoe had confronted a similar situation earlier in the fourth quarter. Bledsoe paid the price, ending up on the wrong side of a collision with Mo Lewis, and eventually had to be replaced.

"You are just trying to get out of bounds and get as much yardage as you can in that situation," Brady said.

Asked if he had considered the consequences suffered by Bledsoe, Brady replied:

"I've played a lot of football. And if I got hit that hard, I would be in the hospital for a month. That shows you how tough, and big and strong, that guy is.

"Drew is such a fighter. Sometimes he will try to make a first down — those big guys were running fast, and he got hit as hard as I've ever seen anyone get hit."

Bledsoe returned for three more plays. But coach Bill Belichick summoned Brady for a last-gasp attempt to rally from a 10-3 deficit with 2:16 on the clock.

Brady had immediate success, advancing the Patriots from the New England 26-yard line to the 49, then, following a penalty, calling on his instincts of self-preservation to run out of bounds at the 50. It was certainly the right choice. Damon Huard was presumably able and willing to fill in, but had he entered he would have been the Patriots' third quarterback in 11 plays.

That also allowed Brady to maintain his faculties for the final 33 seconds. On the next play,

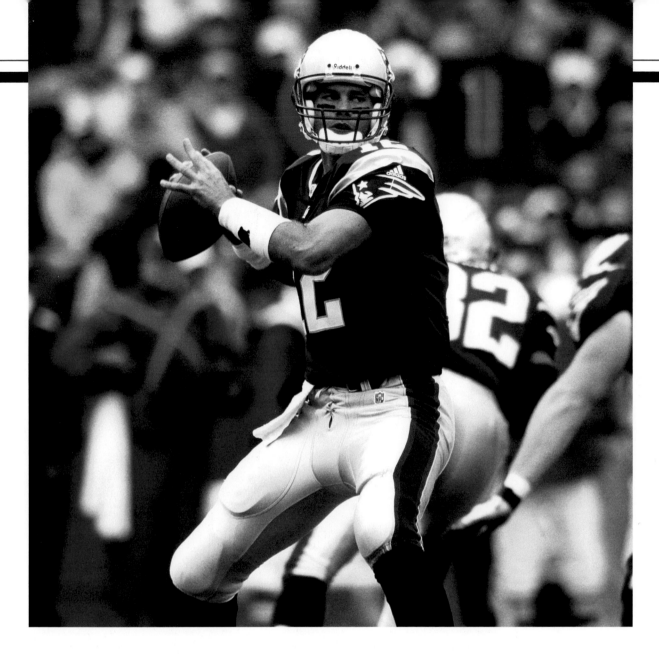

Brady completed a 21-yard pass to David Patten. There would effectively be three more plays. All three were Brady incompletions, but the last two — a Hail Mary toss into the end zone and a throw to Charles Johnson on the goal line — indicated Brady's composure and passing touch. Brady also thrived on the immediacy of the two-minute drill situation.

"Once you get going, the defense is on their heels," Brady said.

Indeed, Brady had little time to prepare for his stand-in role. Asked if he thought Bledsoe had been injured on the fateful play, Brady said, "You have to ask Drew. I was too busy getting warmed up. I was just being prepared. It was a situation where, if he got hit again, you never know."

Asked Belichick's method of informing him of the change, Brady replied, "He said, `Drew is out and you're in.' That's all it takes. I would have loved to pull it off. Every guy in this locker room would have loved to pull it off."

Brady is clearly an admirer of Bledsoe and, for that reason, content to be the second-string quarterback.

"That's the role of a backup quarterback," Brady said. "It could be two minutes at the beginning of the game or two minutes at the end. It's a situation of going in and trying to do the job. I knew we needed a touchdown to tie the game. The last play was pretty close. Everyone was out fighting to the last play. Hopefully, we won't be in a position where it has to go down to the last play. We didn't have to be in that situation because you can't win many games that way." ■

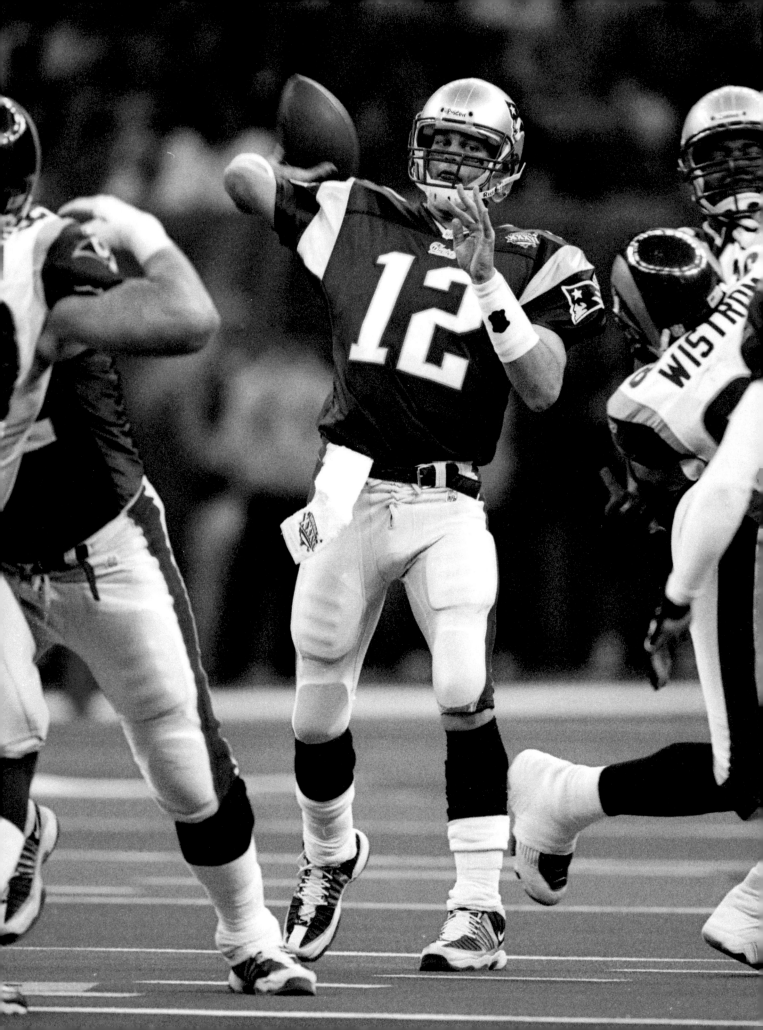

Super Bowl XXXVI vs Rams

February 3, 2002 • New Orleans, Louisiana

» PATRIOTS 20, RAMS 17

Tom Brady's unbelievable ascension to early stardom was capped off by leading the Patriots to the first Super Bowl title in franchise history.

THE REAL DEAL

Tom Brady Tops Off Tale for the Ages in Super Bowl Triumph Over Rams

By Bob Ryan

They say it takes *how* long to make someone into an effective quarterback in this league?

There no longer can be rules or maxims involving quarterbacks. Tom Brady has shattered all the myths. Henceforth, if you can play, you can play. There might be other Bradys out there, other second-year players who completed one pass in three attempts as a rookie, who get their chance when the nine-year veteran gets hurt, and who then conclude a 13-3 regular season and playoff combined run by directing their teams downfield in the final 1 minute 21 seconds of the Super Bowl to put them in position for the winning field goal.

But don't bet Junior's school lunch money on it.

Brady may be the exception that proves the rule. Brady may be the NFL's single most inexplicable personnel phenomenon, a sixth-round pick who spends the season in extended on-the-job training and winds up as the MVP in the Super Bowl.

When Brady took control of the huddle with that 1:21 left, no timeouts remaining, the ball on the Patriots 17-yard line, and the score tied at 17 after the Patriots had once led by a 17-3 score, his teammates did not see a kid quarterback. They saw a leader.

"You can't say enough about that kid," mar-

While Tom Brady only produced modest numbers of 145 yards and a touchdown, he didn't make notable mistakes and managed the game on the biggest stage like a seasoned veteran.

veled wide receiver David Patten. "He has a tremendous amount of confidence, and it rubs off on everyone else. You look in his eyes and say, 'Hey, we've got to go down and win it for this kid.'"

"What can I say about Tom Brady?" added linebacker Tedy Bruschi. "That minute-and-30-second drive has got to be one of the biggest drives in Super Bowl history."

"Brady brings a lot of confidence to the team in that huddle," said guard Joe Andruzzi.

Brady's modest final numbers show you what you can do with numbers when the only real issue is what's on the scoreboard. He was 16 for 27 for 145 yards and one touchdown. But in what you would have to agree was a reasonably important game, he threw no interceptions and did nothing stupid.

"Tom did a super job of managing the game," lauded coach Bill Belichick.

Brady was only overtly great when he had to be. On that final drive, during which he moved the team from its 17 to the Rams 30 in seven plays before spiking the ball to stop the clock at :07, he completed 5 of 6 passes, the sixth being a simple throwaway. The whole performance was eerily similar to his work in the Snow Bowl two weeks ago, when he likewise saved his best for last.

"He did what his team needed him to do," said Rams quarterback Kurt Warner. "He made the plays on the last drive that got them the win. He's done that all year. My hat's off to him."

Brady was so fazed by his first Super Bowl that he took a nap upon arrival. "I fell asleep," he reported, "and when I woke up I said to myself I didn't think I'd feel this good. I convinced myself that it was just a game, just another game."

In some ways, it was. Brady mostly threw the short- and medium-route passes that are his trademark. He had enough of a running game to keep the Rams honest. The defense made huge plays. And when Brady had to be more than just competent, when he needed to be special, he entered another realm and made the plays that had to be made.

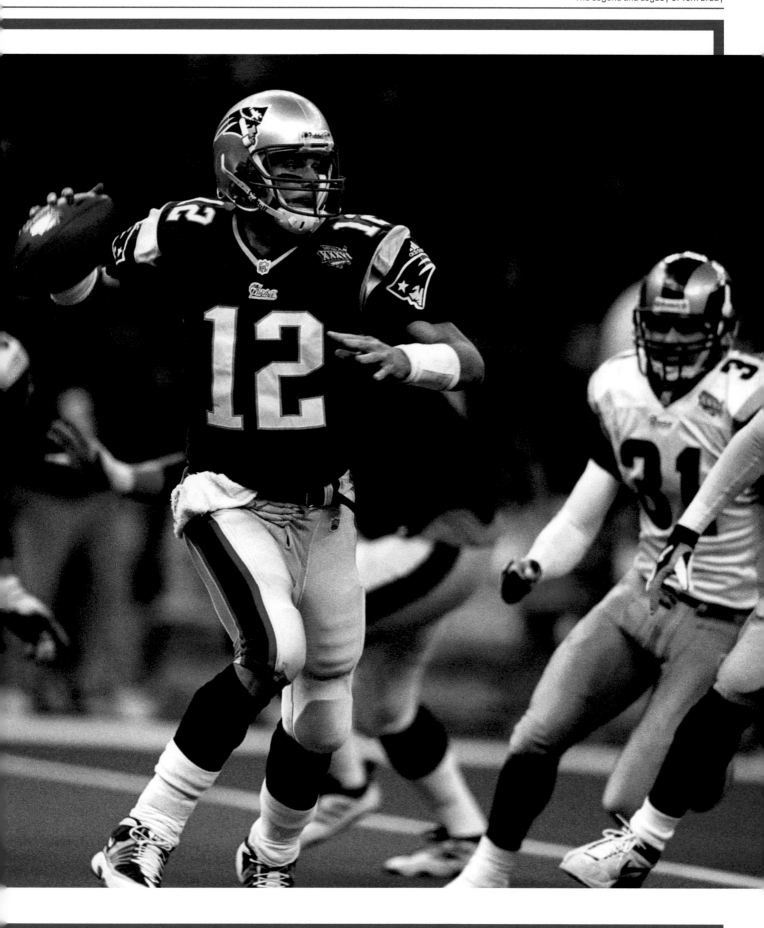

Tom Brady captured the Super Bowl MVP in the thrilling win over the St. Louis Rams.

I am of the firm belief that in the matter of Truth vs. Fiction, especially when it involves your 2001-02 Patriots, it is always wise to take Truth, plus the points. Like, did Drew Bledsoe, the Big Brother/Mentor/Rival, really instruct Brady just before that final drive to "Go out there and sling it?" Well, yes, he did. And did Brady, needing something more than a dink or dunk job, really hit — guess who? — Troy Brown for 23 yards on second and 10 at the Patriots 41? Of course.

"That was the big play," Brady said. "It's called '64 Max All-End,' and the Max stands for, as my coach says, 'We need the maximum time for me to throw.' "

The throw was around neck high, but Brown, a.k.a. Mr. Reliable, snatched it out of the air and ran out of bounds. "The way the Rams play, they really read the quarterback's eyes. I was looking hard to the right, and Troy slipped behind them. They lost sight of him. I hit him, and he did the rest."

That put the ball on the Rams 36. Brady completed one more, to Jermaine Wiggins for 6 yards, spiked the ball, and turned the proceedings over to Adam Vinatieri, who never had missed an indoor field goal attempt — and still hasn't.

This Brady is a kid whose only realistic goal when the season started was "to become a far better player by the time it was over." The only way he was going to get Bledsoe's job was if Bledsoe got hurt. As for the Super Bowl, please.

The Super Bowl. Tom Brady just won the Super Bowl. How bizarre is that?

"I ran into Dan Marino down here," Brady said. "I've never met him before. I know he was in his second year when he went to the Super Bowl, and I asked him what he was thinking about the day after. He said, 'Tommy, I was wishing I could play it over again, because you never know when you'll get back.' It's all about seizing your opportunities."

There are few things in life more disastrous than to receive your big break and not be prepared to make the most of it. When Bledsoe went down, Brady stepped in with aplomb. The other 10 men in the huddle knew he was prepared. He proved himself to be an astonishingly quick learner. He proved himself to be a winner.

Week after week after week other teams in the NFL learned to respect Tom Brady. Now, in the biggest showcase American sport has to offer, Brady has demonstrated to a fascinated American public that he is a special athlete, that he is a certified champion.

The story line is utterly fictional, but Tom Brady is completely real. He is the Truth who has obliterated all the Fiction. ■

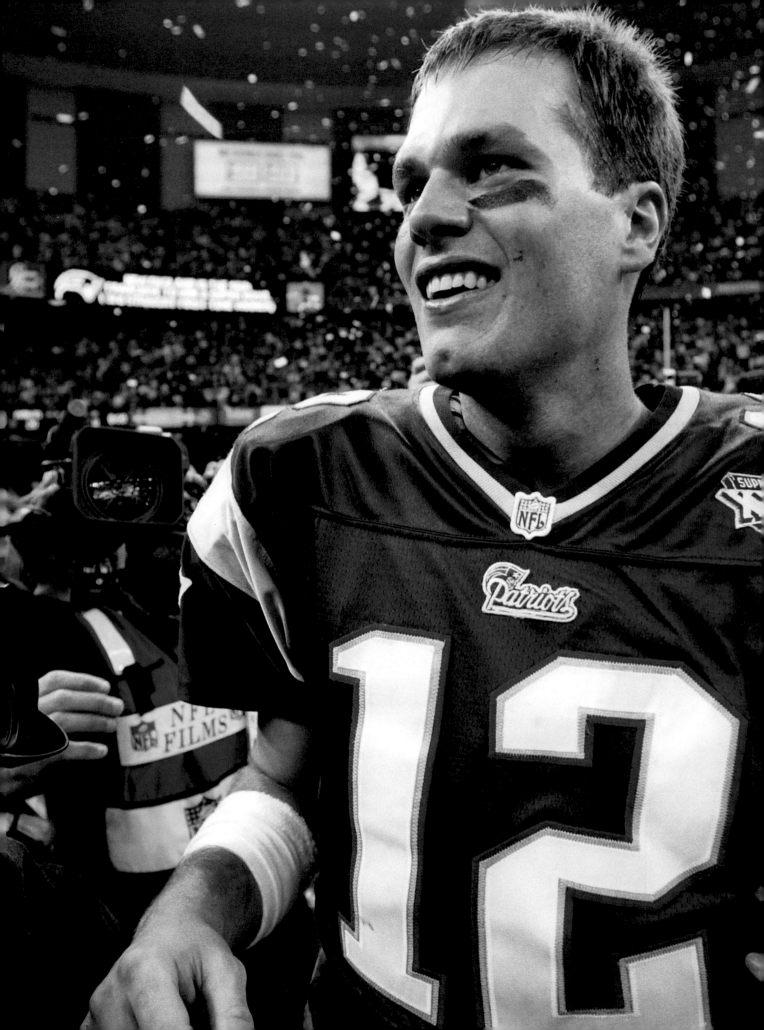

The Patriots and Tom Brady enjoyed the aftermath of their historic Super Bowl win, but eventually turned the page in the off season and got back to work.

LOOKS CAN BE DECEIVING

Tom Brady and the Patriots Go Back to Work After Super Bowl Dust Settles

By Will McDonough • May 5, 2002

Don't worry. Our Tom has not gone Hollywood, New York, or even Back Bay. Our Tom is still the same young man who helped win a Super Bowl for the Patriots, and did it with style and grace under difficult conditions.

However, there are some who think Tom Brady, cover boy for Sports Illustrated and star of local gossip columns, has not been minding his business — his football business. Nothing could be further from the truth. The people who are in Foxborough every working day will tell you that Our Tom is there with them, usually from 7 a.m. to 11 a.m. four days a week, lifting, running, throwing, studying.

Brady is aware of the skeptics who question the way he has conducted himself since the Super Bowl, and he is bothered by it.

"You read this stuff [about yourself] or hear it, and you wonder where it comes from," he said. "Most of it just didn't happen. But what can you do about it? It bothers me, because it just isn't true.

"I went to some of the guys on our team to talk to them about it, and I told them there was nothing to it. They told me they knew that, and not to let it bother me, but it does. I'm a football player. I could care less about that [publicity] stuff. I don't want it, I don't look for it. I went out more with my buddies last year, when no one knew who I was up here, than I do now. They make it seem

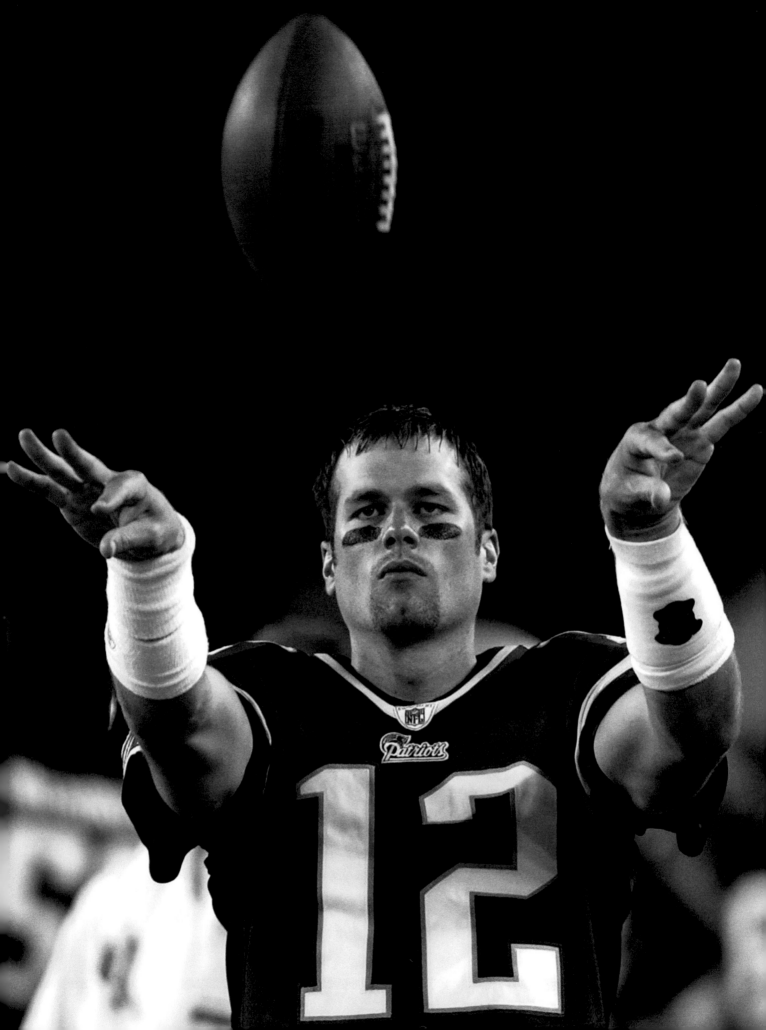

Even with Tom Brady's early success, he always made a point to develop his game in the off season to take it to the next level.

like I'm out all the time. I'm not.

"I don't want to get to the point where I don't go out and all, and my friends on the team tell me not to do that. I've never gone through this before, so I'm not sure how to handle it. This is all new to me. I don't think the right thing would be to make corrections every time something appears about me that isn't true."

Instead, Brady loses himself inside what is left of the Patriots headquarters at Foxboro Stadium, getting ready for next year, knowing it is going to be a tremendous challenge.

"I've been studying what I did last year," he said. "The coaches have broken down the film. You see what you did well and what you didn't do well. Then you try to find out why what happened, happened. Right now, I'm in the greatest condition of my life. I came into workouts [March 1] and was even stronger than I was at the end of last season. I really didn't take any time off. When I went home after the Pro Bowl, I started lifting right away.

"I'd rather be in here lifting weights than be downtown, believe me. I look forward to coming in here and working. I love to practice. Fun for me is running seven-on-seven drills in the heat of training camp. That's fun. I love it."

This upcoming season is going to be different for Brady in just about every way. Last year he came to training camp virtually unknown to Patriots fans, though growing in stature with the coaching staff. It was a year ago that his offseason work at the team's training facility produced 15 additional pounds of muscle and more zip on his fastball, making his career as an NFL quarterback not only possible but probable.

Then stardom reached out and grabbed him by the right arm when Drew Bledsoe was knocked out of the lineup with a serious chest injury. Brady entered, and never looked back. The team was 0-2 when Bledsoe went down, but 14-3 under Brady the rest of the way. There was just one hang-up — the Brady-Bledsoe conflict in the media, which worked Itself out this spring

with the trading of Bledsoe on the second day of the draft. That move was double-edged, as far as Brady is concerned.

"We gave up a great player," he said. "When I was a kid, and heard the name of the New England Patriots, I thought about Drew Bledsoe. It was Drew Bledsoe's team. I felt the same way when I got drafted. Drew Bledsoe was the Patriots. Now he's gone. In one way, there's relief. This will do away with all of the talk week to week that had become a distraction for everyone. At the same time, Buffalo has a great quarterback and we have to play against him a couple of times a year.

"We had a good relationship. He helped me a lot. He is a good friend. It was a difficult situation for both of us. When I was playing last year, I knew I had his support.

"In the Super Bowl, when [the Rams] tied it up with less than two minutes to play, I walked down the bench to talk with [offensive coordinator] Charlie Weis to find out what he wanted to do. He had just finished talking with Bill [Belichick]. He turned to me and said, 'We're going for it.' I said, 'Great.' But he cautioned me about making bad decisions or turning the ball over. That could be the game for them.

"Drew and Damon [Huard] were standing there. They asked me what I thought would work. I gave them two or three plays. They liked what I thought. There was no timeout after the Rams touchdown, so there wasn't a lot of time before we got the ball back. I looked at Drew just before I ran on the field, and he said, 'Throw the ball. Go for it. Just get out there and sling it.' And that's the way I thought when I went into the huddle for that final drive.

"I wasn't nervous. In fact, I don't think I was nervous once all year. The Thursday night before the Super Bowl game, I was in bed thinking, 'Hey, how come I'm not nervous? This is the Super Bowl.' I never felt nervous. The night before the game, I had a great sleep. And after the first play of that [winning drive], I felt confident we were going to do it.

A young Tom Brady holds the Super Bowl trophy after a compelling Super Bowl XXXVI win.

"The Rams had played basically the same defense in passing situations the entire game. They played like Tampa Bay: two-deep zone with the safeties deep and outside. Then they drop the middle linebacker straight down the field so it's almost like a three-deep zone. It's tough to hit the deep ball on them. That's the one they are trying to take away. They make you stay patient.

"When we came out and hit the first pass on them, I could see them backing off. It was visible. You could see it in their faces and the way they reacted. I was confident of what we were going to see from them, and how we were going to react to it."

Brady moved his team into position for Adam Vinatieri's winning field goal, but even at that moment, he still didn't realize how big it was.

"When we won, it felt just like the other games we won," he said. "From the point in the season when we were 5-5 until then, it was a must win every week. We had to beat the Jets. Then we had to beat Miami. And then we had to beat Oakland and Pittsburgh. But I never felt the pressure. Maybe it's because I played in Michigan and we heard the same thing every week. They were all must games.

"But since we won the Super Bowl, and we see the way things have happened around here, then you realize you have won the No. 1 game in the world. A year ago, I'd go home after working out and be all alone after that. Now I get finished, and I've got all kinds of things to do with commitments. I wish it was just football. I really do. I could do away with all of the other stuff. I don't need it."

Brady knows the 2002 season will be one of adjustment, and he is looking forward to it. The opponents on the schedule are already analyzing Brady's 2001 performance — what he did well and what he had difficulty with. He hopes to surprise them.

Brady feels he can play better than he did a year ago. He thinks the experience of playing 17 games, plus his being stronger and having a better cast around him, will make the New England offense more productive.

"I think [free agent wide receiver] Donald Hayes is a good pickup," he said. "In workouts he looks really good. I look for us to stretch the field more than we did last year, with the tight end [Daniel Graham] and Hayes. If we can make the other teams respect us more deeper than they did last year, that should help the rest of our offense.

"I'm going to work on throwing the deep ball better. I know I can do that. But I'm going to have to prove it. I anticipate that other teams will pack the middle of the field because we had our best success throwing short and intermediate. No matter what they do, we have to do what we do best. Last year, that was throw it in the middle of the field. There is no better receiver in the middle than Troy Brown. This is where he is best. So we went to him there. No matter what happens, they can't cover all three areas of the field — short, intermediate, long. They can't do that. So we will take whatever they give us.

"I'm working at being better in the pocket. I dropped too many balls last year, and I gave up some more on hits that I should have been able to hold. I'm going to hold it more with two hands rather than just one. I'm going to have the guys bang me around a little in practice to make me more aware of holding on to the ball.

"I'm also working at strengthening my lower body, so when I get hit, I have a better chance of staying on my feet. I got hit a couple of times last year with just one arm and I still went down. Drew was great at that. Guys would bounce off him in the pocket." ∎

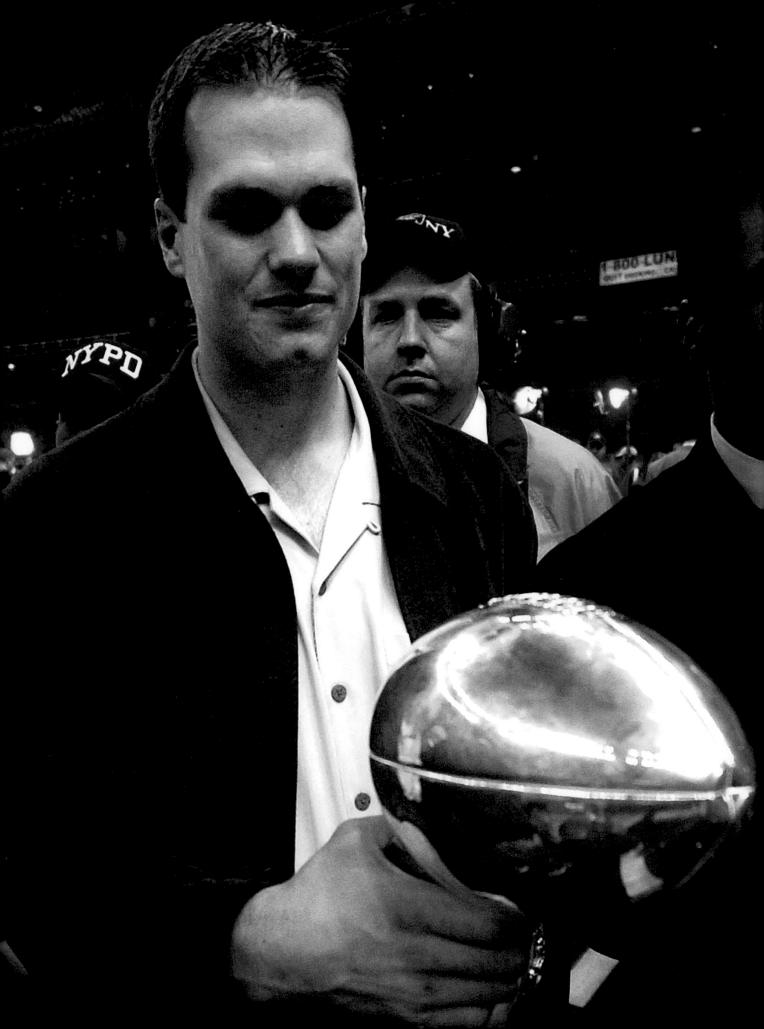

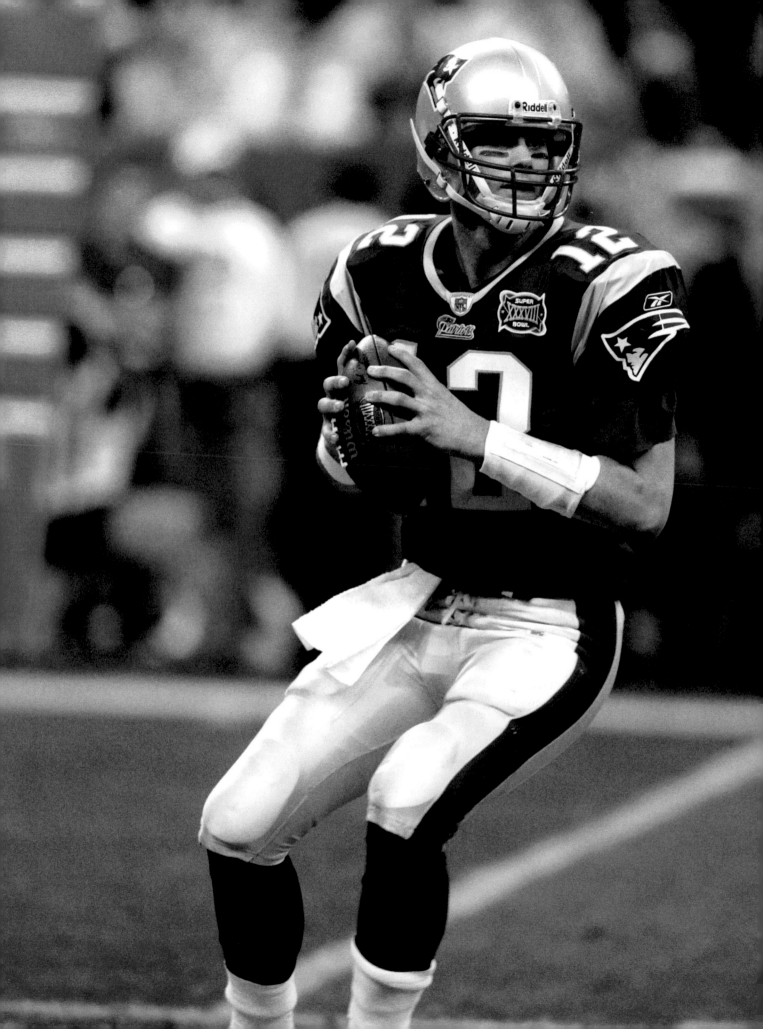

Super Bowl XXXVIII vs Panthers
February 1, 2004 • Houston, Texas
» **PATRIOTS 32, PANTHERS 29**

ONE FOR THE AGES

Tom Brady and Patriots Prevail over Panthers in One of the Greatest Super Bowls Ever Played

By Bob Ryan

Tom Brady had a huge performance in the Super Bowl win over the Panthers, completing 32 of 48 passes for 354 yards and a touchdown.

And that, ladies and gentlemen, is why a couple of billion people around the globe are hooked on sport.

Hype doesn't matter. Prognostications don't matter. Talk doesn't matter. When the game starts, performance is all that matters, and the two teams playing in Super Bowl XXXVIII gave everything they could possibly summon, sometimes from who-knows-where, to produce what may very well go down in history as the greatest of all Super Bowls.

Even Bill Belichick took note. "That was a terrific football game to watch," said the coach whose team gave him a 32-29 victory that makes him a two-time Super Bowl championship men-

tor. "But it was not a terrific game to coach. I was having a heart attack out there."

These teams sure gave us a decent bang for the buck. For a game that remained scoreless longer than any previous Super Bowl, it turned into a wild west shootout with 61 points over the last 33 minutes, with the subplot being the greatest quarterback duel the title game has ever seen. Game MVP Tom Brady played the game we've come to expect (32 of 48, 354 yards, 3 touchdown passes, and 1 near-disastrous interception), but he had to be an MVP-type because Panthers counterpart Jake Delhomme made the most improbable personal in-game turnaround ever.

After starting out 1 for 9 with huge negative

Even Tom Brady and his teammates were amazed at the drama and excitement of Super Bowl XXXVIII.

yardage, he connected on 15 of his final 24 passes, good for 323 yards and three TDs. He accomplished what neither Steve McNair nor Peyton Manning could, eating up huge chunks of real estate against a suddenly baffled Patriots defense that was helpless to stop him.

Like, what happened?

"They made some nice adjustments," acknowledged defensive coordinator Romeo Crennel. "We played a little bit more conservative in the second half, but they made adjustments and found some soft spots in our zone."

"We just started moving around, hitting seams," said Carolina veteran wideout Ricky Proehl, who caught the tying touchdown with 1:08 remaining. "We started getting into a rhythm, and they got a little tired."

Once the offenses got rolling, the defenses had no answer. "It was supposed to be defense vs. defense," said Patriots offensive coordinator Charlie Weis, "but it turned out to be offense vs. offense." It meant the coordinators did what they had to do, which, in the Patriots' case, meant utilizing linebacker Mike Vrabel as a pass receiver in the red zone. Vrabel drifted out of the line of scrimmage to catch a 1-yard touchdown with 2:51 remaining.

"136 X-cross Z-flag," explained Vrabel. "The play was put in, and I knew on that one I'd have a chance."

The defenses simply lost control of the game, which suddenly turned into an Indianapolis-Kansas City shootout, completely unlike anything the Patriots had engaged in all year. Sure, they had to hold off the Colts in that famous 38-34 game Nov. 30, but they had been ahead, 31-10, before they got careless and Manning got hot. Once this one got rolling, it was a matter of "Can you top this?"

"Two good, tough football teams," said Vrabel. "It was Ali-Frazier. We hit them. They hit us. We hit them. They hit us. But I'll take my chances with Tom Brady, Troy Brown, David Givens, and Adam Vinatieri any day of the week."

It was, frankly, a humbling experience for both defenses.

"It was a horrifying game," acknowledged Ty Law, who found himself on the field with the likes of Asante Samuel and Shawn Mayer after regulars Rodney Harrison (broken arm) and Eugene Wilson (hip flexor) were forced out of the game. "Both defenses were tired. We knew it would come down to the end and we knew we'd have the advantage because we have Adam Vinatieri."

Oh, him. After missing a 31-yard try and having another one blocked, Vinatieri was summoned to the field in a virtual instant replay of the proceedings in New Orleans two years ago. He, of course, knocked the Super Bowl-winning field goal right down Broadway, or whatever happens to be the main drag in Rapid City, S.D. And in another deja-vu-all-over-again scenario, Proehl was once again a member of the victimized team.

"I will have nightmares about Adam Vinatieri for a long time," Proehl acknowledged.

There really is no way for the participants to have grasped just what they were a part of. It just doesn't work that way, because it's just too hard doing it, let alone analyzing it. The one thing the Patriots know is that they have some key people to trust when things get sticky, like, say, with 1:08 remaining and the score tied at 29.

"Tom's a winner," acknowledged Belichick. "The quarterback's job is to do what he needs to do to help his team win, and that's what Tom does."

And Troy Brown. He is the most flat-out reliable Patriot receiver ever. He's not the most talented, but he is the most reliable.

"I want the ball in the big situations," Brown said. "A lot of people depend on me, and I don't want to let them down."

He came through when he had to, as did David Givens, as did Tom Brady, as did Adam Vinatieri.

"We made one more play than they did," said Law with a smile.

What they all did, Patriots and Panthers alike, was elevate sport into something noble. Lawdy, Lawdy, was this a football game, or what? ∎

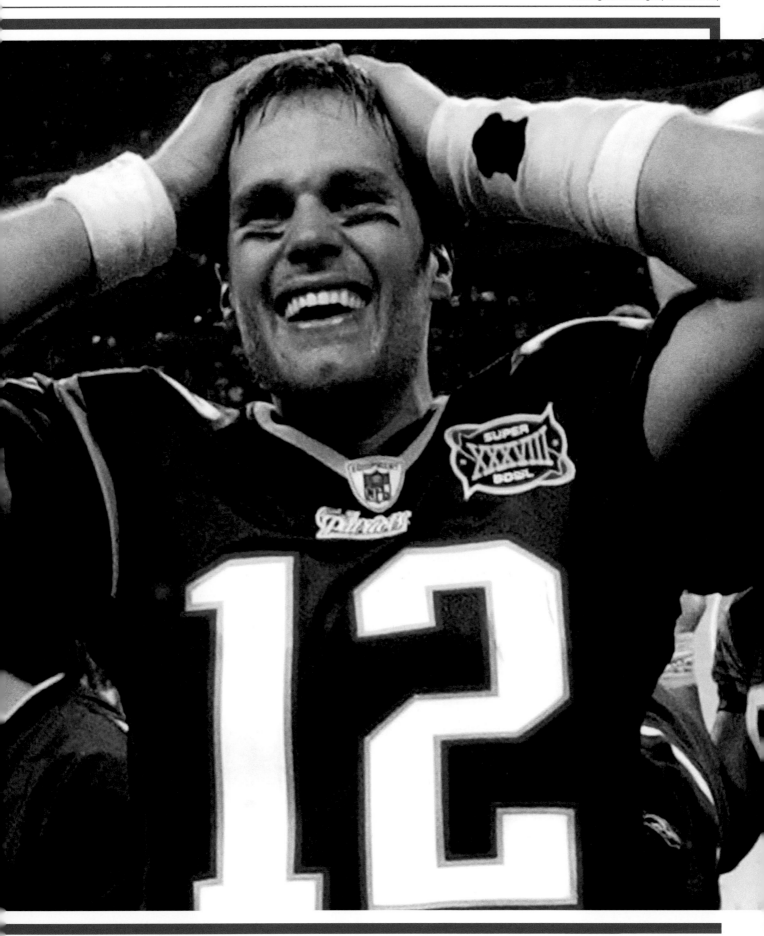

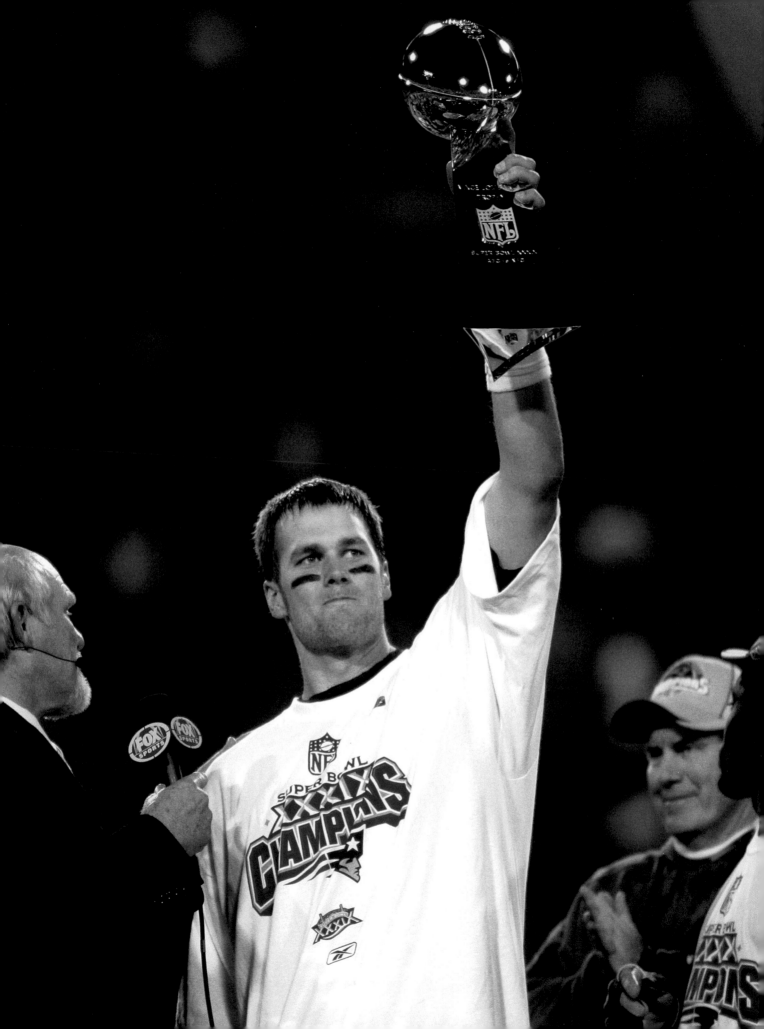

Super Bowl XXXIX vs Eagles
February 6, 2005 • Jacksonville, Florida
❖ PATRIOTS 24, EAGLES 21

LET IT REIGN

Tom Brady and the Patriots captured their third Super Bowl title in four years, with Brady contributing 236 yards and two touchdowns in the 24-21 win over the Eagles.

Patriots and Tom Brady Capture Third Title in Past Four Years with Win over Eagles

By Nick Cafardo

The red, white, and blue confetti floated in the sky and dropped ever so gently on their latest field of dreams. There were hugs, pats on the backs, and family moments with children hugging their hero dads, and wives kissing their hero husbands. There was Bill Belichick, Romeo Crennel, and Charlie Weis, the brain trust of the Super Bowl XXXIX champions embracing for the final time, with Weis off to Notre Dame and Crennel off to Cleveland.

The Vince Lombardi Trophy was touched, kissed, and embraced like a loved one.

The New England Patriots, draped in blood, sweat, and tears, won the Super Bowl for the third time in four years, beating the Philadelphia Eagles,

24-21, last night before 78,125 at Alltel Stadium.

Dynasty?

"We're champions now," said Patriots safety Rodney Harrison. "I don't know about dynasty right now."

Football historians will look back upon the current run by the Patriots and decide if it is indeed a dynasty. But for now it's clear that no football team in the world is better.

The Patriots broke a 14-14 tie and took control with two fourth-quarter scores against the Eagles, who couldn't stop Tom Brady and Co. when it counted most.

Brady, who played with a heavy heart with his 94-year-old grandmother passing away Wednes-

Tom Brady flips the camera on the fans for a change during the Super Bowl XXXIX parade in Boston.

day, completed 23 of 33 passes for 236 yards and two touchdowns for a 110.2 quarterback rating. He was the calm, cool quarterback who had been there and done that. His Eagles counterpart, Donovan McNabb (30 of 51 for 357 yards, three touchdowns, and three interceptions), looked jittery at times in his Super Bowl debut.

Brady's favorite target was Deion Branch, who tied a Super Bowl record with 11 catches for 133 yards and was named the game's most valuable player.

"It doesn't make a difference who gets what," said Branch. "Our plan was to come in here and win the game. We had a lot of doubters and we showed them that we are a big team and we came out and won tonight."

The Patriots boosted their lead to 24-14 in the fourth quarter courtesy of Adam Vinatieri's 22-yard field goal, which capped an eight-play, 43-yard drive.

McNabb, who has a history of overthrowing receivers at crucial times, got the ball with 5:40 remaining and tried to rally the Eagles.

The Patriots played another stout defensive game, showing McNabb looks — including lining up two linemen and five linebackers — he may have never seen on film. They had to adapt after losing free safety Eugene Wilson for more than half the game with what was thought to be a broken arm.

The Eagles pulled within 24-21 with 1:48 remaining when McNabb found Greg Lewis for a 30-yard touchdown pass over rookie safety Dexter Reid — Wilson's replacement. That capped a 13-play, 79-yard drive that consumed 3 minutes 52 seconds.

The Eagles attempted an onside kick, but it was recovered by Christian Fauria at the Eagles' 41. While the Eagles forced a Patriots punt, McNabb couldn't pull off the heroics, with Harrison icing the game with his second interception.

While the Eagles received a strong perfor-mance from Terrell Owens (nine catches, 122 yards), the flamboyant receiver never found the end zone.

"Obviously we had a lot of turnovers," said Owens. "My hat goes off to the New England Patriots. They're a good team. It was a hard-fought ballgame. We just gave it away."

"I think we had everyone on the edge of their seats when we went back out there with 50 seconds left. We possibly could have won that game," McNabb said.

But it wasn't to be.

You could sense the Patriots were taking over late in the second quarter, and by the time Paul McCartney had finished "Hey Jude" at halftime, Belichick's troops were ready to take the field and carry on the momentum.

Offensive coordinator Weis said the 25-minute halftime allowed him time to figure out how to beat the Philadelphia blitz. He did it with short passes and screen passes.

The Eagles were still intent on blitzing, and the Patriots were happy to see it.

"They were blitzing up the middle with [Jeremiah Trotter] in an attempt to make Brady get out of the pocket and so we had to do something to combat it. We used the screens and the shorter passing game, and it really opened things up for us," Weis said.

Brady was picking it up very nicely, spotting Branch for gains of 27 and 21, the latter giving the Patriots a first down at the Philadelphia 2-yard line. From there, Brady went to designated short-yardage tight end Mike Vrabel, who gathered a tipped pass for his second touchdown reception in as many Super Bowls, giving the champs a 14-7 lead with 11:09 left in the third.

A fired-up Brady returned to the sideline and screamed to his teammates, "Let's keep it going! Let's keep it going!"

Yet the Eagles answered quickly, evening things at 14 with 3:35 remaining in the third. It

was turning into a heavyweight title fight, and McNabb appeared poised for the challenge.

The Eagles targeted rookie corner Randall Gay, throwing at him often during the drive. McNabb completed passes of 15, 4, and 10 to Brian Westbrook, the last catch good for 6 points. He also found Lewis and Owens twice each on the drive. His favorite first-half target, Todd Pinkston, was cramping up and was in the locker room receiving intravenous fluids.

The chains kept moving and even with a blitzing Willie McGinest coming at him, McNabb managed to drill a pass to Westbrook between two Patriots for the tying score.

With the score even after three quarters (a Super Bowl first), the Patriots started a well-orchestrated drive to regain the lead. Brady was very methodical in leading the Patriots 66 yards, using Kevin Faulk as a key component.

Faulk caught passes of 13 and 14 yards (both beating Eagle blitzes) and ran twice for 20 yards in picking up three first downs on the drive. Corey Dillon capped it with a 2-yard touchdown run off left tackle with 13:44 remaining, giving the Patriots a 21-14 lead.

"We were 0 for 4 on first downs in the first quarter and we really couldn't get into any rhythm offensively," said Brady. "We just didn't move the ball. We tried to run it and didn't gain a whole lot of yards. We made a few more plays in the second half."

At one point in the first quarter, the Eagles led the battle of first downs, 9-1. The Patriots committed costly penalties early and Pinkston made two beautiful catches on the first scoring drive, which culminated in McNabb hitting L.J. Smith in the end zone with 9:55 remaining in the first quarter.

On their next possession, the Patriots tried to answer but Brady fumbled when his hand hit Faulk's hip at the Eagles' 5-yard line (New England's first turnover of the postseason).

New England finally scored when Brady hit David Givens for 4-yard score to make it 7-7 with 1:10 left before intermission.

That was not respectable for the three-time Super Bowl champions.

In the end, they adjusted, they executed, and they conquered. ∎

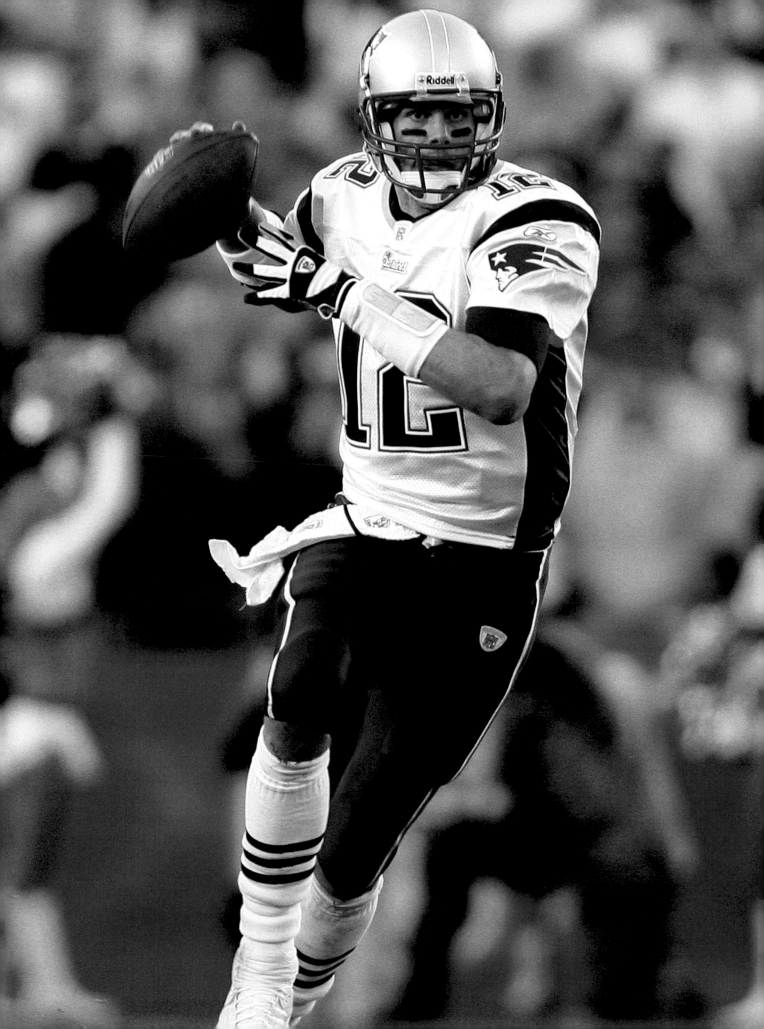

AFC Divisional Round

January 14, 2007 • San Diego, California

» PATRIOTS 24, CHARGERS 21

IN BRADY THEY TRUST

While Tom Brady wasn't at his sharpest, going 27 for 51 for 280 yards, two touchdowns, and three interceptions, he did enough to help the Patriots to the close win.

Tom Brady and Pats Find a Way to Advance to AFC Championship Once Again

By Bob Ryan

In Tom They Trust.

Fallow stretches, uncharacteristic bad picks, whatever. Doesn't matter. Remember Magic Johnson's celebrated "Winnin' Time?" Mr. Tom Brady has one, too.

"That's Tom Brady," said Heath Evans, spare back and special teamer extraordinaire. "He's the one guy we don't ever worry about."

Tom Brady was not Tom Brady for long stretches of this memorable game, and a lot of that had to do with the San Diego Chargers. "That was as tough a game as I ever remember playing," said Brady, who had to air it out 51 times yesterday in order to produce a 24-21 triumph. "We

were doing everything we could to gain 5 yards out of them."

Brady's final numbers weren't that dazzling (27 of 51, 280 yards, two touchdowns, three interceptions, and a pedestrian 57.6 rating), but when has Tom Brady ever been about the numbers? Tom Brady is about one thing, period.

He's about winning the game.

This was a long, tough afternoon for your New England Patriots, who had two leads: 3-0 and the final score. The rest of the day was a brutal struggle to keep from getting destroyed by a 14-2 team that had been 8-0 at home. But the Patriots had two big things going for them, the

The Patriots advanced to the AFC Championship for the fifth time with Tom Brady at the helm with the win over the top-seeded Chargers.

first being San Diego's peculiar self-destructive nature and the second being their battle-tested quarterback. In the three most crucial offensive situations of the afternoon, Tom Brady made the plays he had to make.

Ever heard *that* one before?

The first situation occurred late in the first half. The Chargers had just gone ahead, 14-3, with a four-play, 77-yard drive highlighted by a 58-yard screen pass and run by LaDainian Tomlinson that gave the home squad a first down at the New England 6. So the Patriots rather seriously needed a score before the half.

Ever heard that one before?

And, of course, they got one, with Brady completing passes of 17, 16, 9, 7, and finally 6 yards, a pass to the left rear corner of the end zone to the ever-improving Jabar Gaffney.

The second situation began with the Patriots taking over at their 37 after San Diego had gone in front by a 21-13 score with 8:35 remaining. The official record will show a 32-yard drive, but it was, in reality, a 63-yard drive, since it was broken in two once the Patriots emerged from a bizarre play in which Brady had thrown a fourth-down interception, only to get the ball back when Troy Brown, a.k.a. Mr. Reliable, stripped the ball from San Diego's Marlon McCree and Reche Caldwell recovered at the Chargers' 32. Brady got them to the end zone in five pass plays, and Kevin Faulk got them the needed 2-point conversion on a direct snap play featuring a superb left-to-right improvisation.

Then, of course, there was the final drive. After the defense had made a clutch stand to force a three-and-out, Brady took over on his 15, needing somewhere in the vicinity of 52 to 53 yards to give Stephen Gostkowski a reasonable chance to kick the winning field goal.

OK, OK, he cut it close. He began the drive by hitting Daniel Graham for 19 yards, but it came down to a third-and-10 at his 34. But Brady

wasn't going to settle for 10.

"They were [in] press coverage late in the game," explained coach Bill Belichick. "That gave us an opportunity to go deep."

Reche Caldwell went down the right sideline. Brady was the beneficiary of superb protection when he most needed it, and he took full advantage be delivering a room-service morsel to a hungry Caldwell, who gathered the pass in for a 49-yard gain to the San Diego 17.

It was the clutchest of clutch plays. Ever heard that one before?

"He put the ball in the perfect spot and Reche made the grab," summarized Evans.

"In a situation like that," said Gaffney (10 receptions, 103 yards), "there's no one better."

You knew Brady wasn't going to do anything stupid from there on out, and he didn't. Seven would have been nice, but the only smart play was to go for 3, and that's what they got when Gostkowski nailed his third field goal of the day, from 31 yards.

You know this stuff never gets old for Brady, who lives to make the Big Play in the Big Situation. He's had a lot of satisfying games and moments, but you can be certain he will save a spot in his heart for this one. The Patriots had come into Qualcomm Stadium and knocked off the AFC's top-seeded team, a team, in turns out, that had quite a lot to say during the game for an outfit that has yet to win anything. The Patriots, as you may know, prefer to do the playing and leave the yapping to others.

And there will be no more talk about the receiving corps. To borrow a phrase, they are what they are, and in the two 2007 playoff games they have been good enough for Brady to get the W. They are getting more and more skilled at making the tough catches from the knees down that keep the chains moving. If the Gaffneys and Caldwells of the world weren't accomplished at this maneuver before they came to the Patriots, they are now.

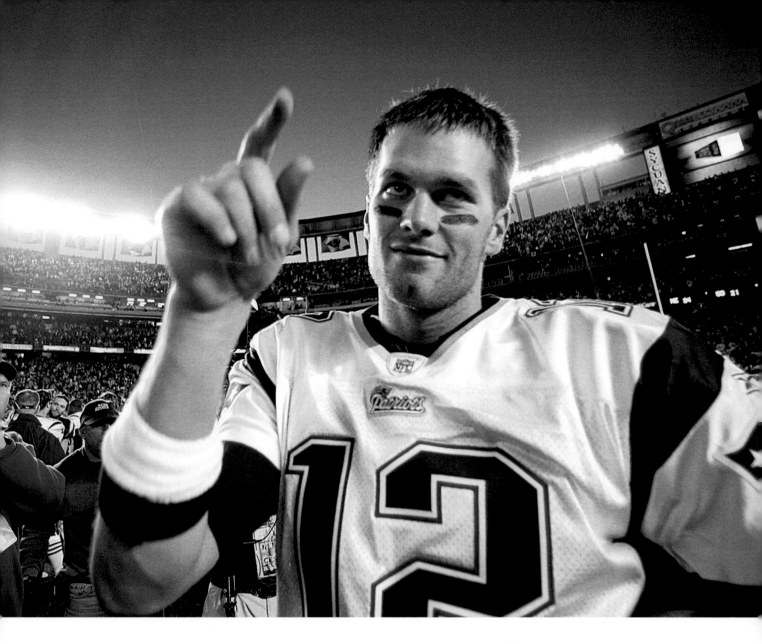

They understand that Brady will throw the low ball, and their job is to catch 'em, no questions asked.

The Chargers made them work for it; that's for sure. "It was a challenging day all the way around," Brady confirmed. "I just couldn't find any rhythm for a while. Tried the quick stuff. That didn't work. Tried the screens. That didn't work. Every time I came off the field in the first half, I'd say, 'God, we've got to try something else.' "

But he knows it's not always going to be easy, and, in fact, he expects it to be a chore, so he never even comes close to being frustrated. He is gifted with enormous patience and at this stage of his career he has the requisite experience to probe and probe until he finds something that will work.

Someone asked him to define "mental toughness."

"Mental toughness," he pondered. "It's just not letting anything get to you. You have to be mentally tough enough to fight through whatever it might be, whether it's a bad play or a situation. We've got mentally tough guys."

One in particular. That's why the Patriots' official motto might as well be "In Tom We Trust." Because they do. ∎

The pairing of Tom Brady and Randy Moss in 2007 was even more successful than could've been imagined, with Brady throwing for a league leading 50 touchdowns, and Moss catching a league leading 23 touchdowns.

SETTING THE RECORDS STRAIGHT

Tom Brady and Randy Moss are the Perfect Match as Pats Improve to 16-0

By Jackie MacMullan • December 30, 2007

Here's how you know you're destined to go down in history as something special.

You call your dream play — Randy Moss streaking down the right side of the football field while Tom Brady cocks his golden arm and throws it just about as far as he can — and the ball is just a little bit short, and Moss has to come back to it, and incredibly, unbelievably, drops it at the 18-yard line, with no one between him and the end zone.

Your quarterback appears stunned, agitated. He even puts his hands in his helmet for a split second before waving his team back into the huddle.

"I wish I could have made a better throw," Brady confessed when it was over.

So the quarterback regroups, and the Patriots design a short pass play for receiver Wes Welker, because its third down and 10 in the fourth quarter, and the clock is ticking down, and New England is losing 28-23, and after all, history is on the line, and both teams have played so hard, and even though both coaches probably would have liked rest their starters for the postseason, neither were about to blink in the midst of this electric football battle.

The Patriots step up to the line of scrimmage

Although the Patriots couldn't close out a perfect season in Super Bowl XLII, it remains an unforgettable campaign for Brady and Moss.

and Moss positions himself on the right side of the field, exactly where he was one play earlier, but he's not expecting the ball.

"I'm running the same thing as the last time — a 9 route — to clear out so Tommy can get the ball to Wes," Moss said. "Only the corner and the safety come over and trap Wes, and they are trying to trap Tommy into making a bad throw."

Brady looks at Welker, sees the coverage, and has a split second to make a decision. So he reacts to what he senses is his best option — and he heaves the ball down the right side of the field again, to the guy who is wearing No. 81 and the red gloves, the guy who had dropped the ball moments earlier, the one who has been his best option since the day he reported to training camp and vowed he would be nothing but a positive influence on this New England Patriots team.

You know, the guy running the 9 route.

This time, Moss strides down the field, 65 yards in all, as Brady lets it fly, watching in absolute glee as the ball floats over the head of safety James Butler and nestles safely in the outstretched arms of the best receiver the franchise quarterback has ever seen.

Touchdown. Game-breaker. Record-breaker.

And so it is done. The Patriots are 16-0 and have established a standard of excellence. Brady is the NFL season leader in touchdown passes and Moss is the season leader in touchdown receptions. New England once again proves it will bend, but it will not break.

Together, the Giants and the Patriots combine to provide America with the most exhilarating and exciting game that meant absolutely nothing in terms of playoff positioning, but was played with the passion and intensity of a Super Bowl.

The pursuit of perfection has been grueling, taxing, and last night was no exception. The Giants attacked this game as though their season depended on it.

For three quarters, they were more composed

than their more-celebrated opponent. Their young quarterback Eli Manning was neither flummoxed or flustered by the Patriots' defense, as so many prognosticators forecasted.

The Patriots, quite frankly, were in trouble. Their defense was unable to contain Manning and his receivers. Brandon Jacobs literally ran over some of New England's top personnel, including team leader Rodney Harrison.

Offensively, New England moved the ball, but was thwarted from punching it into the end zone. The Patriots scored on their first four offensive series, but three of those were field goals.

They trailed, 21-16, at the half, 28-16 early in the third quarter, and 28-23 at the 12-minute mark of the fourth quarter.

There was nothing perfect about it.

But they have been here before, down to Dallas, down to Indy, down to Baltimore, and each time New England found a way to win.

Last night, the weapons of choice were familiar. It was Brady and Moss, now the two most prolific season scorers in the history of their respective positions.

There is only one pigskin to signify their incredible fourth-quarter connection. The 65-yard pass from Brady to Moss not only cemented the team's history, it cemented their milestones as well.

So what to do with the ball? Donate it to Canton, Ohio? Feed it to Jonathan Papelbon's dog? Cut it in half and share their historic moment?

"That's what I suggested, to be honest," Moss said. "But Tom said, 'Oh no, you keep it.'"

The quarterback is asked in the wake of this satisfying 38-35 victory what it means to him to surpass the totals of his friend and rival, Peyton Manning, who held the mark of 49 touchdown passes in a season.

"It's not as important as what I've experienced the last seven years — or tonight," Brady said.

Moss, whose checkered past left him bent on silencing his critics this season, claims he knew from the day he walked into the Foxbor-

ough locker room that success of historic proportions was possible.

"I had done my homework on why I wanted to be a New England Patriot," said Moss, citing coach Bill Belichick, Brady, and the chemistry in the locker room as the major components. "I love what I do. I love to play football. When I came here, I looked down the road and — I know this is hard to believe — but I predicted this."

It takes a supremely confident athlete to predict his team will not lose a game during the long, arduous NFL season.

Moss fits the bill. So does Brady.

No wonder they wound up perfect. ∎

Along with Tom Brady's massive success came added opportunities and responsibilities off the field as his career progressed.

FOR NUMBER 12, A GILDED AGE

A Super Talent, but How Tom Brady's Changed

By Bob Hohler • September 7, 2008

In his wilderness days as an NFL nobody, Tom Brady often stopped at a roadside café on his ride from work to his vinyl-sided, cookie-cutter condo town house in Franklin. No one recognized him but the kid behind the counter.

"He was all about the ham and cheese [grinder] and onion rings," Alex Kontoulis, the counter guy, said at his family-owned Omega Pizza a few miles from Gillette Stadium. "That's all he ever needed."

The man who would become the greatest quarterback and most paparazzi-stalked sports celebrity in New England history washed it all down with an orange soda.

"He really was just an average Joe," Kontoulis said. "Now he's a legend. He's Hollywood."

As the Patriots open a new season of hope and opportunity today, their leading man returns to football as a figure almost entirely transformed from the unassuming, and ferociously talented, number 12 the region fell in love with as soon as the spotlight found him, in 2001, his first Super Bowl season. He was the rare superstar with a convincing common touch, the oddly approachable, albeit absurdly handsome, boy next door.

Seven seasons later, the talent remains unrivaled, but almost all the other adjectives have changed.

Brady comes back to Foxborough's artificial turf from one of the most rarefied offseasons imaginable. With the world's wealthiest model at his side, he has been juggling the unrivaled pampering of money and privilege and the jangling discomfort of serving as daily prey for the gossip mongers and the stalkarazzi.

And for the first time in the Brady Era in Boston, the iconic quarterback begins a season

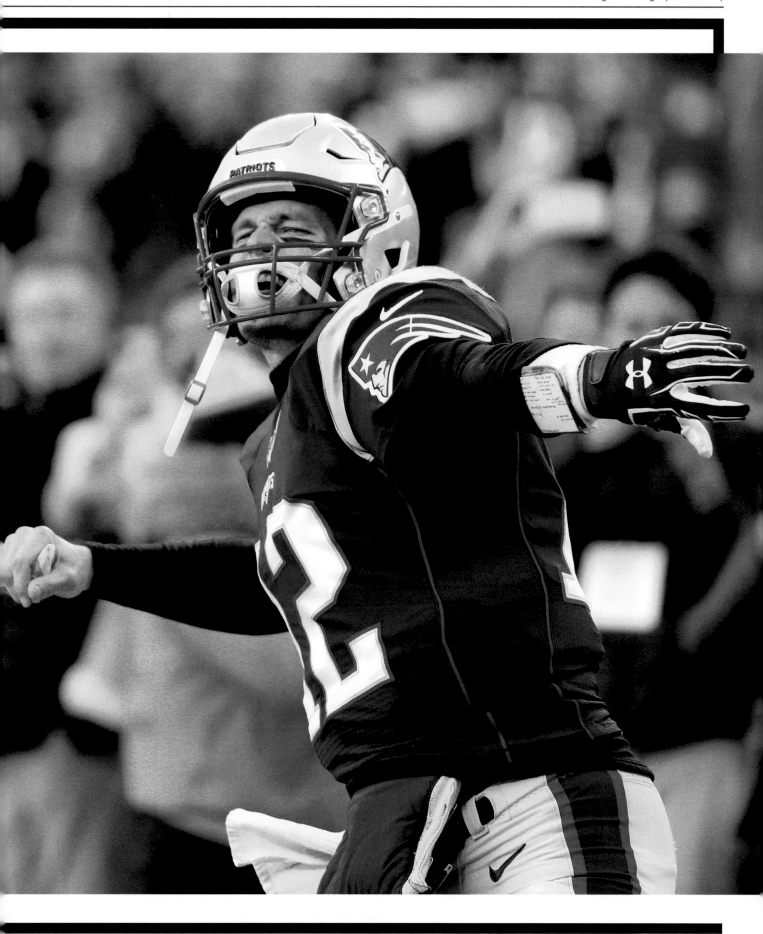

Tom Brady, seen with Gisele Bundchen at the Metropolitan Museum of Art's Costume Institute Gala, became increasingly high-profile away from the game.

trailed by a word rarely associated with him: uncertainty. Nursing some sort of injury to his foot (As is the pattern with the Patriots, no one will say what the problem is.), Brady missed all four pre-season games, all losses in which the team looked ragged and leaderless. Brady also opted out of the team's voluntary offseason workout program for the first time since he arrived as an unheralded backup in 2000. It seems a small matter, but it was always part of his charm — that the quarterback would also show up as a grind-it-out workout warrior.

Brady, in short, has been more visible to television viewers this year on shows like "Access Hollywood" than ESPN's "SportsCenter."

The last time he touched a football in game action, Brady heaved a desperation pass to Randy Moss — an incompletion — with 10 seconds remaining in a devastating 17-14 loss to the New York Giants Feb. 3 in Super Bowl XLII. The loss spoiled an otherwise perfect season for the Patriots. For Brady, was it also an intimation of mortality?

"You have to be concerned," said Bill Mercer, a Patriots diehard and one of many everyday people in Greater Boston who crossed paths with Brady on his spectacular journey from obscurity to global celebrity.

"I would have liked to have seen him in at least one preseason game," said Mercer, a grocery manager at the Fruit Center Marketplace in Milton, where Brady liked to shop before his life changed.

Ready to go

Fear not, Brady has assured Patriots fans. He told reporters last week he would be prepared to face the Kansas City Chiefs today in Foxborough.

"Throwing so many footballs over the course of my life, it's not like I need to learn to throw a football," he said.

Every NFL player takes time off after a brutally long season. But only Brady chills with the world looking over his shoulder, the gossip machine trying to chart every nuance of his romance with Gisele Bundchen, the Brazilian

beauty who became the face of myriad brands, from Victoria's Secret and Max Factor to Apple computers and Ipanema Flip Flops.

See images of Tom and Gisele smooching on South Beach and canoodling in Rome. See them lolling in the grass with baby John, Brady's son with actress Bridget Moynahan. See Tom surfing in Costa Rica, grocery shopping in California, spiriting Bundchen away from tart-tongued photographers trying to get a rise out of them in New York. Finally, when Tom and Gisele tire of it all, see them pulling hoods and scarves over their faces as if they are shielding themselves on a perp walk.

Brady's discomfiture with the ugly side of fame is palpable in the images.

"He's a very, very private person," said Terri Angelis, Brady's former neighbor at Marina Bay in Quincy. When residents tried to engage him in conversation, Angelis recalled, Brady often pointed to his ear, indicating he was listening to music or talking on the phone, and proceeded silently past them.

Brady's contempt for cameras wanes, however, when he can influence the shoot. He has hosted "Saturday Night Live," played himself on "The Simpsons" and "Family Guy," cameoed in the movie "Stuck on You," and appeared with several teammates on a Wheaties box. He has graced numerous magazine covers, including this month's Esquire. There he is resplendent in Gucci's finest wools and silks, his hair swanked up by his personal stylist, Pini Swissa, and his wrist adorned with a Movado limited-edition Tom Brady watch (retail price: $2,500).

His taste in food has also evolved considerably from the Omega Pizza days. As he gushed last year to Details magazine, he has learned in his travels that the steak Fiorentina in Florence is "oooh, the best."

As a former Catholic seminarian's son, he, however, has tried to balance his great fortune with a measure of spirituality — expressed in his trademark, salty way.

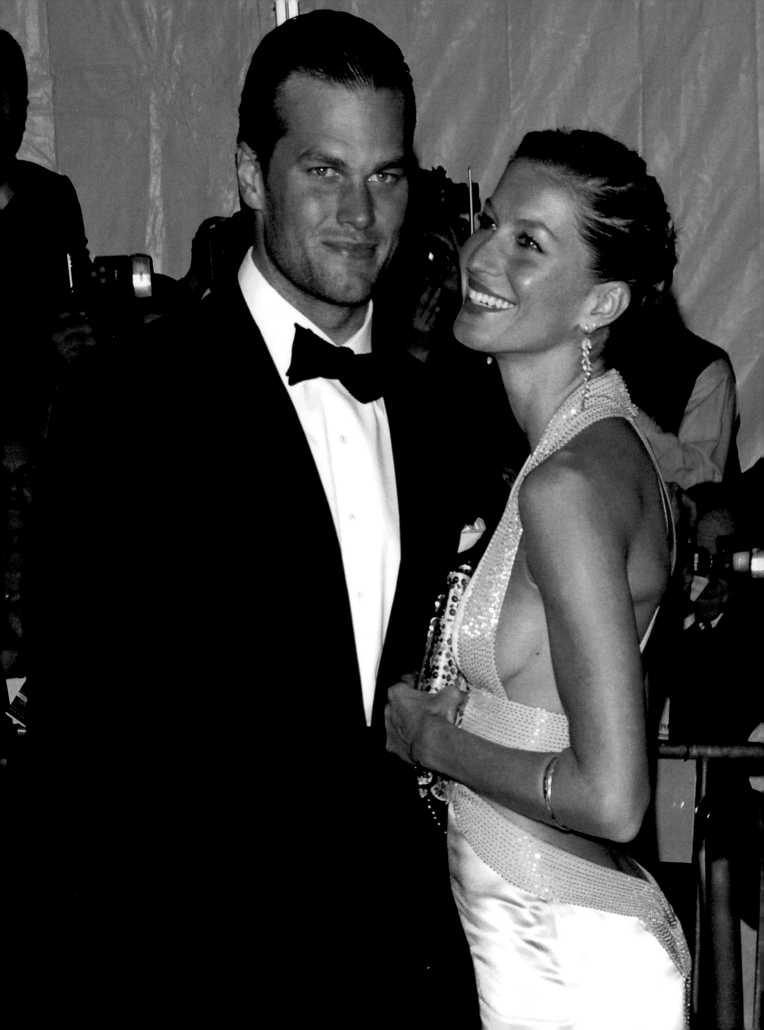

Even as his lifestyle changed off the field, those around Tom Brady still called him "an average guy."

"Look at the attention I get: It's because I throw a football," Brady told Esquire. "But that's what society values. That's not what God values. God could give a [expletive about football], as far as I'm concerned."

The course of a person's life can be traced in many ways, and Brady's trajectory is remarkable by almost any measure.

Professionally, he went from an afterthought in the 2000 NFL draft, the 199th selection (134 picks after the San Francisco 49ers chose soon-to-be-cut signal-caller Giovanni Carmazzi), to become the only quarterback in NFL history to win three Super Bowls before his 28th birthday.

In short order, Brady has advanced from the frat party circuit at the University of Michigan to the ranks of the fabulously wealthy; he is midway through a six-year, $60 million contract with the Patriots, which he supplements with an estimated $9 million annually in endorsement deals.

Has the whole package

Factor in his dimpled-chin dashing looks, his charm and intellect, and he has reigned for years as one of the most eligible bachelors in sports. Ordinary people whose lives have intersected with his have watched Brady romance his way from Tara Reid to Moynahan to Bundchen, all the while preserving much of his independence and some of his everyman ethos.

"It's amazing," said Bill Sarro, who owns the Fresh Catch restaurant in Mansfield, which Brady frequented early in his Patriots career. "I partied with him and Bridget after the Super Bowl in Houston [in 2004] and he was as excited about getting Snoop Dogg's autograph as Snoop Dogg was about getting his. Tom doesn't seem to change. He's still an average guy."

Nothing is average, though, about his real estate portfolio. Chart his life by his property holdings, and he has zoomed from the Franklin town house, which he bought from teammate Ty Law in 2000 for $265,000, to Boardwalk on the Monopoly board.

Brady this year extended his holdings to the left coast. He and Bundchen reportedly paid more than $11 million for a vacant lot in Brentwood, Calif. The property, in a gated community with striking ocean and mountain views, abuts a $24.5 million estate owned by heirs to the Hilton fortune and is a few doors down from an $11.5 million mansion occupied by California Governor Arnold Schwarzenegger and Maria Shriver.

"Tom will become one of the many extremely high-profile people who live here," said Jay Handal, who owns San Gennaro Cafe in Brentwood and serves on the Greater West Los Angeles Chamber of Commerce. "But does it mean that he has made it because he can live here? I think Tom Brady already made it. The house doesn't make the man. The man and his spouse make the house."

The Brentwood site complements Brady's 74th floor condo at New York's Time Warner Center, which overlooks Central Park (he bought the unit in 2004 for $14 million and recently placed it on the market for more than $18 million). Bundle his New York and California properties with his Beacon Street town house, which he bought in 2006 for more than $6 million and spent several million to renovate, and Brady has gone far from the modest Chestnut Ridge condominiums in Franklin.

"We really don't see him here anymore, unfortunately," Sarro said at Fresh Catch, where Brady once found happiness in the coconut shrimp, 2-pound lobster, and filet mignon. "His life has definitely changed."

Long way from deli days

Brady's climb toward the real estate stratosphere began when he upgraded from Franklin in 2003 to an $808,000 town house at Marina Bay. Soon, he was a regular at the marina's waterfront restaurants as well as the Fat Belly Deli in Dorchester, often arm-in-arm with Moynahan. He even partied at the deli after one of the Super Bowl parades.

While Tom Brady would go on to spend less time in the Boston area in the off season, he made an appearance courtside for Game 7 of the NBA Eastern Conference semifinal between the Celtics and the Cavaliers.

Those days are over, though. Brady sometimes visits his sister, Nancy, at Marina Bay his family and Bundchen celebrated his 31st birthday there at Siros with him last year — but he has not been spotted at the Dorchester deli since he moved from Quincy in 2005 to the historic Burrage House mansion in the Back Bay. He bought the Commonwealth Avenue condo for $4.1 million and sold it last year for $5.28 million.

"He's pretty much out of our neighborhood now," said Kenny Blasi, who owns the Fat Belly Deli and often prepared Brady chicken sandwiches with sauteed onions. "He's in a new world, and it seems like a whirlwind."

At 31, Brady is entering the autumn of his playing career, though he has yet to show any sign of his skills diminishing. Sports Illustrated featured him last week on the cover of its NFL preview issue and predicted he would guide the Patriots to their fourth Super Bowl championship in seven years.

Should the Patriots succeed, Brady will ride the duck boats, then likely bid Boston goodbye again in the offseason. His life may remain a feast, but for many of the ordinary folks who befriended him on his journey from Franklin to fame, there will be an empty seat at the table.

"I liked him a lot," Kontoulis said. "I wish I could see him again." ∎

A torn ACL and MCL in Week 1 of the 2008 season would knock Tom Brady out for the year.

ACCEPTED, DREADED PART OF THE GAME

Knee Injury Knocks Out Brady; Patriots Soldier on to Victory

By Bob Ryan • September 8, 2008

It's football, remember?

Football is a contact sport, a collision sport, a physical sport, a violent sport, a brutal sport, and, some might say, a barbaric sport. If American mothers had their way, there would be no football, at least none involving their precious sons. Injury in football is not surprising. It is inevitable.

Tom Brady has started 128 consecutive games, which, frankly, is beyond fortunate. No one knows this morning when he will start the next one because the greatest fear of every Patriots fan — not to mention the owner, the coach, and Brady's teammates — was realized with 7:27 left in the first quarter of yesterday's game against the Kansas City Chiefs at Gillette Stadium when the whistle blew and Brady failed to get up.

And now there is a very real fear that he sus-tained a torn anterior cruciate ligament — yes, the dreaded ACL — and has thrown his last pass of the 2008 season. Unless the Patriots choose to dabble in the free agent market for the likes of (hold your nose) Trent Dilfer, the new starting quarterback around here is Matt Cassel.

Brady had completed a 28-yard pass to Randy Moss, who wound up fumbling the ball. But those interested in the fortunes of the Patriots were not as concerned about the team's second such turnover of the first quarter as they were about the status of Brady, who limped off the field with what coach Bill Belichick confirmed was an injured left knee, not to be seen again.

"I was standing right there," said running back Sammy Morris, "and I couldn't help him up. It's a tough feeling, but it's part of the game."

It's part of the game.

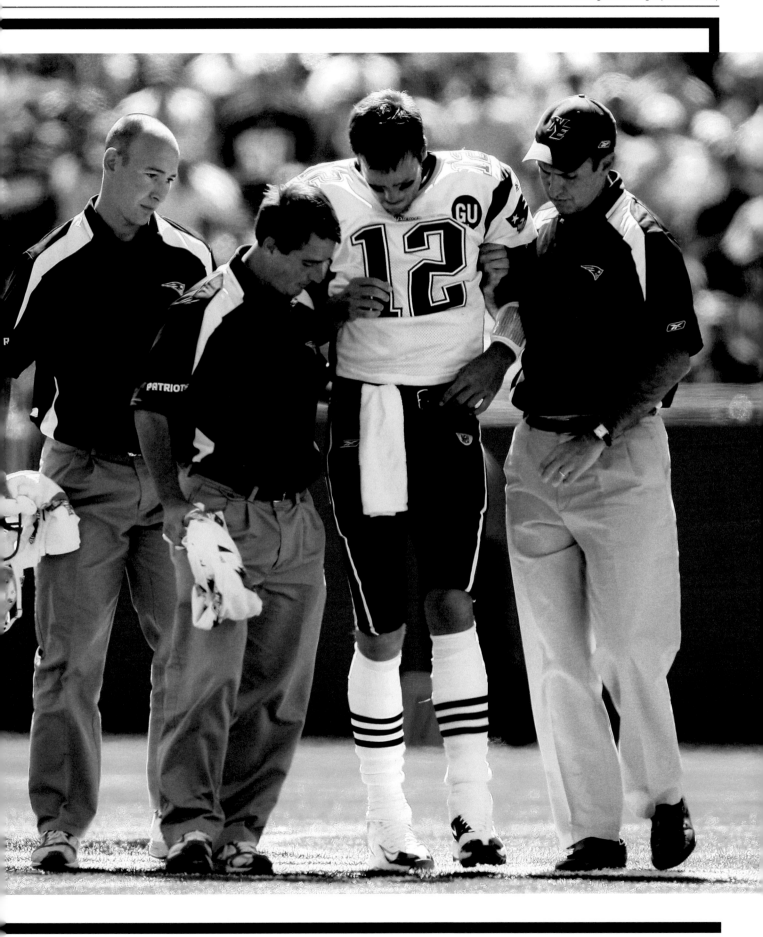

Tom Brady rarely missed games in his career, but the disastrous Week 1 injury would eventually lead to backup Matt Cassel steering the Patriots to an 11-5 record, yet still missing the playoffs.

It certainly is. Morris knows all about it. He sustained a sternum-clavicle separation in last season's sixth game and never played another down. He can empathize.

"You see the hurt on his face, and you feel the same hurt," Morris said.

The reigning league Most Valuable Player religiously had been placed (some say mischievously placed) on the weekly injury report by Belichick for more than two years with an unspecified right shoulder injury, and he had missed all four exhibition games because of an issue with his right foot. But what happened yesterday had nothing to do with a shoulder or a foot. It had to do with a blitzing Kansas City safety named Bernard Pollard being picked up by Morris and then, after being knocked to the ground, reaching out and grabbing Brady's lower left leg in an attempt to bring him down. Brady fell awkwardly, injuring his left knee.

Was it necessary for Pollard to do that? Most Patriots either didn't see the play or declined to express an opinion, but wide receiver Randy Moss was rather forthright.

"I don't really want to get into it," he said. And then he got into it.

"Me personally, I thought it was dirty," said Moss, who had studied the replay. "I've never been a dirty player. I honestly don't even know how to play dirty. I just play the game. It is not my decision. Hopefully, the league will look into it. If it's good, it's good. If it's bad, it's bad. They [NFL] will handle it."

Whether it was dirty, unnecessary, or extraneous, it happened, and the Patriots did not have time to call a team meeting to discuss and analyze the situation. There was a scoreless game that had more than 52 minutes left to play. Brady was gone, Cassel was going to be the quarterback, and that was that.

These men are professionals, and they have been trained to expect the unexpected. Other important players have gotten hurt during this glorious Patriots run, and the team always persevered. One of its most valued individuals even suffered a stroke, which was a very emotional situation to deal with. But life always went on, and so it would against the Chiefs.

"Football players are used to seeing guys get hurt," said guard Logan Mankins. "You've got to move on."

It all starts with the coach. Belichick has stood before the media countless times and discussed the necessity of people just "doing their job." So it was really no more complicated than that.

"We always have the feeling," explained linebacker Tedy Bruschi, the aforementioned stroke victim, "that the next person in line is prepared. Hopefully, he did his homework. Tom's Tom. He's our quarterback. But it's just, 'Who's next?' "

Who's next was Cassel, who has been the primary Brady understudy for four years, and who, if he's known for anything, is the curiosity who spent his entire time at Southern California backing up Heisman Trophy winners Carson Palmer and Matt Leinart, and thus has not started a regular-season game for anyone since his senior year at Chatsworth (Calif.) High School some time back in the late 20th century.

Let's be honest. The fans had no faith in Matt Cassel, especially after an exhibition season in which he had failed to generate a touchdown for the team, despite being given ample opportunity to do so. But he proved to be a perfectly adequate short-term replacement, going 13 for 18 for 152 yards, one touchdown (an acrobatic Moss grab at the back of the end zone), no interceptions, and, most notably, a signature play any Brady or Manning would have been proud to hang his hat on. For in his first series of downs, on third and 11 a half-yard from his end zone, he recognized a Moss improvisational theater breakoff of a route and hit the great wideout for a 51-yard gain.

If any teammates had doubted him, that play won them over. "That play showed he had a little something going right there, and everyone

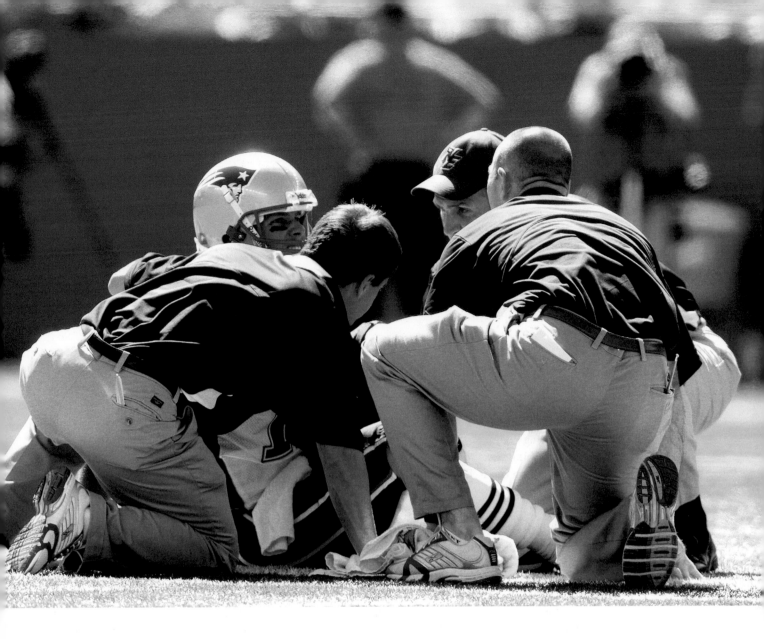

stopped holding their breath after that," said defensive tackle Ty Warren.

It was one play, and this was one game, and it was against the Chiefs, who should feel perfectly free to schedule family vacations for the month of January, 2009. But when it was all said and done the Patriots had 17 points and the Chiefs had 10 and the Patriots were the same 1-0 they would have been had an untouched Tom Brady thrown for 350 yards and four TDs.

"It's always about a team effort," Warren reminded. "A collective effort of guys contributing, whatever their job is. Tom is a big part of that. But, like I say, the game has to go on, with all due respect."

When Brady went down, it immediately became a losable game. The postgame reflections could have contained lots of couldas, shouldas, and wouldas. But there was none of that. The rest of them just did their job, and, no matter who happens to be the quarterback, they'll all head down to the Meadowlands with the same attitude next week against the Jets.

That's what true professionals do. ∎

Eventually the archetype for an NFL quarterback and leader, Tom Brady started his career with the Patriots as an afterthought.

FROM FACELESS TO FRANCHISE

Believe It or Not, Tom Brady was Once Invisible in Pats' Locker Room

By Dan Shaughnessy • December 30, 2010

It's like thumbing through your high school yearbook and discovering that the wallflower you ignored in US History turned out to be Angelina Jolie.

Tom Brady was here 10 years ago, and we barely noticed.

In the old Foxboro Stadium locker room, the kid from San Mateo, Calif., via the University of Michigan had a stall along the row where Drew Bledsoe dressed. Brady regularly had to make room for reporters who wanted to speak with Bledsoe.

Drew was the Patriots' franchise quarterback. Drew was the three-time Pro Bowler who had led the Patriots to a Super Bowl in 1996. Drew was the guy with the 10-year, $103 million contract extension.

Brady was . . . in the way.

I was there, but I don't remember Brady. (The soundtrack to this column is Joan Osborne's "[What If God Was] One Of Us?") Who bothers to pay attention to a sixth-round pick who never plays? Like most of the other reporters, I was working to get words from big Drew. Tom Brady wasn't even Brian Hoyer.

In 2000, the Patriots were staggering through a 5-11 season under first-year coach Bill Belichick. Not yet a hooded genius, Belichick in 2000 was a suspect Bob Kraft hire who had been run out of Cleveland, Grady Little-style.

With Bledsoe taking the snaps, those 2000 Patriots staggered through losses at New York, Miami, Indianapolis, and Cleveland. Belichick looked

An all-time NFL trivia question, there were six quarterbacks drafted ahead of Tom Brady in 2000: Chad Pennington, Giovanni Carmazzi, Chris Redman, Tee Martin, Marc Bulger, and Spergon Wynn.

especially pasty and unsure of himself. Brady was listed as inactive for all but two games. He played only once, throwing three passes (completing one for six yards) at Detroit on Thanksgiving.

Today Brady is touted as one of the greatest quarterbacks in the history of football. He's the modern Joe Montana. He has a chance to win his fourth Super Bowl. He has thrown an NFL-record 319 consecutive passes without an interception. He has thrown a touchdown pass in all 15 games and at least two in each of the last eight games. He has thrown 24 TD passes since his last interception and he looks like a lock for a second MVP award. He's one of the most famous men in the world and looks like a guy who could be president someday.

So how did we miss him 10 years ago?

Easy. In 2000, Brady was New England's fourth-string quarterback, playing behind Bledsoe, Michael Bishop, and John Friesz. His rookie season was a virtual redshirt year. He got into the preseason games (22 of 33, one touchdown, no picks), but who's paying attention in August when it doesn't count?

Longtime publicist Stacey James remembers rookie Brady in 2000, and says, "He used to overhear me arranging to take Drew upstairs for press conferences. Tom would tease me and say, 'When's my press conference?' I told him to be careful what you wish for."

Globe multimedia producer Alan Miller was part of the Patriots "All-Access" crew in 2000, and remembers, "We profiled just about everybody that year, and by the end of the season, we were running out of guys, so we profiled Brady, about how he was drafted by the Montreal Expos and went to the same high school as Barry Bonds. He told us he loved watching 'All-Access.' "

The 2001 edition of the Patriots media guide features 26 pages on Bledsoe. He has the long hair and the extensive résumé. Brady's bio merits less than one page and he looks a little chunky in his photo.

Everyone knows what happened that year. Near the end of a Week 2 loss to the Jets in Foxborough, Bledsoe was almost killed on a hit by Jets linebacker Mo Lewis. Brady came off the bench and never looked back. He won the Super Bowl four months later.

We'll never know how long it would have taken Brady to demonstrate his greatness if Bledsoe hadn't been hurt.

We know only that Brady beat out Damon Huard for the No. 2 job during the 2001 preseason. He completed 31 of 54 passes and threw two touchdowns with no interceptions in four exhibition games. Brady opened the season as Bledsoe's backup.

"The broadcast production crew had a meeting with Belichick before the first 2001 preseason game," said Miller. "We asked him who would improve the most, and he cited Stephen Neal and Tom Brady.

"He went on and on about Brady and what a leader he was, and at the end of that meeting, I walked out and said to the others, 'Bledsoe's not long for this job.' "

In Charles P. Pierce's excellent book "Moving the Chains," former Patriots offensive coordinator Charlie Weis says, "Bill and I talked and I said maybe we ought to give Brady an opportunity to beat this guy [Bledsoe] out."

Easy to say now. But we'll never know.

While Bledsoe was still recovering from the Lewis hit, Brady threw his first touchdown pass (to Terry Glenn) in an overtime victory against the Chargers. A month later, Bledsoe was healthy enough to play but Belichick made the bold decision to stick with the kid. And now the Hall of Fame-bound coach and quarterback are primed for their fifth Super Bowl appearance as they take their place as the top coach-quarterback tandem in NFL history.

Ten years later, who can name the six quarterbacks drafted ahead of Brady?

They are Chad Pennington, Giovanni Carmazzi

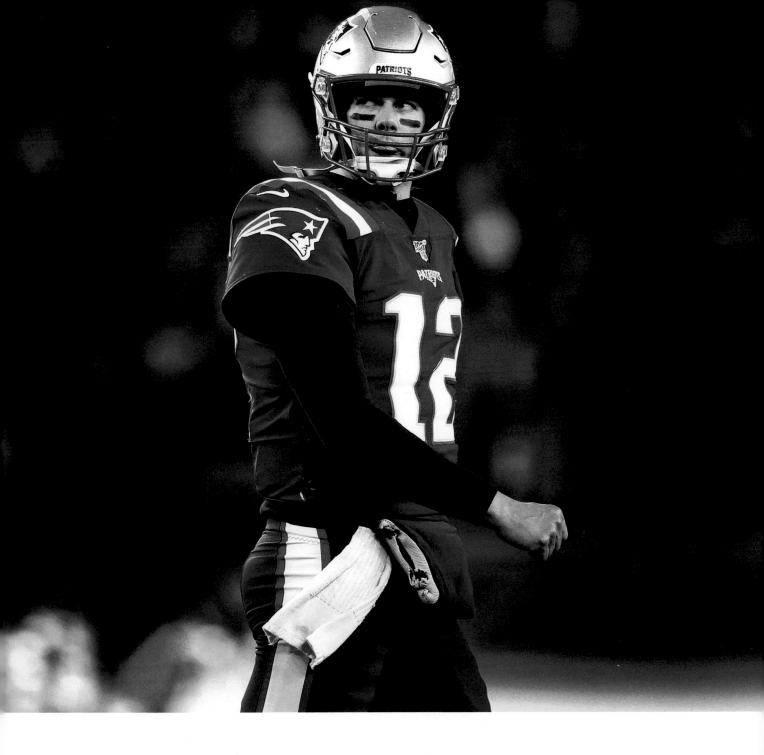

(drafted by Brady's beloved 49ers), Chris Redman, Tee Martin, Marc Bulger, and the immortal Spergon Wynn out of Southwest Texas State.

Maybe it's easier to name the players New England drafted ahead of Brady in 2000.

They are Adrian Klemm, J.R. Redmond, Greg Robinson-Randall, Dave Stachelski, Jeff Marriott, and Antwan Harris.

"I was the 199th player picked," Brady said before playing the 49ers in 2004. "I'll never forget those days."

The rest of us remember none of it. Those were the days when Tom Brady was invisible. Right in front of our eyes. ∎

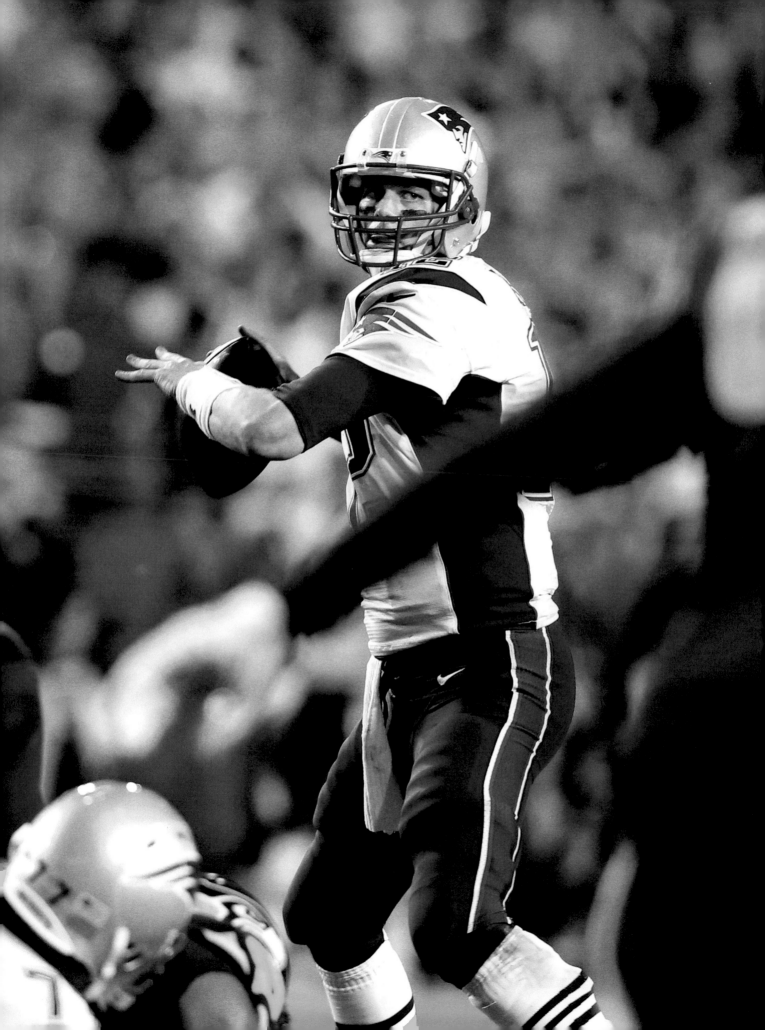

Super Bowl XLIX vs Seahawks
February 1, 2015 • Glendale, Arizona
» PATRIOTS 28, SEAHAWKS 24

ELITE COMPANY

Tom Brady Joins a Select Class of QB with Fourth Super Bowl Title

By Rachel G. Bowers

Tom Brady added another thrilling Super Bowl victory to his resume, this time throwing for 328 yards and four touchdowns as cornerback Malcolm Butler sealed the victory with a late goal line interception.

Tom Brady's Super Bowl drought has ended. The Patriots quarterback threw for 328 yards, four touchdowns, and two interceptions in New England's 28-24 win over Seattle to earn his third Super Bowl MVP award.

"It's been a long journey," he said during the postgame ceremony on the field of University of Phoenix Stadium. "We've been at it for 15 years, and we've had a couple tough losses in this game. This one came down to the end, and this time we made the plays."

Brady joins Joe Montana and Terry Bradshaw as the only quarterbacks to win four Super Bowls. He is also the only quarterback to go 10 years between Super Bowl wins, and the only

quarterback to throw four touchdowns to four different receivers in the championship game.

"It's incredible to experience this feeling once, and I've been fortunate to be on really great teams," he said in his postgame news conference. "I'm very blessed."

When rookie cornerback Malcolm Butler pulled down the interception to secure the victory, Brady was elated, jumping up and down on the sideline and throwing his hands in the air.

Brady took responsibility for a few "crappy plays," including his two interceptions, one to Jeremy Lane and another to Bobby Wagner.

"It wasn't the way we drew it up. Certainly throwing a couple picks didn't help," he said of

Right: Tom Brady looks on as his son, Benjamin, admires the Vince Lombardi Trophy during the victory parade in Boston. Opposite: With the Super Bowl XLIX win, Tom Brady joined Joe Montana and Terry Bradshaw as the only quarterbacks in history to win four Super Bowls.

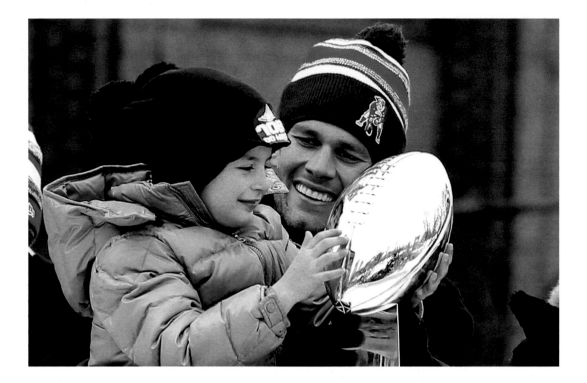

being down 10 points to start the fourth quarter. "A lot of mental toughness. Our team has had it all year. We never doubted each other. That's what it took. That was a great football team we beat."

Linebacker Jonathan Casillas said Brady should be considered the greatest quarterback in league history.

"He's a legend, man," Casillas said. "Six appearances. Four rings. I mean, consistently he's unbelievable, man. He does it all."

Brady deflected the questions about his legacy, turning the compliments back to his teammates.

"I never put myself in those discussions. That's not how I think," he said. "There's so many great players that have been on so many great teams and we've had some great teams that haven't won it.

"I think you got to just enjoy the moment."

He cited the Patriots' last two Super Bowl appearances, both losses to the New York Giants, saying it made this one sweeter.

"We've been on the other end of this twice now and being ahead late and not being able to make the plays to win," he said. "This time, we made the play to win, so it's just awesome. What an experi-

ence. A lot mental toughness by our team."

Brady set several Super Bowl records in the win, and extended a few of his own:

- Most touchdown passes/career: 13 (passing Joe Montana)
- Most passing yards/career: 1,605
- Most completions/career: 164
- Overcame largest second-half deficit (10 points)
- Most completions/game: 37
- Most passing first downs/game: 21

'We were down 10 and we just said, 'Look we got to put one drive together to get us back in the game,'" Brady said. "We made the plays. We overcame a couple penalties and made the plays to do it and got the ball back and then scored again. They had a great drive, had some phenomenal plays, but we made a great play in the end. These games, they're tough. They go down to the end."

"It was a tough day. A lot of energy. A lot of effort," he said. "We just made enough plays to win." ■

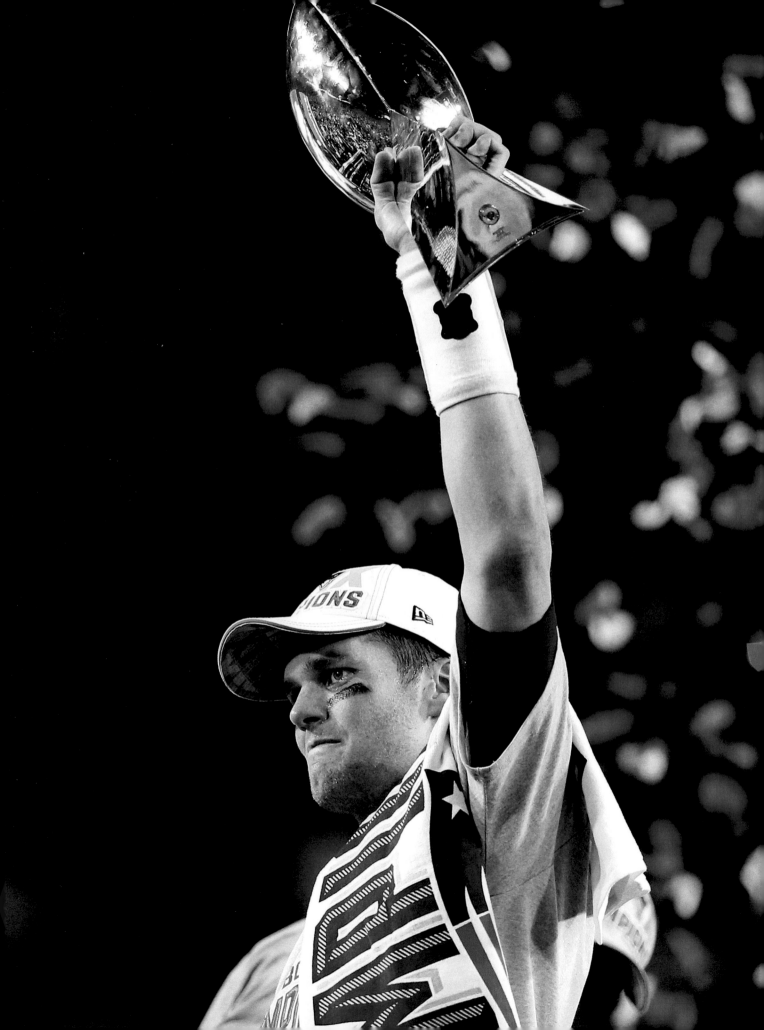

During Larry Bird's heyday it was hard to imagine his greatness being surpassed by a fellow Boston athlete, but Tom Brady was firmly in the conversation after winning his fourth Super Bowl.

QUEST TO BE THE BEST

Is Tom Brady the Best Athlete in Boston History?

By Christopher L. Gasper • February 8, 2015

Winning Super Bowl XLIX and his fourth championship, Tom Brady made his case for consideration as the greatest quarterback of all time. He also threw his hat, or helmet, as it may be, into the ring for another, loftier title — greatest athlete in the modern history of Boston professional sports.

I think I just felt my e-mail inbox bulging under the weight of replies fired off at Mach speed to that last sentence.

A case can be made that Brady is at the head of the class of professional sports athletes in this town.

He inspires a faith that is usually reserved for Sunday Mass. He has won more championships than Bobby Orr and Ted Williams combined. He is more popular and possesses a higher national profile than Celtics legend Bill Russell, a state-

ment on both the popularity of the NBA and the reluctant embracing of African-American idols during Russell's era. At 37, Brady's prime has outlasted Larry Bird's.

Brady is the best combination of individual brilliance, statistical accomplishment, championship credentials, and pop culture panache to grace Boston sports. He is both celebrated and a celebrity. He makes news when he tries to dance, takes a vacation, or changes hair styles.

We have been blessed that some of the most illustrious athletes in American professional sports have plied their trade and constructed their pedestals in our backyard. Teddy Ballgame, Russ, Orr, Yaz, John Havlicek, Bird, Rocket Roger Clemens, and Brady to name a few.

One of the unalienable rights of following sports is the ability to compare and debate ath-

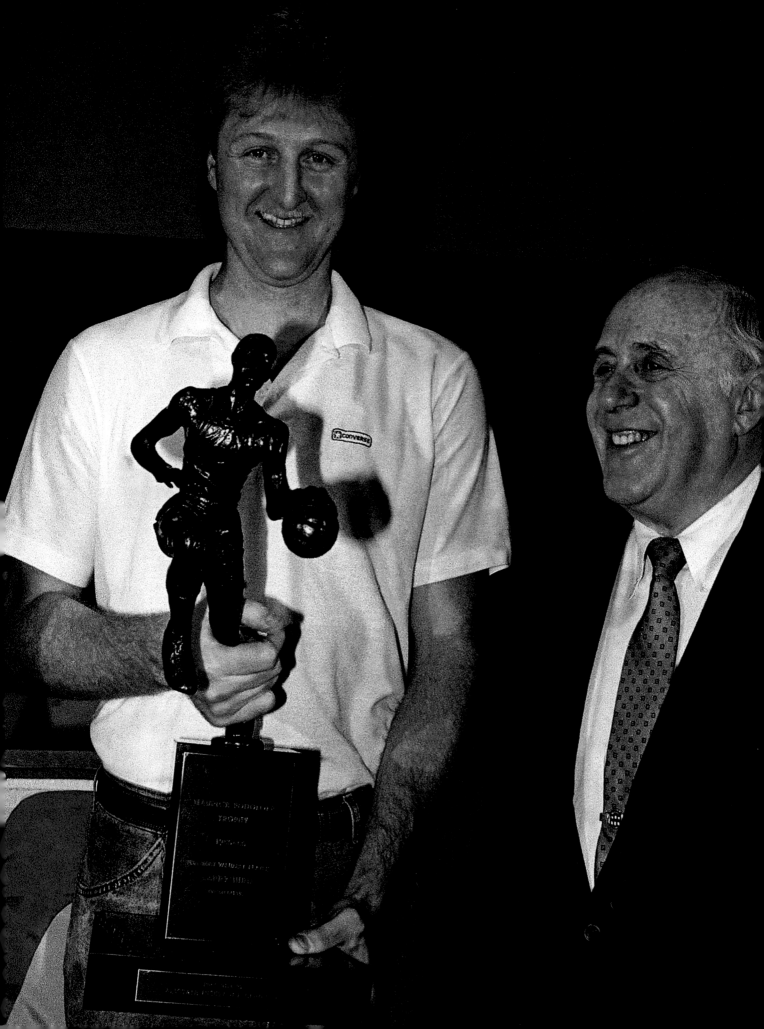

Bruins legend Bobby Orr was also etched on the Boston sports Mount Rushmore and in his prime during the 1960s and 1970s when the Patriots were largely not competitive.

letes, games, and teams. Like taste in movies or music, it's subjective.

A few rules should apply in a discussion of Boston's best, though.

You can't be the greatest in Boston sports history if you're not the greatest in your own franchise's history. Unless you think Yaz or David Ortiz are better than Ted Williams, they're not eligible for the discussion.

You can't be the greatest if the defining time in your career occurred elsewhere (see: Ruth, Babe).

If it's all about winning, then there is one choice and one choice only, William Felton Russell. Next to the word winner in the dictionary, there should be a picture of Russell swatting a shot. He won 11 titles for the Celtics in 13 seasons and was the fulcrum of a dynasty. He revolutionized the way basketball was played by dominating with defense and rebounding. He won five MVP awards while never averaging 20 points per game in a season.

If I had a time machine, he is one of the first athletes I would get in the DeLorean to go back and see.

If it's about being a sui generis talent, then the answer is No. 4, Bobby Orr. He danced across the ice like a firefly on a warm summer night. He is the only defenseman to ever win an NHL scoring title, doing it twice. His game-winning goal in the 1970 Stanley Cup Final and parallel-to-the-ice exultation is one of the most iconic poses ever. It was the sports equivalent of a Farrah Fawcett poster in the 1970s.

Orr won three consecutive Hart Trophies as the NHL's MVP (1970-72) and two Stanley Cups. Like John F. Kennedy, his legend has only been enhanced by the fact he was taken away too soon. His left knee gave out in 1975, at age 27. He was coming off a season in which he had scored a career-high 46 goals and 135 points.

If it's about being a larger-than-life hero and the master of the hardest feat in American sports — hitting a round ball with a round bat — then it's Theodore Samuel Williams. The Splendid Splinter is the last man to hit .400 in a major

league season, batting .406 in 1941. He batted .388 at age 38. His .482 career on-base percentage is the highest in baseball history. He won two Triple Crowns and six batting titles.

Williams lost parts of five seasons to military service as a fighter pilot, serving during World War II and the Korean War. He landed a burning plane during the Korean War.

At 41, he hit a home run in his final major league at-bat, the moment inspiring John Updike's famous panegyric. He became such an avid fisherman that he hosted his own show and was inducted into the Fishing Hall of Fame. Williams was a man of such diverse talents and accomplishments that his life was better than fiction.

As a child of the 1980s, there will always be a soft spot in my heart for Bird.

Bird's rivalry-turned-friendship with Magic Johnson begat the modern NBA. He won three straight MVPs from 1984-86. He led the Celtics to five NBA Finals and hoisted three banners to the rafters. Bird elevated passing to an art form. He practically invented the dagger 3-pointer.

But you can't be the greatest Boston athlete of all time if you're not the greatest Celtic.

If it's about the total package, it's Brady. He has the Horatio Alger backstory of being a lightly regarded sixth-round pick, which only adds to his mystique. Quarterback is the glamour position in American sports, so Brady gets bonus points for that.

Brady had the 50-touchdown season in 2007. He has been to six Super Bowls. He has won three Super Bowl MVPs and two regular-season MVPs. His rivalry with Peyton Manning is one of the most indelible individual matchups in all of North American sports history.

Is Brady the greatest Boston sports athlete of all time? No, the distinction still goes to Russell in this corner.

But let's revisit the discussion after TB12's Drive For Five next season. If he becomes the only quarterback to win five Super Bowls, we might have to do some rearranging of the seating chart on our own Mount Olympus. ∎

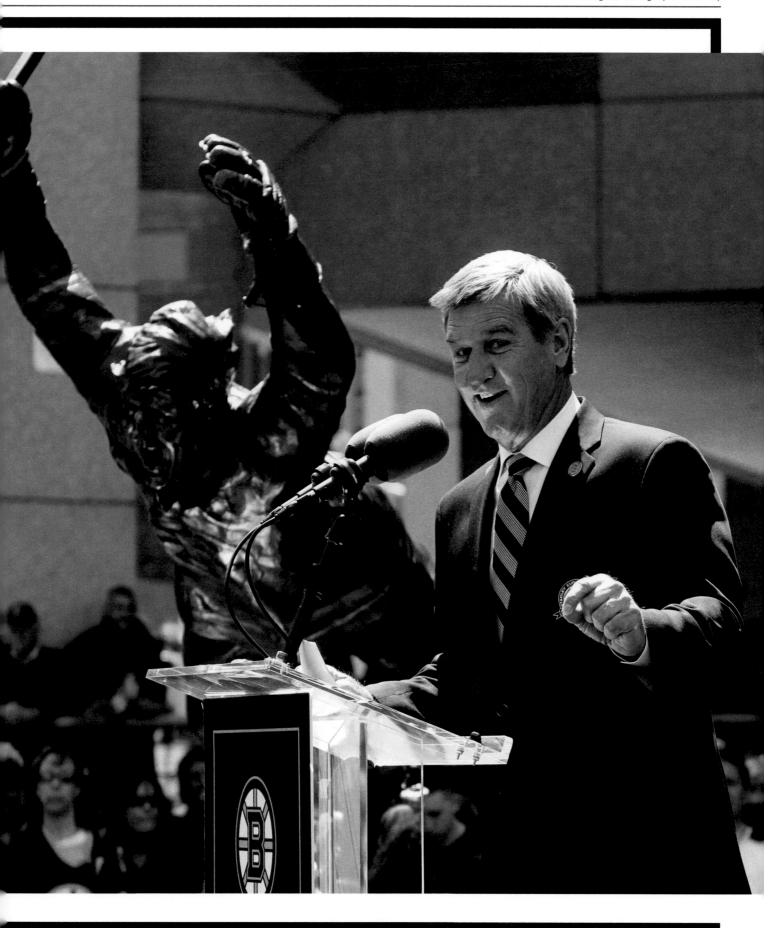

The Deflategate scandal put a stain on the Patriots and Tom Brady and is still a hotly debated topic among NFL fans.

THE HARD TRUTH

Like It or Not, Tom Brady and Patriots Cheated

By Dan Shaughnessy • July 29, 2015

In a 20-page decision that was released at 2:32 p.m. Tuesday, NFL commissioner Roger Goodell upheld Tom Brady's four-game Deflategate suspension. In the day's most shocking revelation, the commissioner revealed that Brady ordered his assistant to destroy his cellphone on the same day (March 6) Brady was interviewed by NFL investigator Ted Wells. Brady did not disclose this development for several months and it was not confirmed until the day of his suspension appeal hearing, June 23.

What do you say now, Patriot fans? Still think the NFL is out to get the Patriots? Still think Tom Brady is clean? Still think this is a witch hunt?

Of course you do. And that is why at a time when you should be embarrassed, you are probably emboldened.

Please. Give up. It's time for local loyalists to parachute down from Planet Patriot and get in touch with reality. Stop twisting yourselves into knots to justify the petty crimes and coverups of the Patriots and their quarterback.

According to the NFL, the Patriots cheated. They tampered with footballs after the balls were approved by game officials. The NFL terms it an ongoing "scheme." It's not a huge transgression, but the tampering was done to gain a competitive advantage. It appears to have been systematic. Tom Brady knew about it, then he destroyed evidence.

Sorry. Obstructing an investigation by destroying evidence doesn't play in America. No matter what happens now, the hard-earned accomplishments of Brady and the Patriots are tarnished.

This just keeps getting worse for the Patriots.

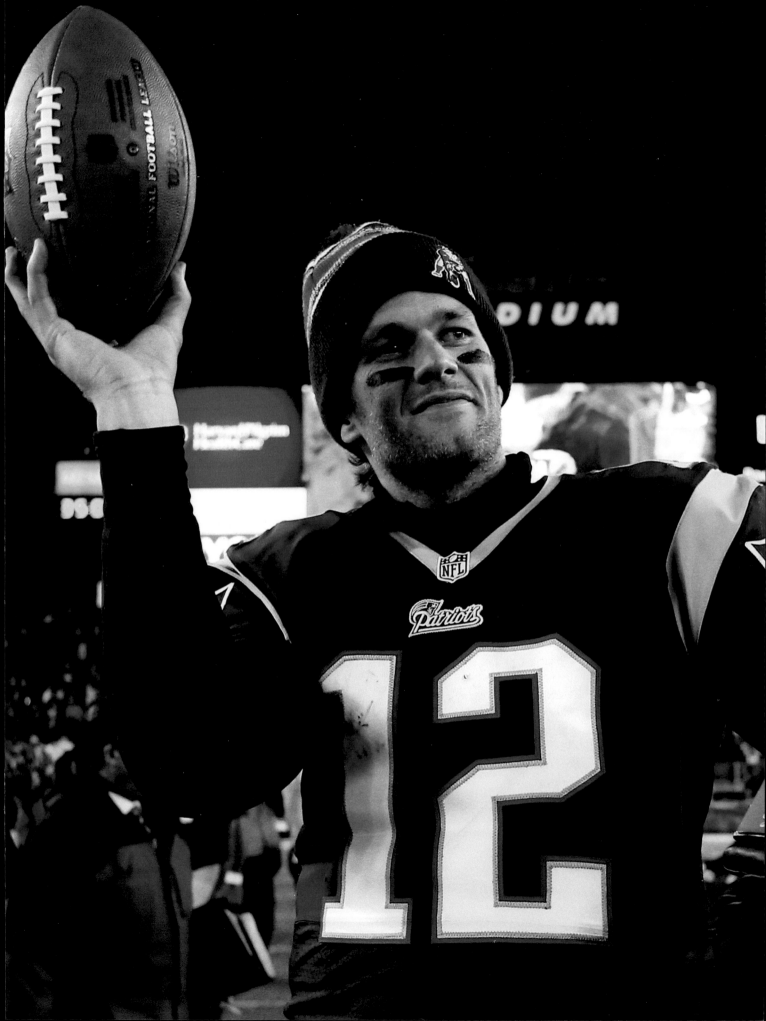

This is way worse than Spygate. It's worse than losing the perfect season in Glendale, Ariz., in February of 2008.

It's time to hear from Brady. Instead, late Tuesday afternoon we got a statement from Brady's preposterous agent, Don Yee, who "eloquently" stated that "the science in the Wells Report was junk," and also said, "neither Tom nor the Patriots did anything wrong."

Really? Then why did the Patriots suspend Jim McNally and John Jastremski? Why did Bob Kraft accept the loss of two draft picks (one a first-rounder) and the largest fine in the history of the NFL without a fight? Why didn't the Patriots produce McNally for a final interview after Wells learned about damning texts? Why didn't they bring McNally back last month when Goodell again offered to bring in the former equipment man for clarification?

The Patriots, like Brady, evidently arrived at the conclusion that it was better to cover up than to comply. It makes you wonder how bad this really was. What else are the Patriots hiding? What else might come out?

The NFL Players Association is fully prepared to take Brady's case to federal court in a case that would test the punishing powers of the commissioner. Swell. The Patriots and Brady believe they can escape on a legal loophole, like a criminal who goes free because the cops made a procedural error.

It might work. Brady could get an injunction that would allow him to play football while the case is adjudicated. Maybe the NFLPA will prevail and Brady's punishment would be erased. But it could backfire. Going to federal court could result in Brady serving his suspension at a more inopportune time (December?). It threatens to send the Patriots into their 2015 season under a cloud of uncertainty. We all know Bill Belichick hates uncertainty.

How far does Brady want to take this? Belichick has skated thus far. Does Brady want to go down any path that might get his coach (the man

with the Spygate prior on his résumé) involved in this mess? Does getting a suspension lifted on a technicality restore the image of a guy who tosses his cellphone like a character in "Breaking Bad"?

Perhaps now we know why Kraft rolled over at the owners meeting in San Francisco in May. He knows that disclosure is not the Patriots' friend in this matter. The Patriots have been stubborn and defensive since the news of this scandal broke. Rather than admit guilt and accept punishments, they have denied everything and insisted that the league "has got nothing." Kraft went so far as to demand an apology when he arrived at the Super Bowl. This strategy — probably directed by angry son Jonathan Kraft — has blown up in the Patriots' facemasks at every turn.

Tuesday's disclosure that Brady destroyed his cellphone is yet another example of the latter point. If Brady had simply accepted his punishment and not appealed, chances are we would not know about this blatant obstruction of the NFL's investigation. The Patriots media cartel could continue to promote the narrative of Patriots-as-victims.

A statement from the team late Tuesday afternoon perfectly demonstrated the intransigence that got everybody here in the first place. The Patriots said they are "extremely disappointed" in Goodell's ruling, again noted the "folly" of the Wells Report science, and said it was incomprehensible that the league is trying to destroy the reputation of one of its greatest players and representatives.

Way to go, Patriots. Keep howling at the moon. We all know that Planet Patriot orbits in an alternate universe.

Time to give it up, people. Your quarterback destroyed his cellphone on the day he was called to explain Deflategate. What more do you need? ∎

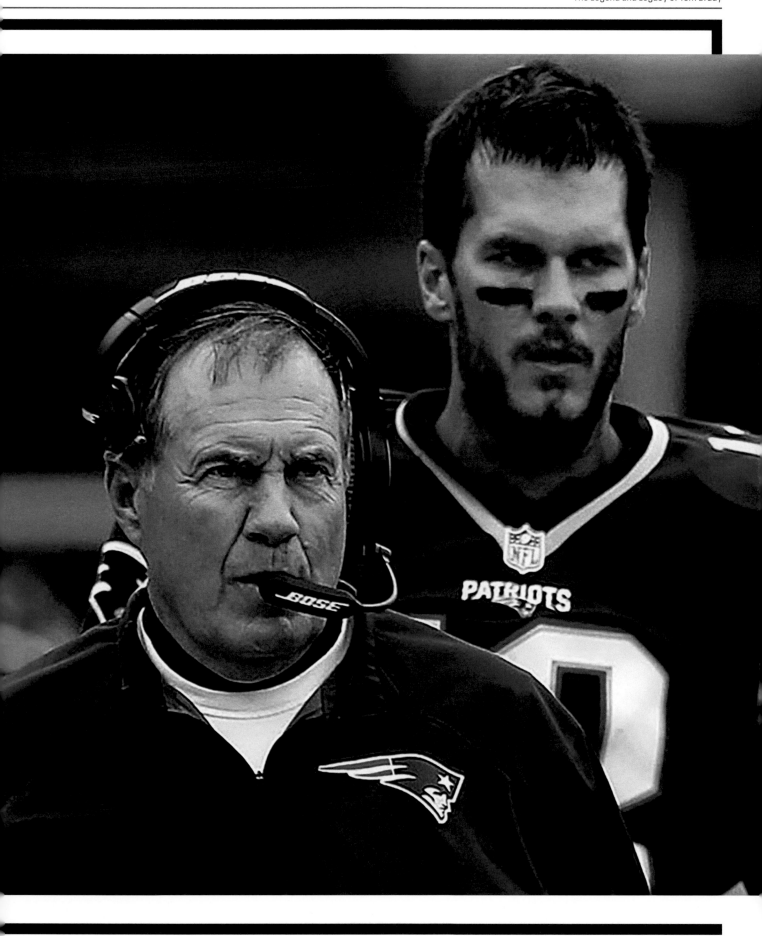

Drew Bledsoe, left, and Tom Brady, right, cheer with the crowd at a pep rally held at the Statehouse in Boston in 2002, before the Patriots went to New Orleans to play in the Super Bowl XXXVI.

HUMBLE BEGINNINGS

Tom Brady Set Lofty Goals, Even from the Bottom of the Roster

By Bob Hohler • February 1, 2017

Tom Brady, a skinny Patriots rookie subsisting on junk food and dreams in a no-stars motel on the Foxborough strip, was engaged in two struggles he seemed certain to lose. Both involved Drew Bledsoe, New England's entrenched starting quarterback and the NFL's highest-paid player.

It was the summer of 2000, and Brady was fighting for Bledsoe's job. He also was trying to vanquish the Patriots great in a pranking war that laid bare each man's will to prevail.

Round 1 went to Bledsoe when he rigged the vents in the rookie's car so that when Brady turned the ignition, the air blower unleashed a blizzard of glitter that enveloped him.

Long before Brady gained international fame and commanded big money to pose for glossy marketing campaigns — that's him in the high-

tech PJs — he was draped in Bledsoe's glitter, dumbstruck, to the delight of Patriots teammates who had lain in wait for the ambush.

Now, as Brady prepares to guide the Patriots against the Atlanta Falcons Sunday in his record seventh Super Bowl start, it seems like a lifetime ago that he arrived in New England as a fourth-string quarterback bent on avenging the humiliation of every NFL team that spurned him until the Patriots made him the 199th selection in the 2000 draft.

He was a nobody in a football no man's land. The Patriots had not won a Super Bowl in their 40-year history. Gillette Stadium had yet to be erected. And Bill Belichick, newly arrived as the coach, had let Brady languish deep into the draft's sixth round, selecting him only after he had chosen the likes of Dave Stachelski, a tight

Tom Brady, right, had goals of unseating incumbent quarterback Drew Bledsoe, left, within three years of joining the league, a timetable that was accelerated with Bledsoe's injury in Brady's second season in the NFL.

end, and Jeff Marriott, a defensive tackle, neither of whom ever started an NFL game.

Welcome to the show, kid, fate seemed to whisper to Brady. Here's your number, 12. Take a locker next to 11, Bledsoe, and prepare to become the butt of his pranks. Maybe you can scrapbook some memories.

Brady had other ideas. All of 22 and ensconced at the former End Zone Motor Inn, where the Patriots lodged their new players for the summer, Brady rode one night with rookie linebacker Casey Tisdale to a nearby pizzeria. Along the way, Tisdale vividly remembers, Brady vowed, "Within three years, I will have Bledsoe's job."

Several other teammates recall similar predictions, but none remembers snickering, because they were struck almost immediately by Brady's football IQ, his leadership skills, his team-building instincts, his competitive grit, his commitment to practicing on the field, training in the weight room, studying in the film room — and his readiness to counter-prank the team's reigning star.

They also saw early signs of him becoming a Belichick disciple. Belichick, stern as ever in his first full meeting with his 2000 rookies, recited his litany of rules, then surprised them with an oral quiz.

"Brady," Belichick barked at the nascent fashionista, who was decked out in corduroy pants, a long sweater, and a scally cap. "What do you tell the media if you tear a knee ligament and they ask you about the injury?"

"You say you have a bad leg," Brady replied, parroting Belichick's instructions to say as little as possible.

Days earlier, Brady had attended the team's precamp quarterback school. He was the only rookie.

"I'll never forget, it was the four of us — Drew, me, Michael Bishop, and Tom," recalled John Friesz, the second-string signal caller. "The rest of us waited for him to start asking rookie questions, like every rookie does when he comes into the NFL. There are things you just don't

know as a rookie.

"Not Tom. He didn't ask a single rookie question. I was scratching my head at how advanced he was before he even stepped on the practice field. I knew right then he was special."

Third-year fullback Chris Floyd had been lifting weights before the draft when Belichick asked him about Brady, his former teammate at the University of Michigan. Amid clanging weights and grunting players, Floyd briefed the coach on Brady as a third-string sophomore quarterback in Ann Arbor.

"As a football player, he knew everything, even then," Floyd said in an interview. "If I had a question about a play and didn't want to go to a coach, I went to Tom because I knew he would always have the answer."

In Brady's junior year at Michigan, he narrowly won a fierce competition for the starting quarterback's job. He went 20-5 over his final two seasons and capped his collegiate career with a dramatic victory over Alabama in the 2000 Orange Bowl.

By the time he reached Foxborough, Brady was so confident about his future that he quietly held out for a couple days before he agreed to a reported nonguaranteed three-year deal estimated at around $1 million, with a signing bonus of $38,500.

He drew on the bonus for a down payment on a cookie-cutter townhouse in Franklin that he bought from teammate Ty Law for $265,000. To make ends meet, he enlisted defensive tackle David Nugent and tight end Chris Eitzmann as housemates.

Only later would Brady buy and sell swanky real estate from Boston to Manhattan to a Los Angeles palace that would make the Medfield manse that Bledsoe sold to Curt Schilling in 2004 for $4.5 million seem like a bungalow.

In 2000, Brady's nutritional regimen also matched his budget. Long before he embraced a mostly vegan diet and began marketing $200 TB12 cookbooks featuring the likes of sweet po-

Drew Bledsoe and Tom Brady connected before a Patriots game at the Denver Broncos in 2017.

tato gnocchi with escarole, his go-to lunches were ham-and-cheese subs with onion rings, washed down with orange soda, his dinners often pizza.

Patriots owner Robert Kraft remembers encountering Brady that summer as the rookie carried a pizza box toward the stadium. Brady paused to introduce himself and, with all the audacity of an undiscovered prodigy, famously informed Kraft, "I'm the best decision this organization has ever made."

Brady had yet to date Tara Reid, have a child with Bridget Moynahan, and marry and begin raising two children with Gisele Bundchen. He had little time for dating, and one night he found himself awkwardly greeting a girl who knocked on his condo door and asked him to accompany her to her high school prom.

"He couldn't say 'no' to her face because he's so nice," Nugent recalled. "So he called her later at the number she gave him and explained that he couldn't go but thanked her for the offer."

Brady was more inclined to socialize with his teammates. One summer night, he took seven of them to a game at Fenway Park, thanks to Red Sox outfielder Darren Lewis, his occasional workout partner back home in California.

Another night, he joined a group of teammates at the Foxy Lady strip club in Providence.

"Everybody was loud and drinking beer and having fun," Floyd said. "And Tom was sitting in the corner, all quiet. It looked weird, but that was Tom."

Brady was adept at guarding his reputation without alienating his teammates. At Michigan, his close friends "were into beer pong and beer guzzling, but he always laid low and stayed out of trouble," Floyd said.

His chief form of recreation that summer involved a video game.

"He went to a pawn shop and bought an old Nintendo system," Nugent recalled. "We played 'Madden Football' for hours, and if he lost, he got so mad that he threw the game system across the room against the wall."

Bishop recalls a more subdued Brady. On their occasional trips to Boston to play pool, Bishop said, "We spent a lot of time just talking about the team and our college days and where we saw ourselves in two or three years."

They were competing for the same job and, Bishop said, "so hungry we could taste it."

They made a pact.

"We agreed that if either of us got the opportunity, we would take the job and wouldn't give it back," Bishop said. "No matter which one of us got the opportunity, the other one would be happy for him."

Neither of them, however, was given a snowball's chance in summer of getting an opportunity anytime soon. Bledsoe had taken every snap the previous season, his seventh as the starting signal caller. He was a three-time Pro Bowler who had broken nearly every major team record for a quarterback, and in 1996, he had led them to the Super Bowl, where they lost, 35-21, to Brett Favre's Packers.

Brady had lots to prove and little time to do it. He played well in two preseason games, but media analysts predicted that his Patriot days would be fleeting. NFL teams rarely carry four quarterbacks, and Bishop remained ahead of him on the depth chart.

"Brady is likely earmarked for the practice squad — even if it means risking losing him on waivers," the Globe reported late that summer.

Belichick, it turned out, thought otherwise. He began to recognize Brady's special traits, among them his obsessive preparation.

Friesz had never seen a quarterback so tirelessly analyze film of himself leading a scout team in practice. And Nugent recalled returning home from road games early in the morning when Brady didn't travel with the team and finding him hunched over a coffee table, studying his playbook.

"I said, 'Tom, how do you not get frustrated?'" Nugent recalled. "He said, 'I can't control what anybody else thinks of me. All I can do is focus

Drew Bledsoe and Tom Brady will be forever linked in both Patriots and NFL lore.

on the things I can control, like how much I know the playbook, how hard I practice, and how hard I work out.' "

Belichick rewarded Brady with a precious spot on the 53-man roster. But the coach, in making the announcement, indicated he would have preferred to release Brady and sign him to the practice squad if not for the chance of another team claiming him off waivers.

After all, Belichick had no immediate plans for the kid. Brady was inactive for the first nine games on the 2000 schedule, and he has since described one of his sharpest memories of the season as idly scarfing nachos before kickoffs while his teammates prepared for action.

He finally dressed for a game in Week 11, but only because Belichick ignored the noise from Patriots fans. With Bledsoe listed as questionable because of an injury, the Patriots website polled fans on which backup quarterback they favored. The landslide winner was Bishop, with 78.5 percent of the vote, followed by Friesz (12.8 percent) and Brady (8.7 percent).

Bledsoe managed to start the game, but Belichick, bucking the fans, elevated Brady above Bishop that week on the depth chart. Eleven days later, on Thanksgiving in Detroit in 2000, Brady made his NFL debut, calling four plays in the fourth quarter of a 34-9 defeat, the team's worst of the season.

The loss dropped the Patriots to 3-9, and Brady was stunned afterward that many of his teammates appeared indifferent.

"Why does it seem like nobody really cares?" Friesz recalls Brady complaining.

Friesz tried explaining that the team had lost its shot at the playoffs and that professional football players often react to wins and losses differently from collegians.

"None of it made sense to him," Friesz said. "He didn't like the quit he saw."

Brady did not play again his rookie season, but he continued to impress his teammates.

Even as he clung to a roster spot, he risked Belichick's wrath in practices by trying to protect his teammates, particularly the linemen who blocked for him.

Grey Ruegamer, a backup lineman that year, said, "There were times when I screwed up and Belichick started riding my butt, and Tom would say, 'Hey, coach, that was on me, not him.' He would take a bullet for a teammate. That kind of loyalty goes a long way."

Others were impressed by Brady's perfectionism. In a routine scrimmage that summer, Tisdale picked off one of Brady's passes. Afterward, Brady wrapped his arm around Tisdale.

"Nice interception," he said. "But you will never intercept a pass from me again."

Tisdale knew better than to be offended.

"Tom wasn't being a jerk," he said. "It was just his way of trying to be the best he could be."

Others admired Brady for trying to parry Bledsoe's pranks. He countered the glitter blast by securing a life-size cardboard standup of Bledsoe and wedging it into the revolving door at the Patriots practice center. With every turn of the door, Bledsoe's image spun around, as if his teammates had not already seen enough of him.

"That's when Drew said, 'OK, I'm going to win this,' " Friesz said.

Bledsoe enlisted a friend who knew an FBI agent to help him obtain a vial of the red dye used to foil bank robbers. Friesz secretly poured it into Brady's socks in his gym bag, and when Brady donned them in a locker room filled with his teammates, the dye ran up his socks and stained his skin all but indelibly. He left scarlet footprints in the carpet as he stomped to the shower, his teammates chortling.

"The stains went deep into Tom's skin," Friesz said. "He had to go to Home Depot and get every solvent they had and scrub and scrub, and he still didn't get it all out."

So it was that Bledsoe won the pranking war. But the course of the greater struggle soon turned.

On Sept. 23, 2001, in the fourth quarter of a 10-3 loss to the Jets in Foxborough, Bledsoe was leveled by linebacker Mo Lewis and suffered an injury that knocked him out for two months and effectively ended his reign as the Patriots starter. In went Brady, poised to fulfill his prophecy.

He started his first NFL game the following week, piloting a 44-13 rout of the Colts in Foxborough. But the Patriots faltered a week later in Miami, 30-10, and their record sank to 1-3, hardly playoff-caliber.

The next morning, Belichick held his regular team meeting. As it ended, Brady asked to address the players. The coaches departed, and Nugent cringed.

"As much as I liked and respected Tom, I said to myself, 'Man, this is just too soon,'" Nugent recalled. "He was so young, but he stood in front of a room full of grown men and said, 'I know these aren't the circumstances you expected this year, but our time is now. I'm going to do everything in my power to win every game.

I just need you guys to be with me.'

"There was something about his passion that lit a fire under everybody."

The Patriots won 12 of their next 14 games, then the Super Bowl, with Brady named the game's most valuable player. He would win three more Super Bowl rings and twice more be named the game's MVP.

Today, Bledsoe runs a winery in his native state of Washington. Friesz is in Montana, often ice fishing, and Bishop is home in Texas, training young athletes. All three plan to watch Brady try to become the first quarterback to win a fifth Super Bowl, and one of them, Bishop, expects to reflect on a pact they made 17 years ago.

"To this day, I have the most respect for Tom because he did what we said we would do: When his opportunity came, he took the job and didn't give it back," Bishop said. "He's still doing what he loves to do, and I'm happy for him." ∎

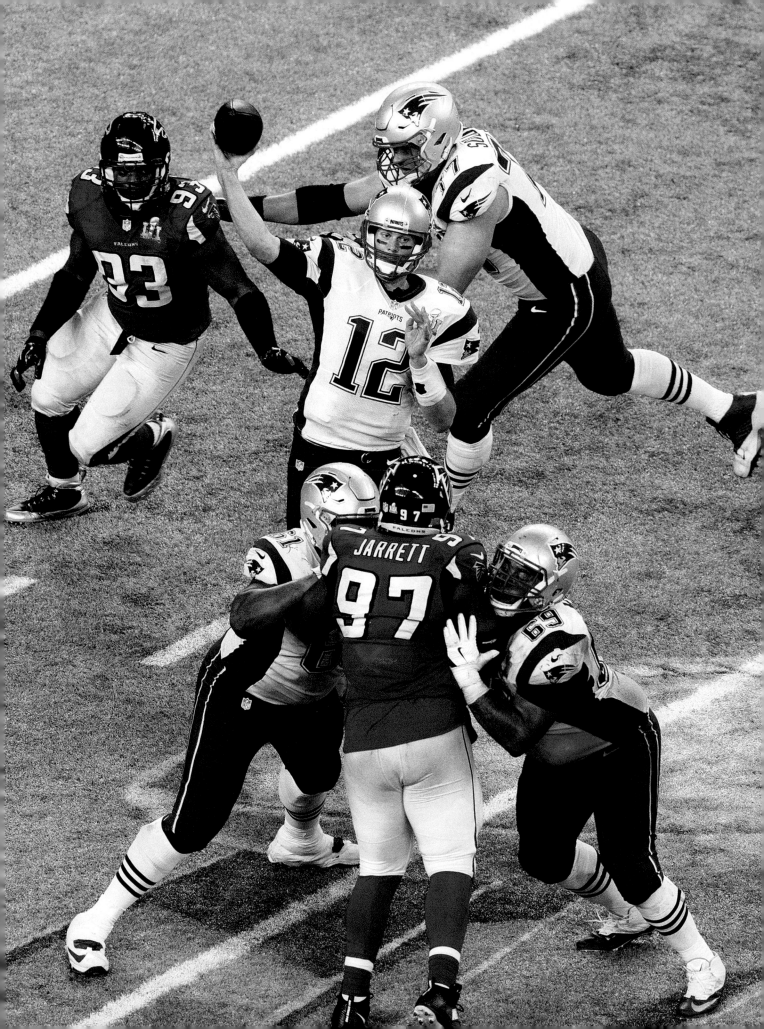

Super Bowl LI
February 5, 2017 • Houston, Texas
» PATRIOTS 34, FALCONS 28

CASE CLOSED

In a Comeback for the Ages, Brady and Patriots Beat Falcons in Heart-Pounding Super Bowl

By Jim McBride

Tom Brady and the Patriots came storming back from a 28-3 deficit to shock the Falcons 34-28 in Super Bowl LI.

Case closed. Tom Brady cemented his legacy as the greatest quarterback in history Sunday night and he did it in the most dramatic fashion.

The Patriots quarterback earned his fifth Super Bowl title and collected his fourth Super Bowl MVP as the Patriots staged the most incredible and improbable comeback in history of America's game, beating the Falcons, 34-28, in overtime at NRG Stadium.

Erasing a 25-point second-half deficit, the Patriots scored 31 unanswered points against a Falcons team that played the fourth quarter as though they were waiting to be fitted for their rings rather than finishing their business on the field.

James White's 2-yard run in OT — the first in Super Bowl history — was the difference as the Patriots pulled off their second stunning Super Bowl victory in three seasons.

"This is unequivocally the sweetest," said team owner Robert Kraft after that long-awaited, awkward moment when commissioner Roger Goodell handed him the Vince Lombardi Trophy.

Brady was astoundingly brilliant in the second half and put on a fourth-quarter performance that was incredible, even by his lofty standards.

For the record, Brady finished 43 of 62 for 466 yards and a pair of touchdowns. He hit White and Danny Amendola with fourth-quarter TD passes and they each converted 2-point conversions on

Tom Brady helped the Patriots outscore the Falcons 31-7 in the second half and overtime.

the other's TD to tie the score at 28-28.

The Patriots won the toss in overtime and Brady carved up the gassed Falcons, driving 75 yards, capped by White's run.

"Yeah, they're all sweet," said Brady, when asked if this was the best, considering the Deflategate saga of the past two seasons. "They're all different and this was just an incredible team and I'm just happy to be a part of it. It's just a great group of coaches and teammates and we overcame a lot of different things and it's all worth it."

It is the fifth Super Bowl title for the Patriots, who are now tied with the 49ers and Cowboys for the second most in NFL history (the Steelers have six).

All of New England's titles have come under the stewardship of the Kraft family, Bill Belichick, and, of course, Brady,

For two weeks, Belichick extolled the virtues of the Falcons' speed to anyone who would listen. Sunday night the 70,807 on hand and millions across the world found out just what the New England coach was talking about.

Atlanta blitzed the Patriots with 21 straight points, displaying tremendous speed and feverish quickness that left the favorites defenseless and helpless.

It felt over. Well, almost over.

The Falcons gave a preview of things to come on their first offensive play from scrimmage when Devonta Freeman gashed them for 37 yards.

The Patriots were able to put the clamps on the Falcons for the rest of the opening 15 minutes. Problem was, Brady and the offense couldn't sustain any momentum.

The one drive the Patriots showed life came at the end of the quarter, when a pair of passes to Julian Edelman — the second one for 27 yards on the first play of the second quarter — gave them a first down at the Atlanta 33. LeGarrette Blount, however, fumbled on the next play and the Falcons took advantage.

Matt Ryan led a surgical five-play, 71-yard drive that ended with Freeman's 5-yard zip around left

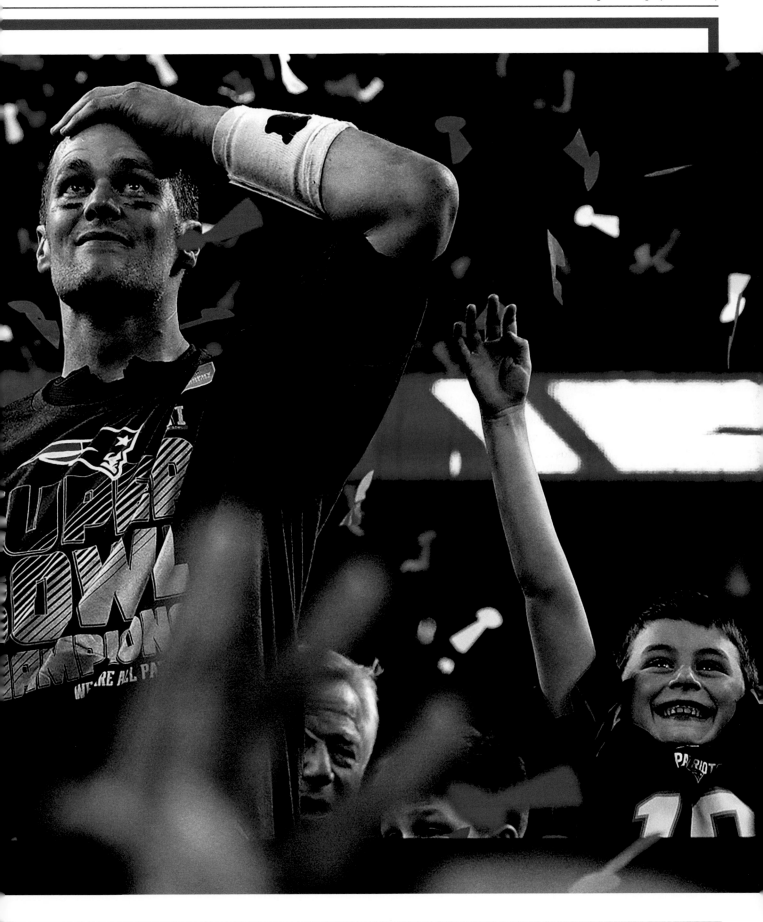

Winning his fifth Super Bowl tile and fourth Super Bowl MVP, Tom Brady threw for 466 yards and two touchdowns.

end. He went in untouched. Ryan, the former Boston College star, hit Julio Jones for 19 and 29 yards before Freeman went the final 29 yards on three carries.

It marked the first time the Patriots had trailed in a game since Week 11 against the Jets.

After another three-and-out by the Patriots, the Falcons set up shop at their 38 after a 38-yard punt from Ryan Allen.

Ryan, looking every bit the league MVP he was voted Saturday night, went back to shredding the Patriots defense. He hit Taylor Gabriel for 24 yards and Jones for a toe-tapping 18-yarder. Two plays later, Ryan dropped a beautiful 19-yard pass into tight end Austin Hooper's hands in the end zone to double the lead to 14-0.

The Patriots appeared poised to finally stop the hemorrhaging on the ensuing possession but again a turnover proved to be a killer.

After methodically marching from their 25 to the Atlanta 23 — aided by three defensive holding penalties — it appeared New England could still make a game of it.

That's when Robert Alford stepped in. Literally.

The cornerback cut in front a Brady pass intended for Danny Amendola and was off to the races for an 82-yard Pick-6 — with only a helpless and airborne Brady in his way.

It was a waste of an 11-play drive for New England.

The Patriots did mount an 11-play, 52-yard drive on their next possession, but it stalled when Martellus Bennett was called for holding, negating a White catch and run that would have put the ball inside the Atlanta 5.

Though Stephen Gostkowski would finally put the Patriots on the board with a 41-yard field goal, it was without a doubt the hollowest 3 points of the 2016 season.

Ryan was superb over the first 30 minutes, hitting on 7 of 8 passes for 115 yards. Brady was 16 of 26 for 184 yards and took two sacks. It was Brady's first multiple-sack game since Week 8 against Buffalo.

"We were down, some had some doubts [at halftime], we're only human," said Patriots defensive end Chris Long. "But we had enough guys pulling us along. Duron Harmon walked in and said, 'This is going to be the best comeback of all time.' And we completely believed that. And it was."

Nate Solder was a little more blunt.

"I felt like I played like total poop," he said.

After trading three-and-outs to start the second half, the Falcons extended their lead to 28-3 when Ryan hit Tevin Coleman with a 6-yard swing pass touchdown. Gabriel was the star of the drive, hauling in catches of 17 and 35 yards.

Brady, who set a Super Bowl record with his 43 completions, rallied the Patriots when he got the ball back, driving 75 yards in 13 plays, capped by a 5-yard strike to White. Gostkowski doinked the extra point off the right upright and it was 28-9.

Gostkowski drilled a 33-yard field goal to pull the Patriots closer at 28-12 on the team's first possession of the fourth quarter, and two plays later, Dont'a Hightower got the ball back when he strip-sacked Ryan to hand the Patriots the ball at the Atlanta 25.

"Biggest play of the game," said Long.

Brady fired a 6-yard TD pass to Amendola, and White scored on a 1-yard run to make it 28-20.

The tying drive — Edelman's incredible 23-yard catch the key — went 91 yards, matching New England's longest drive of the season. White finished it with a 1-yard run and Amendola caught the 2-point conversion. It was 28-28.

Ryan got the ball back and for the first time all night, he looked frazzled and overwhelmed, woefully misfiring on a third-down pass.

Once the Patriots won the OT coin toss, it was over. ∎

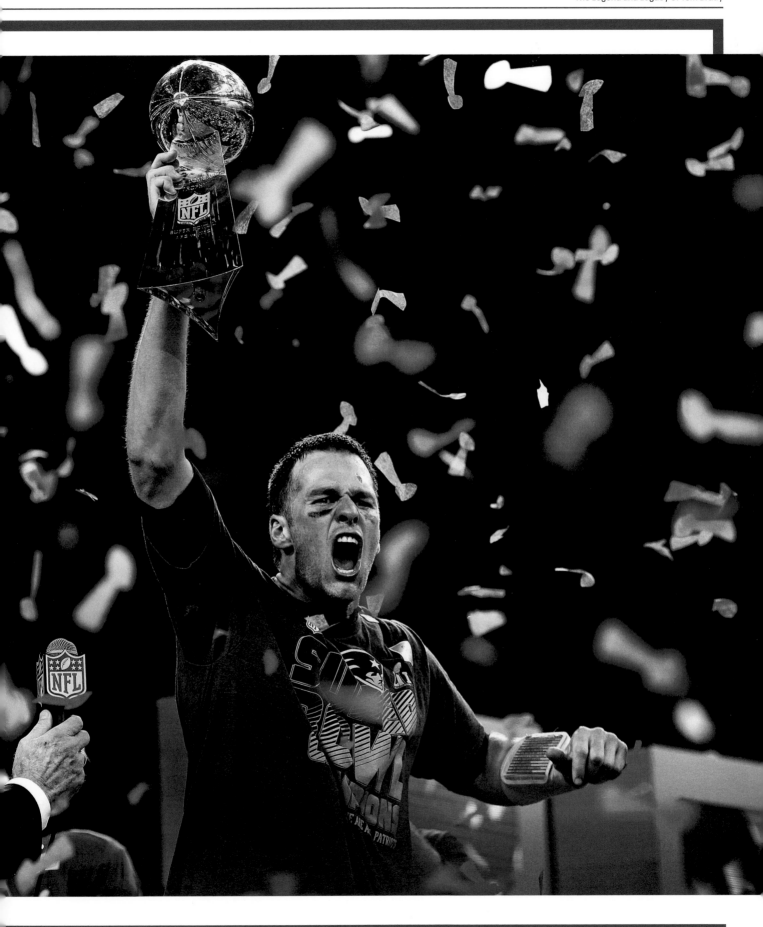

Tom Brady hugs his mother, Galynn, the day before facing the Giants in Super Bowl XLVI.

ROOTS RUN DEEP

Little Did John and Bridget Brady Know That Their Marriage Would One Day Lead to the Birth of One of New England's Most Revered Sports Figures

By Bob Hohler • March 4, 2017

His native land withered by famine, his countrymen dying by the hundreds of thousands, John Brady fled Ireland in the mid-19th century and found work as a laborer in Boston. Soon, he married Bridget Bailey, herself a refugee of Ireland's Great Famine, and at age 22 they began raising a family.

Little did John and Bridget Brady know, as they coped with the hardships of their new lives in a new land, that their marriage one day would help make possible the birth of one of New England's most revered sports figures. They were the great-great-grandparents of Patriots legend Tom Brady, according to new research into the five-time Super Bowl champion's roots.

Census records show that John and Bridget Brady had two children in Boston, including a son, Philip, who is Tom Brady's great-grandfather. Philip's birth certificate is not available, but a registry in the Massachusetts Archives shows that his younger brother, Henry, was born in 1857, in the family's home on First Street in South Boston.

Brady's Irish ancestry has been no secret. His father, Tom Brady Sr., has previously said his maternal ancestors immigrated from Ireland during the famine. But Jim McNiff, an amateur genealogist who spent months charting the quar-

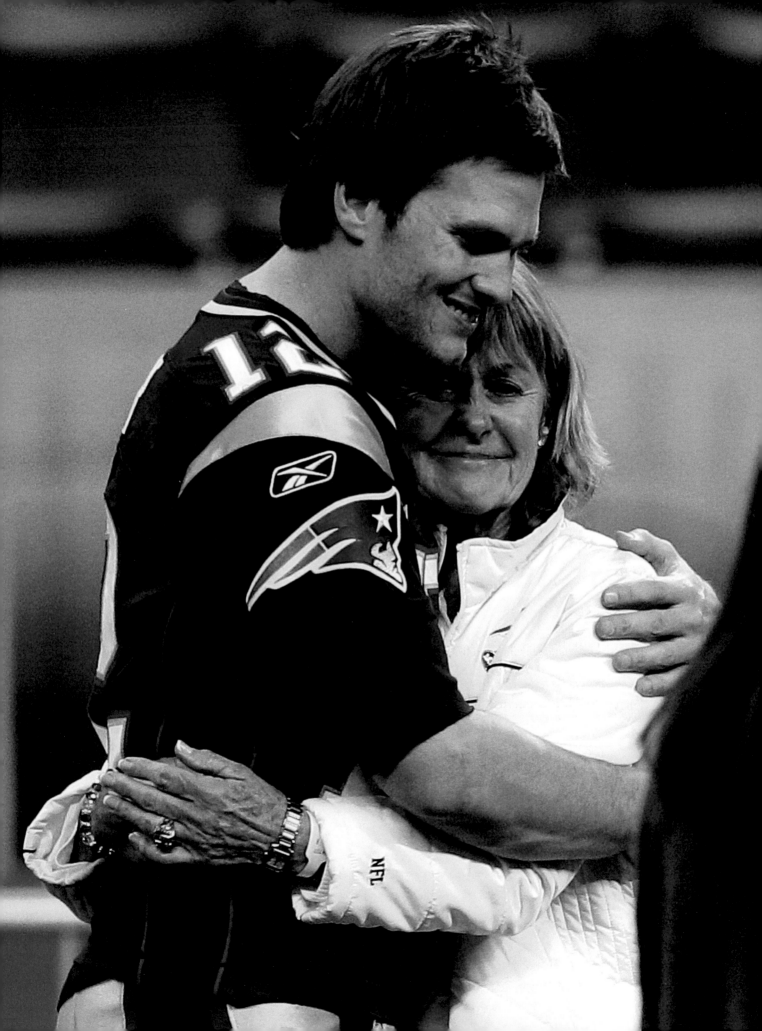

Tom Brady celebrates with his family after the comeback win over the Falcons in Super Bowl LI.

terback's family tree, has helped produce the first public evidence that Brady's father's paternal lineage extends deep into the history of Boston, where the Patriots great would gain his fame and fortune and make his home.

The research shows Brady's ancestors include a major league baseball player, a firefighter who responded to San Francisco's catastrophic 1906 earthquake, a newspaper reporter who was shot to death on the job, a West Point graduate who reportedly became America's first prisoner of war in World War II, as well as Catholic priests and nuns.

It's a story that spans the nation, one that chronicles both the ordinary and extraordinary lives of the Irish refugees on Brady's father side and the German-Nordic immigrants of his mother's family as they followed winding paths to the quarterback's birthplace on the shores of San Francisco Bay.

McNiff is a retired hospital financial manager and college professor who lives in Burlington and has made a pastime of investigating family histories. His work has included producing family trees for WGBH personalities Jim Braude and Margery Eagan and auto magnate Herb Chambers.

McNiff based his Brady findings on census reports, birth and death certificates, cemetery plots, municipal employment records, news articles, and original research conducted by other users of ancestry.com.

He sent copies of his research to the quarterback and his father but has not heard back. Nor were they available for Globe interviews.

Brady made a rare reference to his heritage when the Patriots visited England in 2009.

"I'm very proud of my Irish roots," he told reporters.

Tom Brady Sr.'s cousin, the Rev. Thomas Buckley, said in an interview that he has conducted his own research into the family's genealogy. A retired theology professor who taught at Boston College, Loyola Marymount, and the University of California Berkeley, Buckley said he has re-

viewed McNiff's work and found it credible.

"The Bradys and Buckleys have always been very close," he said. "We're all delighted by Tommy's success in football. He's a wonderful man."

Striking out west

Tom Brady had never been to Boston before his rookie season with the Patriots in 2000. A native Californian, he owes roots there to John and Bridget Brady, who departed Boston for the Pacific Coast before the Civil War.

Boston in the mid-1800s was inundated with Irish emigres. Details of Brady's early American ancestors are scarce, but Irish immigrants in Boston during the mid-19th century generally lived in poverty, many in squalor, and were often treated as unwelcome intruders.

Hordes of Boston's new Irish had survived treacherous Atlantic crossings on packed vessels called coffin ships because so many died. Many contracted typhus on the ocean journey and cholera in their new city. They found work where they could, men generally as laborers on the wharves, women as servants in the homes of the privileged descendants of Boston's early settlers.

In the Civil War, thousands of America's new Irish would be drafted by the Union Army.

As McNiff documents, the young Bradys went west before the war with Bridget's sister, Ann, and her husband, Lawrence Meegan, who also were Irish refugees. The Meegans lived on Porter Street in East Boston, and after Lawrence, a harness maker, was offered a job in San Francisco by a Boston businessman who had relocated there, the families set out for California.

The story of their cross-country odysseys remains untold. But in San Francisco they found themselves in a booming frontier town thick with dreamers inspired by the 1849 Gold Rush and the discovery of silver in the Comstock Lode. In many cases, living conditions were more primitive than they were in Boston, but there was hope and opportunity and jobs, as Lawrence Meegan

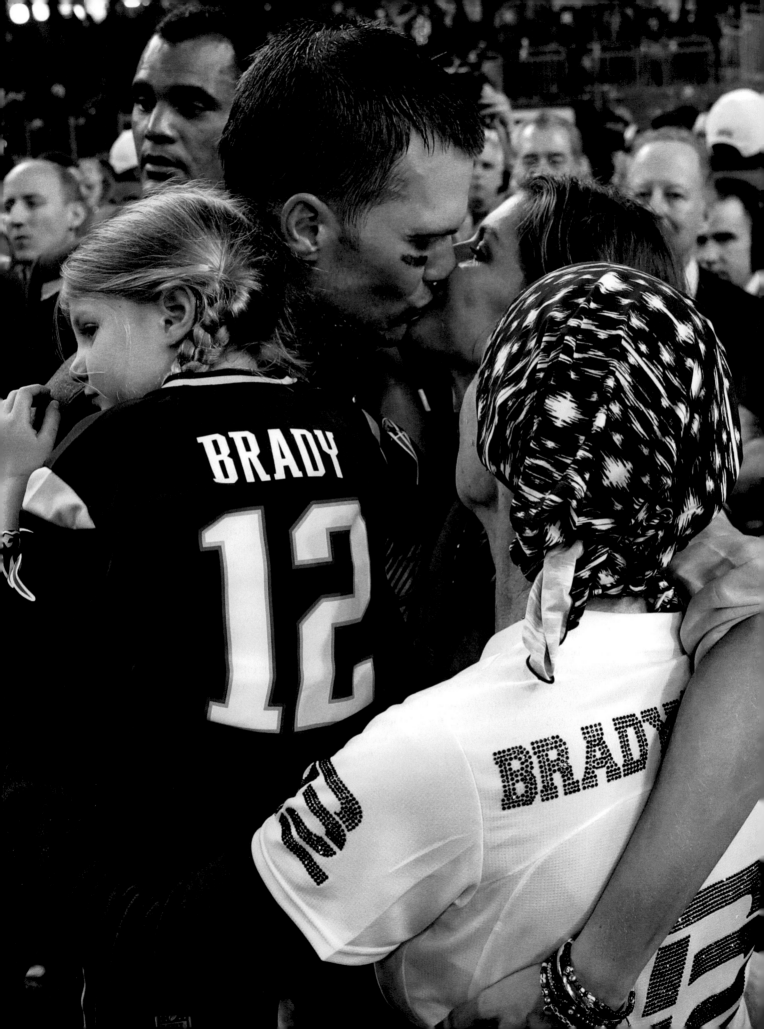

Tom Brady and his father, Tom Brady Sr., have deep roots in the New England area.

— and possibly John Brady — found with the Main and Winchester Saddlery Co.

Census records show the Bradys and Meegans settled next door to each other in San Francisco's Mission District, then lived together after Lawrence and Bridget died in the mid-1860s. Their children almost certainly played together, which means Tom Brady's great-grandfather, Philip, likely tossed a baseball with his cousin, Pete Meegan, who would reach the sport's major leagues as the Brady clan's first professional athlete.

Tom Brady himself was a gifted baseball player, selected by the Montreal Expos in the 1995 draft before he opted for football.

"Steady Pete" Meegan, as he was known in his heyday, pitched in 1885 for the Pittsburgh Alleghenys, who in 1891 became the modern-day Pirates. Meegan threw a menacing curveball, a pitch that once helped him silence "the world renowned Louisville Colonels," ensuring "his name and fame were heard in every town that boasted a baseball team," according to an account in the San Francisco Call.

When Meegan died in 1905 at age 42, the Call observed, "The baseball world lost one of its greatest stars."

A year after Pete Meegan died, Tom Brady's ancestors survived the 1906 San Francisco earthquake, which destroyed more than 80 percent of the city, killing 3,000 and touching off fires that raged for days.

The quarterback's great-grandfather, Philip F. Brady, was a San Francisco firefighter at the time. Classified as a hydrant man, he fought the conflagration though his firehouse had collapsed into rubble and the city's hydrant lines had ruptured. His own home was almost certainly damaged in one of the country's worst natural disasters.

Philip F. Brady witnessed untold horrors in his 27 years with the San Francisco fire department. He also endured, as a parent, an unthinkable horror: the murder of his son, Philip J. Brady, Tom's great-uncle.

Philip J. Brady, a former police sergeant, was a newspaper reporter who maintained close ties to law enforcement. The San Francisco Tribune described him as "a sleuth reporter," who "usually carried two large caliber automatic pistols, a flashlight and a blackjack, and was always prompt in assisting the police."

The paper said, "His weapons earned him the sobriquet of 'Two Gun Brady.'"

On New Year's Day in 1922, Philip J. Brady accompanied three police officers responding to a complaint of an unruly lodger who had barricaded himself in an Oakland rooming house. When they entered the room, the resident opened fire, and Brady, who was covering the incident for a San Francisco paper, was fatally shot in the stomach. He was 34.

Five journalists served as his pallbearers.

"He died a hero to newspaper loyalty," the Tribune reported.

Philip J. Brady's survivors included his younger brother Harry C. Brady, then 16. Harry one day would own a suburban San Francisco pharmacy, and on May 6, 1944, he and his wife, the former Peggy Buckley, had their fourth child, a son named Tom, who would become the quarterback's father.

Military connections

Tom Brady's dad was a World War II baby whose family did not go untouched by the conflict. Less than three years before Tom Brady Sr. was born, his uncle, Michael Buckley Jr., fell captive to the Nazis.

Buckley, a West Point graduate who lettered in baseball, boxing, and soccer, had been deployed by the Army to Egypt to serve as an observer with British forces fighting Germans and Italians under the command of Nazi General Erwin Rommel.

On Nov. 23, 1941, two weeks before Japan bombed Pearl Harbor and the United States entered World War II, Buckley was observing South Africa's Fifth Infantry Brigade when the South Africans were overrun by Rommel's forces.

Captured in battle, Buckley became America's first POW of the war, according to his published obituary. He was held in Italy for six months before he was released in a prisoner exchange. He later served in Japan and, after the war, taught at Santa Clara University.

For all his family's devotion to the military — Colonel Michael Buckley Jr. was the oldest living West Point graduate when he died in 2006 at age 104 — two of his six children chose a different form of service, becoming priests.

Tom Brady Sr. himself told the Globe in 2005 that he spent nearly seven years studying to become a Maryknoll priest. Then he changed course and joined the Marines, only to be discharged during the Vietnam War because of a knee injury.

Back in San Francisco, Tom Brady Sr. was selling insurance when he met Galynn Johnson, a TWA flight attendant. She was two months younger, having been born on the Fourth of July, 1944, in tiny Browerville, Minn., a descendant of Swedes, Norwegians, and Germans who immigrated in the 1850s and '60s.

Galynn Johnson and Tom Brady married in 1969 and settled in the San Francisco suburb of San Mateo. They had three daughters before Tom Brady, their only son, was born on Aug. 3, 1977.

Young Tom's athletic prowess was not shocking, considering that all three of his sisters — Maureen, Julie, and Nancy — became collegiate athletes. Maureen was an All-American softball pitcher at Fresno State.

For many years in Tom's youth, the Bradys vacationed each summer in rural Minnesota, where Galynn's father, Gordon Johnson, had been a barber before he saved enough to operate a small dairy farm. Galynn's relatives recall fond memories of playing on the farm with the future Patriots quarterback.

Tom Brady remains close to many of his relatives in California and Minnesota. He has invited them to his Super Bowl appearances, visited their homes, attended their special events, congratulated them when their babies have been born, grieved with them when their loved ones have died.

When Galynn's father died last year at age 97, Brady read a passage at his funeral in St. Joseph's Catholic Church in Clarissa, Minn., a farm town of about 600.

Then he invited some of his Minnesota relatives to a Patriots game and put them up at a luxury hotel in Boston.

"Tommy is as genuine as he was in the days when he came and played on the farm," his cousin, Paul Johnson, said. "We're all proud of him."

Brady's parents still live in his childhood home in San Mateo, a short drive from Holy Cross Cemetery, where many of his ancestors are buried. Two headstones there are memorials to John and Bridget Brady, onetime Bostonians who helped give Tom Brady the gift of life. ■

Tom Brady, who turned 40 in 2017, aged as gracefully as any athlete in pro sports history.

THE AGELESS WONDER

Is 40 Just a Number to Birthday Boy Tom Brady?

By Ben Volin • August 2, 2017

The birthday card industry doesn't treat the 40th birthday too kindly.

"Some ages are better left unspoken."
"40: The ultimate F-word."
"Keep calm you're over the hill."
"Enjoy your first colonoscopy!"
Happy 40th birthday, Tom Brady.

"They don't have a fun term for 40, do they?" said Brady's partner in crime, Julian Edelman. "There's 'Dirty 30,' and then it's just, '40.' So, he's pretty old."

Brady will hear plenty more wisecracks on Thursday when he celebrates his birthday at Patriots practice.

"I mean, we've got to, right?" backup quarterback Jimmy Garoppolo said. "It wouldn't be right if we didn't. We're there to bring him back down to earth every once in a while."

Brady has always found himself in rarefied air on the football field, ever since beginning his career with three Super Bowl victories in four seasons.

Next month, he enters yet another exclusive club. Brady will become the 60th player in NFL history, and 19th quarterback, to play at age 40, according to the Pro Football Hall of Fame. The Patriots have had a few quadragenarians on the roster in the Bill Belichick era — including quarterbacks Doug Flutie and Vinny Testaverde — but none since Junior Seau in 2009.

Thursday marks the 18th time Brady will celebrate a birthday in Patriots training camp.

"Hopefully it's just a day of practice. That would be the perfect day," Brady recently told Sports Illustrated. "I want the day to just come

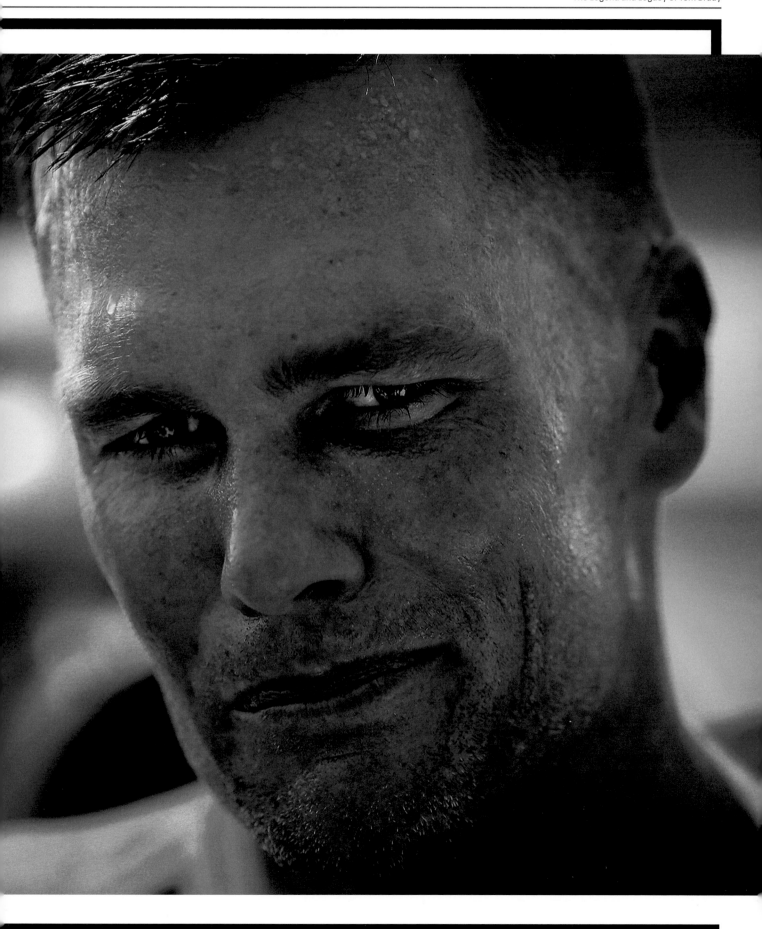

The scrutiny Tom Brady was under only increased with age but didn't negatively affect his performance on the field.

and go, where I'm enjoying being out there with the guys like any other day in August over the last 25 years of my life."

Good luck with that. Edelman and Garoppolo have something cooked up for Brady, flashing devious smiles while declining to reveal any details.

Offensive coordinator Josh McDaniels said he won't be poking fun at Brady. At 41, McDaniels just went through the indignity of turning 40.

"I already lived through that," he said. "I don't really talk about age in there a whole lot. That's really a non-factor for us."

"Always remember that age is just a number (a really huge gigantic number in your case)."

Brady will wake up Thursday as the oldest non-kicker in the NFL, more than six years older than any of his Patriots teammates and nearly twice the age of Patriots defensive back D.J. Killings, who will be 21 years old until Aug. 9.

Brady still has a long way to go to be the oldest starting quarterback in NFL history — Steve DeBerg holds that distinction at 44 years, 279 days. But Brady must feel like an uncle to many of his teammates. Most of this year's rookie class was born in 1994-95, when Brady was finishing his senior year of high school.

"I mean, I'm only 23, so let's put it like that," said Brady's new star receiver, Brandin Cooks. "This guy is still playing this game, so hats off to him. That's amazing. That's a special milestone to hit and I'm happy for him."

"By your age, Neil Armstrong had walked on the moon, Boudica had defeated the Romans, and Alexander the Great had conquered the known world. But, hey, you've done stuff too, yeah?"

But Brady isn't just playing football — he's still dominating it. He has won two of the last three Super Bowls, produced arguably his best season ever at age 39, and continually amazes teammates with his obsessive and relentless training and dieting regimen, which he calls The TB12 Method.

"You kind of don't think about the age, because you're like, 'Man, this dude is good,'" said

Patriots third-string quarterback Jacoby Brissett. "I think that's what's unique about seeing somebody that's been in the league so long, approaching every day as if it's their first day, and it may be their last. That's the approach he gives to me and Jimmy and the offense, is to attack every day. That's one of the biggest things that you learn from watching him."

Brady's longevity has impressed even those who blazed the 40-year-old trail before him.

"The thing that's more impressive to me is how consistent he's been, and how he's been able to play at such a high level for such a long time," said Hall of Famer Warren Moon, who threw 25 touchdown passes for Seattle in his age 40-41 season and last started a game when he was 44. "You look at how he doesn't get hit a whole lot because of the way they throw the football so quickly. Combine that with the fact that he takes tremendous care of his body, probably better than anybody in the league, there's no telling how long he might be able to play."

"40 is great when you look 28!"

Moon said he was able to play until he was 44 because he started taking better care of his body in his mid-30s — focusing on core exercises and flexibility, and paying closer attention to his diet (sound familiar?). His career finally ended because he was in a backup role in Kansas City, and he lost the motivation to train hard in the offseason and be away from his family.

But motivation isn't an issue yet for Brady. He knows he will eventually succumb to Father Time, but his entire life's work now revolves around delaying his defeat as long as possible.

The avocado ice cream and pliability exercises and 8:30 bed times have helped Brady stay on top of his game, and he's now in the process of commercializing his regimen for the public with TB12. Brady reiterated with Sports Illustrated that he wants to play until his mid-40s, which is the linchpin of the TB12 brand.

"There's no question in my mind I'll be able to do it," Brady said. "I know what to do. I know

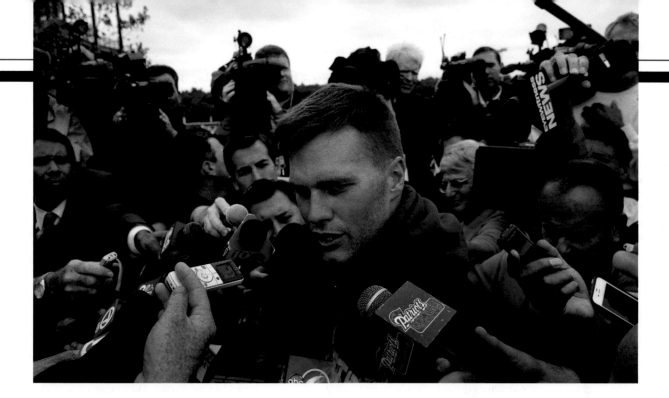

how efficient I am. I know what it takes. And here's the biggest thing: I'm willing to make the commitment. That's important."

"Forty is the new nothing. It's just old."

Also driving Brady's commitment: fear. It's an emotion he has internalized ever since joining the Patriots as a sixth-round pick in 2000: fear of not making the team; fear of sitting on the bench; fear of losing his job.

Today, it's the fear of being too old. Tear up your knee at 28 and you can come back the next year. Tear up your knee at 40 and now you're the old guy who can't stay healthy.

It certainly explains why Brady would hide any concussion symptoms from the Patriots last season, as his wife said this summer.

"When I broke my ribs in Seattle, I was getting shot up every day in practice in order to play the game, instead of maybe taking three weeks off, letting it heal," said Moon, now 60 and the president of his own company, Sports 1 marketing. "I was at that stage where you felt like if you got hurt, when you were older, that your career was over. So I was going to try and stay on the field however I could, and that was my probably my downfall."

And Brady can eat all the avocado ice cream in the world, but injuries in football are unavoidable. In your 40s, those sprained ankles and bruised muscles just don't heal as quickly.

"Mother Nature has a weird way of taking away your abilities, even when you might be thinking you're doing all the right things in the world," Moon said. "But you look at what he's doing right now, he can definitely play a lot longer."

"You're not 40. You're 18 with 22 years of experience."

Brady's training and diet keep him young, but so does being around his teammates every day. He demands that Garoppolo, 25, and Brissett, 24, compete with him in throwing drills during practice.

"Tom doesn't allow us not to compete against him," Brissett said. "He holds all of us accountable, and he wants us to do the same for him."

Brady is also open to sharing his secrets. He wants Garoppolo and Brissett to change their diets, embrace his training program, and learn how to live like a pro, on and off the field. This past May, Brady flew Garoppolo, Brissett, and a few other teammates on a private jet for a bro's weekend at the Kentucky Derby.

"That's the most cool thing about it. He's open to helping you out," Brissett said. "It's definitely a blessing, to say the least."

The birthday card industry thinks Brady has a beer gut, a bald spot, and gray hairs growing out of his ears. It thinks Brady is afraid of turning 40, that he's over the hill and coasting toward the finish line.

The birthday card industry hasn't met Tom Brady.

"To play with a guy like that is special," Cooks said. "The way that he pays attention to the game, he makes you up your level a little more. So when you have that from a teammate you can't ask for anything more." ∎

The TB12 approach to health and nutrition that Tom Brady helped develop changed the way players in the NFL, and quarterbacks in particular, took care of their bodies.

THE BRADY WAY

Around the NFL, QBs are Training and Eating Like Tom Brady

By Ben Volin • August 17, 2017

Aaron Rodgers went almost-vegan in 2016, cutting dairy and most meats from his diet. Russell Wilson dropped 10 pounds this offseason, avoiding all yeast, mold, dairy, and gluten.

And Marcus Mariota risked the ire of his coaches this summer by ignoring their recommendation of playing at 230 pounds and dropped his playing weight to 215-220.

Thin is definitely in this season for NFL quarterbacks, and it's not by accident. It's a movement being led by Tom Brady, who dominated the league in his late 30s and is still going strong at 40, thanks to his vegetable-based diet and flexibility training over muscle mass.

The rest of the league has noticed, and many quarterbacks are starting to follow Brady's lead, cutting weight and working on flexibility to avoid injuries, improve recovery between games, and lengthen their careers.

"I just think it's so the thing right now because Tom's doing it," said 18-year NFL quarterback Matt Hasselbeck, now with ESPN. "You've got the quarterback of the Green Bay Packers announcing he gave up dairy. That's a hard thing to do. But he did, and he had an amazing year last year.

"And now you see guys around the league — whether it's Aaron Rodgers, Matthew Stafford, Marcus Mariota, Andrew Luck — these guys are coming in lighter, and it's not by accident. I think it's because they're seeing the success that Tom's having and the longevity. He's a trendsetter."

Brady's mission, outside of winning another Super Bowl, is spreading the gospel of proper diet, flexibility training, and rest. For 99 percent of football fans, the only way to learn Brady's secrets

Tom Brady's elite play and longevity made his training methods prevalent throughout the league.

is to buy a TB12 cookbook for $200, or his recovery pajamas ($79.99 each for the shirt and shorts on Under Armour's website).

But NFL players get the education for free, and Brady has been more than happy to share his secrets with his fraternity members.

"I've talked to a lot of different players," Brady said after a recent Patriots practice. "I think a lot of people ask me when you get to be my age. I feel like I know what to do. I don't wake up with pain. I come out and play a game and keep working on things that I want to improve at every year, and it's been a lot of fun for me.

"Hopefully I can share that with a lot of people. It'd be great to pass on that wisdom. I feel that's part of my responsibility as a player to do that to other players who may want to seek the same thing, so it's been a really enjoyable part of my career."

'If it works for Tom Brady...'

Brady's influence on teammates is obvious. Nearly every player in the Patriots locker room visits the TB12 facility at Patriot Place for massage work and stretching exercises with Brady's body coach and business partner, Alex Guerrero.

Julian Edelman and Danny Amendola are devoted followers of the TB12 regimen. Rob Gronkowski, the epitome of whey protein shakes and power lifting, is a recent convert, saying he has focused more on flexibility this season to try to avoid injury, and is now eating many of the TB12 prepared meals.

"I look at him and he turns 40 tomorrow and he runs around like he's younger than me," Gronkowski said. "So it's pretty obvious right there."

Quarterbacks Jimmy Garoppolo and Jacoby Brissett can often be seen working with Guerrero after practices. Safety Duron Harmon said at last year's Super Bowl that he wears the performance pajamas.

"I mean, if it works for Tom Brady . . ." Harmon said.

Around the league, Rodgers, 33, directly credits Brady with helping him realize the importance of a plant-based diet. Rodgers used to play at 230 pounds, but since cutting dairy and most meats from his diet, he has reported to Packers camp at 220 the past two years. Now Rodgers talks about playing until 40, just like Brady.

"I can't give up some of the nightshades, but I think Tom sets a good example, and we have been friends for a while and talk about a number of things," Rodgers told People magazine earlier this year. "He has kind of set the standard for taking care of your body."

Brady is not exactly revolutionary in his approach. Drew Brees, who for years has shared the same offseason quarterback coach as Brady, has devoted himself to a similar diet, though he hasn't tried to market it like Brady.

Carson Palmer cut carbs out of his diet as he recovered from ACL surgery in 2015 and lost nearly 20 pounds. In the 1990s, Warren Moon cut meat out of his diet, focused his training on flexibility exercises, and went to a chiropractor twice a week. He dropped 5 pounds from his playing weight and played until he was 44 years old.

"You just didn't want to play heavy," he said.

But Brady is the gold standard of today's quarterbacks, the first to consistently dominate the NFL into his 40s. He's also the most vocal about the importance of changing your diet and lifestyle. And if it's working for Brady, many other NFL quarterbacks figure it can work for them, too.

"They're all looking to Tom; he's the pinnacle," said Ryan Flaherty, senior director of performance at Nike who works with Mariota, Wilson, and nearly half of the NFL's starting quarterbacks each offseason.

"He's the guy that I think everybody wants to be, and even my young guys this year, [Mitchell] Trubisky and Deshaun Watson, both those guys are like, 'Look, I want to be Tom Brady, but I want to be my own version of him.'"

Tom Brady looks on during the TB12 Grand Opening Event at the TB12 Performance & Recovery Center in Boston.

Changing your body

Not everyone takes the diet to the extremes that Brady does, of course. Brady has said that his diet is 80 percent alkaline, 20 percent acidic, and that he eats a mostly-vegan diet that cuts out foods that cause inflammation, like tomatoes, peppers, mushrooms, and eggplants.

When working with Mariota and Wilson this offseason, Flaherty emphasized a pescatarian diet replete with healthy fats — avocado, olive oil, fish — and eliminating carbs and sugar.

The goal wasn't just for Mariota and Wilson to get thinner but to improve their speed. Wilson's 2016 season was hampered by an ankle injury in Week 1 and a knee injury in Week 3. Mariota's first two NFL seasons ended with injury — a torn MCL against the Patriots in December 2015 and a broken fibula in December 2016.

Flaherty doesn't believe in the old theory that packing on a few more pounds of muscle will help quarterbacks take the pounding.

"It's difficult for the young guys because, 'The coaches want me at 230, my GM and everybody wants me at 235 because they want me to absorb hits,'" Flaherty said. "Well, the problem is the first two years, Marcus's injuries have all been contact injuries, because he's getting hit, he's getting caught from behind. But if you're fast enough and you're agile enough, you're not going to get hit.

"Russell, he came in at 230. He's not going to be as agile and fluid and as fast as he is when he's 220. Russell has to think, 'I've got to be light, I've got to be fast, I've got to be agile.'"

Even rookies like Watson and Trubisky have taken notice of the benefits of a lean diet. It's not a lesson Brady learned right away. When he entered the NFL, his favorite meal was a ham-and-cheese hoagie washed down with an orange soda.

"Deshaun Watson was a great example," Flaherty said. "He had no idea how to eat healthy. Fried food was a staple of his diet. Showing him, 'Look, you want to be like Tom Brady? This is what Tom Brady eats, this is why he's able to stay healthy for so long, this is something you need to emulate, you need to put into practice.'

"You're able to show him how he changes his diet, how he changes his body and how that makes him feel. He's like, 'Oh my gosh, I can't believe I used to eat like that.'"

Flaherty, who also works with Philip Rivers, Jared Goff, Carson Wentz, and most of the Arizona Cardinals, said he's grateful to have someone like Brady leading the charge about diet and flexibility.

"I think it's amazing having guys like Tom Brady who are so vocal about it, and how the proof is in the pudding," Flaherty said. "He's kind of an awesome example for the younger guys to see that you don't have to eat a super high protein [diet], take Creatine, and eat high carbs to be 240 [pounds] in order to play for a long time.

"It's great for me because I've been preaching it for a long time, but it takes guys who are the best at what they do like Tom Brady for the guys to pay attention." ■

Tensions between Tom Brady and the Patriots organization increased as his prolific tenure with the franchise wound down.

DEAR TOM BRADY

Can You Please Explain Something to Us?

By Dan Shaughnessy • June 4, 2018

Dear Tom,
What happened?

Or, as Richard Sherman once asked . . . you mad, bro?

Seriously. At what point, precisely, did you decide you like the world of Thurston Howell III more than the football world of Fuzzy Thurston? When did you make the leap from stopwatches to TAG Heuer watches? How can you possibly feel underappreciated when you work here in New England, where every sports citizen wants to throw rose petals in your path, then wash your feet and kiss your five championship rings?

We expect you to be at the Patriots' mandatory minicamp in Foxborough this week, but we are still surprised that we didn't see you for the voluntary organized team activities last week. You attended those in the past — like every other NFL starting quarterback — and were convincing when you told us how important it is to participate in them.

So what changed? And please don't give us the "family time" excuse. While your teammates were sweating it out at Gillette Stadium last week, you jetted off to Monte Carlo to hang with the sovereign prince of Monaco. Wearing a splendid white ensemble, you threw passes to supermodel Bella Hadid while Brian Hoyer was back here throwing passes to Jacob Hollister and Sony Michel. You even threw a yacht-to-yacht completion to Formula 1 driver Daniel Ricciardo. Why not a couple of throws to Patriot running back Jeremy Hill?

Bella Hadid and Daniel Ricciardo are not going to be able to help you against the Steelers in December.

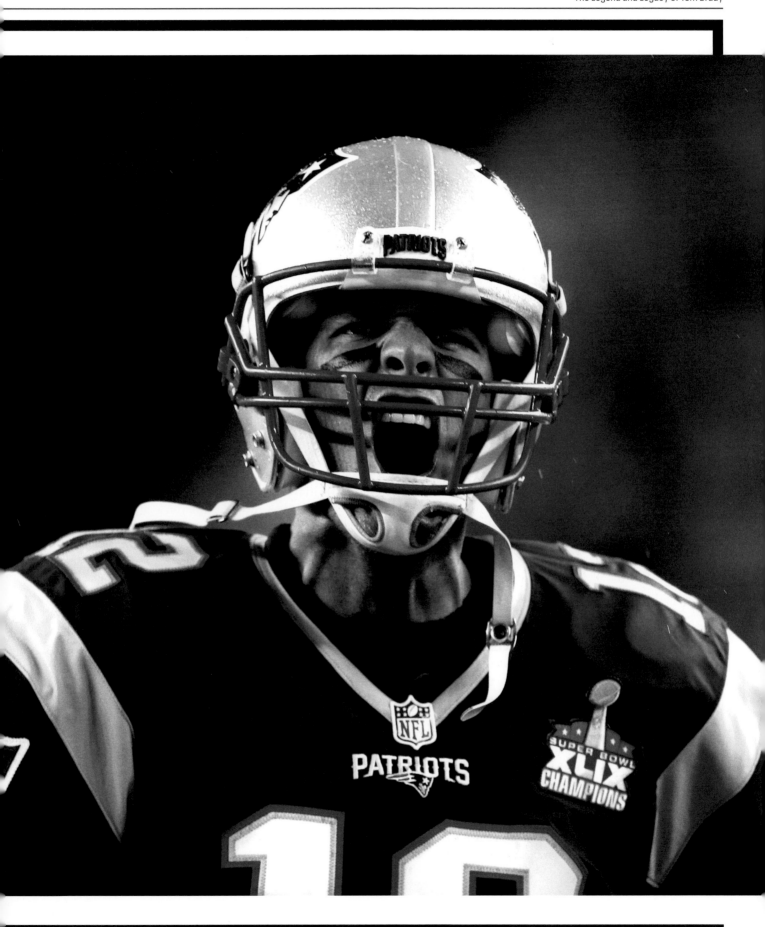

Tom Brady's business interests grew as he approached the home stretch of his career and had an added focus on the next chapter in his life.

Looking back, we wish we'd gotten to know you better back in 2000 when you were the fourth-string quarterback dressing in a stall near star Drew Bledsoe in that crappy old locker room at Foxboro Stadium. It would have been easy to shoot the breeze about Michigan football and your high school baseball career.

You always wanted to know what was going on with the Red Sox in those days, and you had plenty of time. The Patriots were going 5-11 under new coach Bill Belichick and there wasn't too much media coverage. The fourth-string quarterback always has plenty of time.

We knew then, as we know now, that you come from a great family. Any guy with loving parents and three older sisters tends to be the most respectful guy in the room, and that was always you. You were humble, hard-working, confident, and clutch long before you were one of the most famous and decorated athletes in the history of professional sports.

And you are still all those things. Now about to turn 41, you are the near-unanimous "greatest ever" and still have a great chance to get to an unprecedented ninth Super Bowl for a record-smashing sixth ring.

But you have ascended to a level of fame and fortune that has separated you from just about everybody. You are walled off from Everyman. It seems that you are angry with Bill and the Patriots. It seems to us that your brand has become the most important part of your professional life. Your cult-like allegiance to trainer Alex Guerrero appears to matter more than your job as quarterback of the Patriots.

The TB12 Method works so well for you, but there are times you seem to go a little overboard. Do you really think you can make yourself impervious to injury and illness by the sheer force of the method and its message? Sometimes it sounds a little like the time Wade Boggs willed himself invisible to escape from a knife fight.

Truly, Tom, if you were forced to choose between Alex and the Patriots right now, which would it be?

Your family and your personal choices are none of our business. Sure, we'll have some fun with the gold embroidery on your Versace tuxedo jacket at the Met Gala, but it's great to see you lucky-in-love and blessed with three healthy children. Fans understand adjusted priorities from a man in his 40s with a growing family.

But your priorities also seem to have changed professionally, and this has fans worried. You delivered a series of hints in "Tom vs Time." In April, at a paid gig for the Milken Institute Global Conference (another effete event) when corporate stooge Jim Gray asked you if you felt appreciated by the Patriots, you answered, "I plead the fifth," then said it was a hard question to answer.

It is not a hard question to answer. It is a "yes" or "no" answer, and you basically told us you do not feel appreciated.

What is going on, Tom? Did you feel like Bill and the team threw you under the bus in the Deflategate debacle? Are you angry simply because Bill won't allow Alex to fly on the team plane or stand on the sideline, or treat players other than you at the team facilities?

We thought it would make you happy when Bob Kraft threw his loyalty to you and forced Bill to trade Jimmy Garoppolo for a bag of doughnuts last season. Evidently not.

So what else could it be? Did you think Bill tried to bury you with stuff planted in the Seth Wickersham ESPN story? Did it make you angry when Bill said, "It's not like he had open heart surgery," after you played with the cut finger in the playoff game? Could it possibly be about your contract? Are you bothered that Bill didn't give you the best chance to win by playing Malcolm Butler in the Super Bowl?

You've changed, Tom. You didn't make it to Craigville Beach for the Best Buddies bike ride

Saturday. That's different. Troy Brown, Julian Edelman, and James White were there. You are always there.

You don't win the Employee of the Month parking spot anymore.

You're all about The Brand.

You're all about Alex.

And since you work in Fort Foxborough, where truth and candor are enemies of the state, we can only guess what happened.

That's it, Tom. Just wanted you to know we are thinking about you.

See you at the AFC Championship.
Sincerely,
The Fourth Estate. ∎

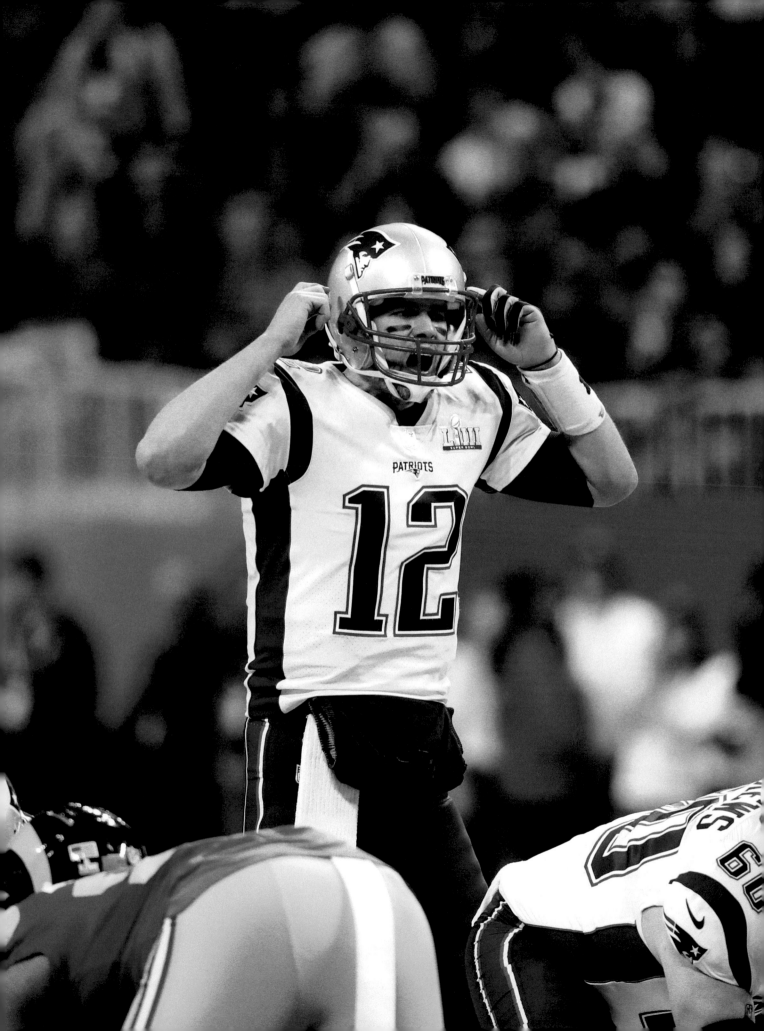

The Patriots offense had trouble getting on track in Super Bowl LIII but leaned on a dominant defensive performance in a 13-3 win over the Rams.

FINDING A WAY, THE PATRIOT WAY

Super Bowl LIII Win Epitomizes the Culture Created by Tom Brady and Bill Belichick

By Christopher L. Gasper

They always find a way in Foxborough. Finding a way is the real Patriot Way.

That was true of a season that didn't project to end with the Patriots' sixth Super Bowl title and of Super Bowl LIII, a tense tug of war in which the Patriots maintained their grip on the rope longer than the Los Angeles Rams and pulled off another victory for history.

The 13-3 victory on Sunday at Mercedes-Benz Stadium, where both the retractable roof and the end zones only opened briefly, was an apropos way for this team to end its season. It reflected their toil, their struggle, their togetherness, and their resourcefulness.

When it looked as if it wasn't their year — three double-digit losses and two two-game losing streaks — the Patriots found a way to win a Super Bowl that didn't go to plan. Locked in a 3-3 struggle in the fourth quarter, the win was a microcosm of their season: Not easy, not smooth, not what we're accustomed to, not possible without late adjustments, but ultimately a success.

Super Bowl LIII wasn't an aesthetically pleasing game to watch, but it was a beautiful illustration of why these Patriots team ended up as champions. They lifted the Lombardi Trophy because they found their way and found a way when it mattered most.

Tom Brady and his daughter, Vivian Lake, take in the scene as Brady celebrates his sixth and last Super Bowl title with the Patriots.

"People counted us out, man," wide receiver Chris Hogan said. "All year. We weren't good enough. The defense wasn't good enough. We didn't have enough skill players. But that doesn't matter. We had one of the best quarterbacks to ever play the game. We got a bunch of skill players that just want to go out there and make plays for their team. We had a defense that just works tirelessly and just wants to grind out wins. We got a head coach that prepares us, we got coaches that prepare us and care about us and want us to win.

"We play for one another. We don't care about the other stuff. Everyone can say what they want. But we're sitting here, and we got a Super Bowl."

Super Bowl LIII was a throwback win, an homage to 2001 and the provenance of the Patriots' reign. The defense carried the day, and Tom Brady was asked to make key plays in the fourth quarter. On the Patriots' only touchdown drive, he hit all four of his passes for 67 yards. Brady, who failed to throw a touchdown pass for the only time in nine Super Bowl appearances and finished with his lowest quarterback rating in a Super Bowl (71.4) after going 21 of 35 for 262 yards with an interception, was part of an ensemble cast. He was not required to be a transcendent franchise frontman to give new meaning to "The Brady 6."

Everyone enjoys a good redemption story, and the Patriots' title run featured redemption for the defense and for coach Bill Belichick. Last year, in Super Bowl LII, both Belichick and the defense tasted humble pie and drew the ire of a region for wasting Brady's Super Bowl record 505 passing yards against the victorious Philadelphia Eagles.

Whatever mistake Belichick might have made in not employing Malcolm Butler last year, he atoned for it this year with a brilliant defensive game plan that kept the league's second-highest scoring offense out of the end zone and out of their comfort zone. Class was in session for precocious Rams coach Sean McVay, and he got schooled by Professor Belichick, who deconstructed McVay's offense with ease. The Rams were 0 for 8 on third down before they converted one with about four minutes left in the third quarter on their only scoring drive.

What a difference a year and a healthy Dont'a Hightower made. Last year, they allowed 41 points, permitted five consecutive scores to close the game, and surrendered 538 yards, the most ever by a Belichick-coached Patriots team. They never sniffed Eagles quarterback Nick Foles and got owned by a top-notch offensive line on a miserable evening in Minnesota.

This year, they harassed Jared Goff all night, sacking him four times and exposing him as an unfinished franchise quarterback product. They never let Todd Gurley get traction.

The Rams had no fans and no offense. They tied the Super Bowl record for offensive futility with just 3 points, set a Super Bowl record by punting on eight consecutive drives, and punted on nine of their 12 possessions. Stephon Gilmore, the guy who got Butler's cornerback contract last season, basically ended the Rams' hopes with a clutch interception at the Patriots' 4-yard line, going anti-Asante Samuel.

"Our defense played unbelievable," Rob Gronkowski said. "You got to give them credit. Without them we would have never won the game."

Just as they had to during a season of offensive inconsistency, the protean Patriots adjusted on the fly. The first play of their fateful fourth-quarter touchdown drive, an 18-yard play-action pass to Rob Gronkowski on which he faked blocking and then released down the sideline, was an ad-lib by offensive coordinator Josh McDaniels.

"We put that play in right there on the spot," Gronk said. "It was a great job, great throw by Tom and a great call by McDaniels."

The Patriots also trapped the Rams in their base personnel by going to two backs and two tight ends, or 22 personnel, but then employed an empty set passing formation out of it. They ran

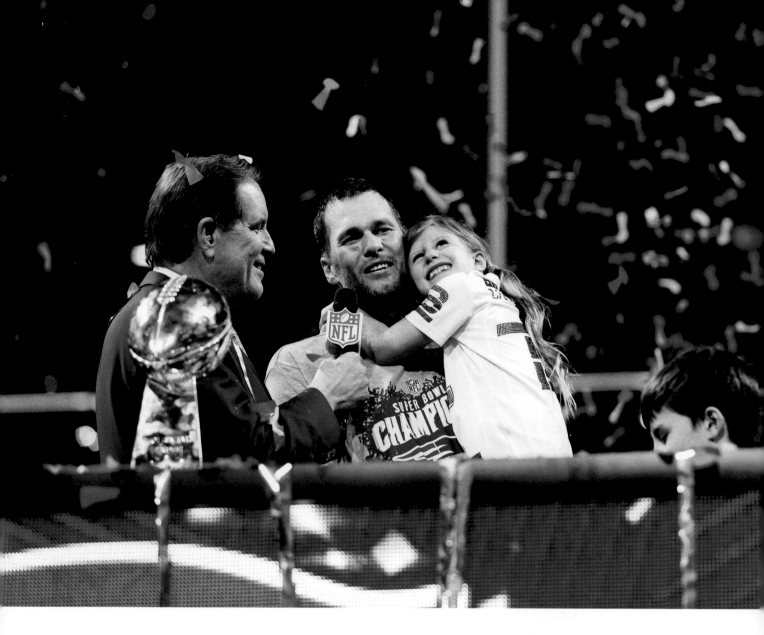

this formation three straight times for Brady completions, the last a 29-yarder to Gronkowski that set up the game's only touchdown.

The Patriots' entire season prepared them for the game they would have to play in Super Bowl LIII.

"It was the most satisfying year that I've ever been a part of," Gronkowski said. "How we came together, the obstacles we had to overcome, the grind from the beginning of training camp to now was just surreal. The obstacles, how we stuck together, it was life. We went through life this year.

"We figured it out. We found our identity. That was our identity — wear the other team out. We were not making big flashy plays all the time, once in awhile. We stuck together, grinded, ran the ball. It was unbelievable, now we're Super Bowl champs."

A team that wasn't good enough found a (Patriot) way to be the best team in football. ■

Two decades of unprecedented success for Tom Brady in New England came to an end following the conclusion of the 2019 NFL season.

'A LIFETIME FULL OF FUN MEMORIES'

After 20 Years and Six Super Bowl Rings, Tom Brady is Leaving the Patriots

By Ben Volin • March 17, 2020

Tom Brady didn't want to say where he will be playing football in 2020. But it won't be in New England.

Brady officially ended the drama around 8:45 a.m. Tuesday, posting a goodbye message to Patriots fans on his verified Twitter account. He didn't say where he will be playing, but multiple reports on Tuesday evening said Brady will soon sign with the Tampa Bay Buccaneers.

"Although my football journey will take place elsewhere, I appreciate everything that we have achieved and am grateful for our incredible TEAM accomplishments," he wrote. "I have been privileged to have had the opportunity to know each and everyone of you, and to have the memories we've created together."

Brady will officially become a free agent Wednesday. The Patriots and Brady agreed to part ways on Monday night, leaving the Bucs and the Los Angeles Chargers as Brady's top suitors. Both teams reportedly offered Brady a financial package worth around $30 million per season.

Brady will count $13.5 million against the Patriots' salary cap in 2020 as they search for his replacement. They have second-year quarterback Jarrett Stidham and journeyman Cody Kessler on the roster.

"I don't know what my football future holds, but it is time for me to open a new stage for my life and career," Brady wrote on social media. "I thank you from the bottom of my heart and I will always love you and what we have shared —

Six Super Bowl titles, three MVP awards, 14 Pro Bowls, and four Super Bowl MVPs later, Tom Brady's time with the Patriots came to a close.

a lifetime full of fun memories."

Brady's announcement marks the end of an incredible two-decade run in New England as part of the most accomplished dynasty in NFL history. Joining the Patriots as a sixth-round draft pick in 2000 — the 199th overall selection — Brady assumed the starting job in 2001 following an injury to Drew Bledsoe, and subsequently led the Patriots to nine Super Bowl appearances in his next 19 seasons, winning six. Both are records that may never be broken.

Patriots owner Robert Kraft said in January, shortly after the playoff loss to Tennessee, that his hope was for Brady to return to the Patriots or retire. He expressed some disappointment Tuesday.

"Tommy initiated contact last night and came over," Kraft told ESPN. "We had a positive, respectful discussion. It's not the way I want it to end, but I want him to do what is in his best personal interest. After 20 years with us, he has earned that right. I love him like a son."

One league source said the Patriots did make an offer to Brady for 2020, but that Brady didn't like it.

Kraft also released a statement on Tuesday.

"I had hoped this day would never come, but rather that Tom would end his remarkable career in a Patriots uniform after yet another Super Bowl championship," Kraft said. "Unfortunately, the two sides were unable to reach an agreement to allow that dream to become a reality. While sad today, the overwhelming feeling I have is appreciation for his countless contributions to our team and community."

Brady and coach Bill Belichick, who also joined the Patriots in 2000, took a woebegone franchise that had never won a championship to unprecedented heights. The Patriots were the most successful NFL organization in the 2000s and 2010s, winning three Super Bowls between 2001-04, and three more between 2014-18.

They were the first team to complete a 16-0 regular season. They made the playoffs in 17 of

Brady's 18 full seasons as the starter (he sat out almost all of 2008 with a knee injury) and won the AFC East 17 times.

Brady racked up individual accolades, as well: three MVP awards (2007, 2010, 2017), 14 Pro Bowls, four Super Bowl MVPs. He ranks second in NFL history behind Drew Brees in passing yards and touchdown passes.

"Tom was not just a player who bought into our program. He was one of its original creators. Tom lived and perpetuated our culture," Belichick said in a statement.

"Tom and I will always have a great relationship built on love, admiration, respect and appreciation. Tom's success as a player and his character as a person are exceptional.

"Nothing about the end of Tom's Patriots career changes how unfathomably spectacular it was. With his relentless competitiveness and longevity, he earned everyone's adoration and will be celebrated forever. It has been a privilege to coach Tom Brady for 20 years."

Under Belichick, the Patriots have been known as a team that trades away star players before they hit their decline. In January of 2018, team president Jonathan Kraft said that Brady would have say in when his Patriots career ended.

"I think Tom Brady's earned the right to have that be a decision he makes when wants to make it," Jonathan Kraft said then.

But there were cracks in the relationship the last few years, even as Brady and the Patriots continued to win. In a 2015 New York Times Magazine article, Brady's father predicted that "it will end badly . . . It's a cold business. And for as much as you want it to be familial, it isn't."

Those cracks deepened in recent years. Brady was upset that Kraft didn't fight harder on his behalf during the "Deflategate" controversy that resulted in a four-game suspension for Brady in 2016.

Brady also was upset that the Patriots played hardball with him on his contract the last few years, making him go year-to-year instead of

helping him achieve his stated goal of playing football until age 45.

Brady has been upset at various times — particularly in 2019 — when he regularly took below-market contracts and didn't believe the Patriots were spending enough money on the pieces around him.

And the divide deepened again in 2017 when Brady's training guru and business partner, Alex Guerrero, had his special privileges with the team revoked by Belichick.

Brady skipped offseason workouts with the team in 2018 and 2019. In a 2018 self-produced Facebook documentary "Tom vs. Time," Brady's wife, model Gisele Bundchen, said, "The last two years were very challenging for him in so many ways. He tells me 'I love it so much and I just want to go to work and feel appreciated and have fun.' "

Last year, while the Patriots were winning games but struggling on offense, Brady told NBC broadcaster Al Michaels that he was "the most miserable 8-0 quarterback in the NFL."

In August, Brady signed a new contract with the Patriots that automatically voided this month and guaranteed he would be a free agent for the first time in his career. He also put his Brookline house up for sale.

Brady's Patriots career ultimately ends with a whimper. First they lost at home in Week 17 to the lowly Dolphins to cost themselves a first-round bye. Then they lost at home to the Titans in the wild-card round, the first time since 2010 that they didn't reach at least the AFC Championship game. Brady's final pass as a Patriot was an interception that was returned for a touchdown by Titans cornerback Logan Ryan.

Relatively few quarterbacks last their entire career with one team. Joe Montana finished his career with the Chiefs. Brett Favre played for the Jets and Vikings. Johnny Unitas went to the Chargers, and Joe Namath to the Rams.

Now Brady can be added to the list if he plays in 2020. The Chargers and Buccaneers are both

reportedly offering Brady $30 million a year.

Julian Edelman, Brady's favorite receiver and close friend, begged Brady to stay this offseason, launching a #StayTom social media campaign.

Montana, Brady's boyhood idol, said in January, "Don't [leave] — if you don't have to. "It's not easy to go to another team and get accepted, no matter how much success you've had and how many years you've played."

Namath said in January, "It's almost beyond my belief that he would go to another team under any circumstances."

Former Steelers quarterback Terry Bradshaw said, "That would be one of the saddest moments in the NFL, to have its greatest player ever, greatest quarterback ever, to not finish it up in New England."

Kurt Warner, who played for the Giants and Cardinals after winning a Super Bowl with the Rams, said, "It's not always easy to change that culture and think it can be done overnight. I just think there's a lot to lose here if you're Tom Brady going somewhere else."

Charlie Weis, Brady's offensive coordinator from 2000-04, expressed sadness Tuesday.

"I felt that Tommy would finish up in New England," Weis told SiriusXM NFL. "I knew that he'd get offers for more money from other places. And I knew the dollar figures would be significant, probably $10 million a year different, at least.

"I have to tell you, I'm a little stunned. I really am." ∎

Tom Brady holds the Vince Lombardi trophy following winning Super Bowl LV in his first season with the Tampa Bay Buccaneers.

REVENGE TOUR FOR THE AGES

Tom Brady Captures Super Bowl Number Seven in Dominant Win

By Dan Shaughnessy • February 7, 2021

The same age as president-elect JFK, older than Elvis lived to be, Camelot quarterback Tom Brady is still The King.

Brady, 43 years old, beat the defending world champion Kansas City Chiefs, 31-9, in Super Bowl 55 on Sunday night, capping the greatest individual sports story of this century.

After 20 seasons and six Super Bowl rings with the Patriots, Brady relocated to Tampa Bay in March and engineered the greatest revenge tour in football history. It took him a couple of months to get acclimated, but he got hot in December, then capped a playoff tour de force with three touchdown passes in one of the most-hyped matchups in the history of the Super Bowl.

It's Brady's seventh Super Bowl victory, more than any NFL franchise. He was named Super Bowl MVP for a record fifth time; John Elway is the only other quarterback to make five Super Bowl starts, period.

How does that taste, Bill Belichick? And what about you, Bob Kraft? Still think Brady wasn't worth a two-year contract after six Lombardis, nine conference championships, and 17 division titles?

Not to pile on here, but it has to be pointed out that Brady's touchdown passes against the Chiefs were thrown to Rob Gronkowski (two) and Antonio Brown, two more ex-Patriots. This could not have worked out better for Brady, or worse for the 7-9, non-playoff, Brady-less Pats. I was expecting a TD pass to Mookie Betts before the night was over.

With Brady matching up against KC young gun Patrick Mahomes, CBS billed the game as "the Super Bowl the universe has been waiting for." A tad

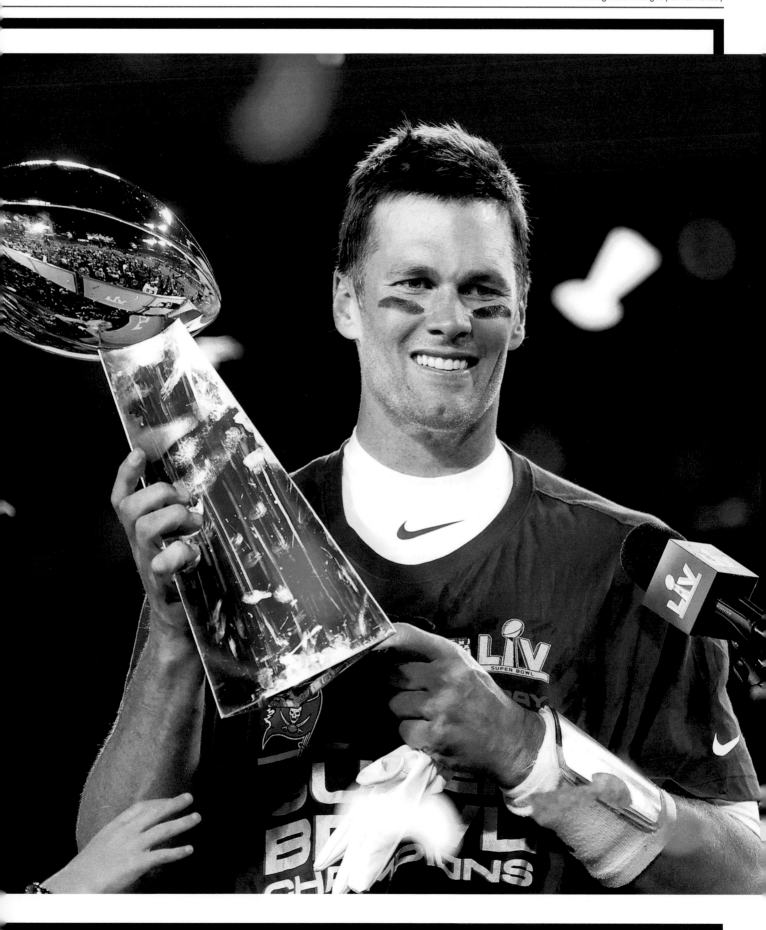

Tom Brady holds his daughter, Vivian Lake, while waving to fans during a celebration of Tampa Bay's Super Bowl LV win over the Chiefs.

lofty, perhaps, but there is no such thing as over-statement when you are talking about Tom Brady.

It was a regional mind-bender for Patriot Nation. In the lead-up to the game, The Wall Street Journal featured a page one story in which clinical psychologists and "breakup coaches" — did you know they existed? — speculated on the mindset of New England football fans who feel jilted by Tom.

Indeed, even though this game pitted teams from Tampa and Kansas City, Super Bowl 55 was all about us. Here in 2021, our doctors, lawyers, stockbrokers, and parents of little children were middle schoolers eating Super Bowl sheet cakes and raising foam fingers when 24-year-old Brady beat the heavily-favored Rams in Super Bowl XXXVI on Feb. 3, 2002.

Fast forward 19 years and Brady has stopped the clock. The bells do not toll for him. The Sunday New York Times put him on a par with freak carnival figures, like P.T. Barnum's bearded lady and four-legged girl: ". . . Brady, wearing a new costume, performs like a carnival act — Come see the ageless man! . . ."

The ageless one started slow Sunday but got a lot of help from the Chiefs and the zebras.

Tom was smothered on Tampa's first two possessions, which resulted in punts. And then, just as Jim Nantz and Tony Romo were telling the CBS audience that Brady had never led his team to a first-quarter touchdown in a Super Bowl, Brady drove the Bucs downfield and threw an 8-yard TD pass to Gronk for a 7-3 lead in the final minute.

It was the 13th time Brady and Gronk combined for a TD in the playoffs, a new NFL record. The biggest play of the drive was a 16-yard Brady completion to the nefarious AB, who played one game for New England in 2019.

As soon as Gronk spiked the ball, you could see the blood drain from the faces of the Chiefs. They started to do all of the stupid things teams always did against Brady and the Patriots: Mindless penalties, bad punts, missed opportunities, poor clock management.

Smelling blood, Brady went to work. His first drive after the touchdown stalled at the KC 1, but then he got a short field, taking over on the Chiefs 38 after a penalty and a hideous punt. Owed to his surprisingly great defense, the short field was Brady's best friend in this year's playoffs.

As usual, Tom got a big break when an interception was called back because of a hold that had nothing to do with the play. He got another when one of the Chiefs lined up in the neutral zone to keep a Tampa drive alive. It was like almost every Patriot game the last 20 years.

Brady's second touchdown pass to Gronk was a 17-yard bullet which made it 14-3 with six minutes left in the half. The Chiefs were called for holding again, but it was a moot point. Another flurry of flags and KC's silly timeouts put Brady and the Bucs back in the red zone in the final minute. The strike to AB made it 21-6. Brady completed 16 of 20 passes in the first half.

The Chiefs were penalized eight times for 95 yards in the first half, and 11 for 120 yards overall. Ted Wells should have been sent downstairs to investigate at intermission.

It was pure coronation in the second half as Tampa Bay's defense stuffed Mahomes and kept giving Brady great field position.

This marked Brady's first Super Bowl blowout. Seven of his nine with the Pats were decided by six points or less. The biggest differential of Brady's nine New England Super Bowls was 10 — the 13-3 win over the Rams two years ago.

That game was played at the domed Mercedes-Benz Stadium in Atlanta, and when the confetti fell on Brady's handsome head after the win, we thought he'd be a Patriot forever. We also thought that might be his last Lombardi trophy.

Neither notion was true. After one more season, Brady was done with the Patriots, but he was not done winning championships. He was not done throwing touchdown passes to Gronk and Antonio Brown.

Take it away, Bob Lobel.

"Why can't we get players like that?" ■

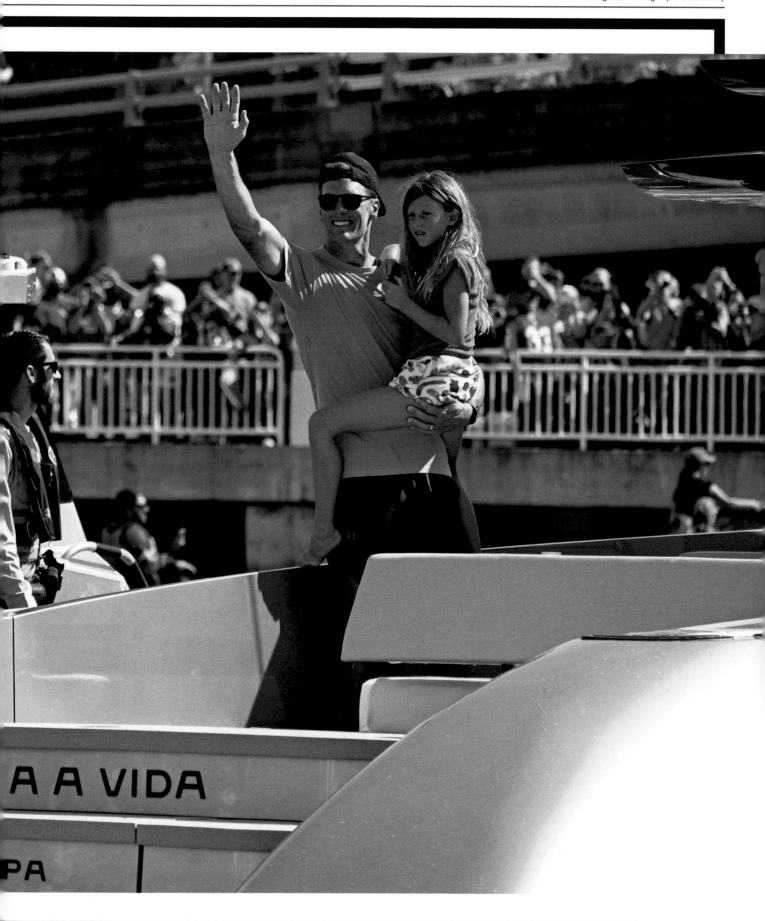

A A VIDA

PA

Tom Brady prepares to take the field for an emotional homecoming to Foxborough to face his former team.

HOMECOMING

Inside Tom Brady's Emotional Return to Foxborough

By Nicole Yang • October 4, 2021

Close to an hour after Tom Brady kneeled to run out the clock in the final seconds of the fourth quarter Sunday night, the 44-year-old quarterback freshened up inside the visiting team's locker room at Gillette Stadium and prepared to speak to the media.

Tampa Bay Buccaneers coach Bruce Arians, wide receiver Antonio Brown, outside linebacker Joe Tryon-Shoyinka, and kicker Ryan Succop each had already fielded questions following their team's 19-17 victory over the Patriots.

After Succop delivered a heartfelt answer about the close relationship he shares with Patriots kicker Nick Folk, who missed a potentially game-winning field goal from 56 yards with 59 seconds left, a Buccaneers official announced that Brady would be the next player at the podium.

But in came linebacker Devin White and then running back Leonard Fournette. Once Fournette left, another 10 or so minutes passed before a staffer announced there was "an unexpected delay" in Brady's arrival.

So, what was the holdup?

Coach Bill Belichick, after completing his own media responsibilities for the evening, had entered the Buccaneers' locker room to have a private chat with his former quarterback.

The two men who won six Super Bowls during their 20 years together in New England had briefly embraced at midfield at the end of the game, when Belichick offered his quick congratulations and briskly walked away. But it turns out there was a reason for the brevity, as both knew they planned to chat again later. When the pair

Tom Brady put up pedestrian numbers against the Patriots, completing 22 of 43 passes for 269 yards, but came away with a 19-17 win.

reconnected, they talked for nearly 25 minutes.

Unsurprisingly, Brady declined to elaborate on the conversation. "All those are personal," he said. "We've had a lot of personal conversations that should remain that way and are very private."

While reports indicate the relationship between Brady and Belichick soured ahead of their split, both parties have repeatedly denied accounts of escalating turmoil. Brady took a moment Sunday night to reiterate his perspective.

"So much is made of our relationship," he said. "But nothing is really accurate that I ever see. It's all kind of — it definitely doesn't come from my personal feelings or beliefs. I have a lot of respect for [Bill] as a coach and, obviously, a lot of respect for this organization and all the different people here that try to make it successful."

The extended meeting with Belichick capped an eventful, emotional 36 hours for Brady, who made his return to Gillette Stadium for the first time since signing with the Buccaneers as a free agent more than a season ago.

The festivities started Saturday night at the Omni Hotel in Providence, where a group of fans stationed themselves outside to greet Brady upon arrival. The Buccaneers landed at Rhode Island T.F. Green International Airport around 7:45 p.m. and then made the 20-minute drive to the team's hotel via bus and police escort.

"Brady! Brady! Brady!" fans chanted as the quarterback entered the lobby.

A warm recep tion seemed to find Brady at every turn.

When the Buccaneers arrived at the stadium around 5 p.m. Sunday evening, a horde of ticketholders staked out the visiting team's drop-off location. As Brady deboarded one of the buses, he once again was greeted with whistles and cheers.

"He probably doesn't know where the visitors' locker room is," one fan cracked.

Brady, dressed casually in black jacket over a hoodie with his last name across the chest, sure enough found his way there. Patriots owner Robert

Kraft made a point to say hello, as the two shared a hug and exchanged pleasantries for a few minutes in the tunnel.

Then, about an hour before kickoff, the "Brady! Brady! Brady!" chants returned, this time from inside the stadium. A throng of fans, despite the increasingly heavy rain, filled a fenced-off area near the visiting team's tunnel and unabashedly showed their support.

Brady's No. 12 jerseys of all iterations were spotted throughout the stadium. Most repped the Patriots, while a handful even sported split jerseys with both teams. Also spotted in the crowd were folks wearing Brady's No. 10 Michigan jerseys and TB12-branded merchandise.

Others brought signs, including one that read, "God, Family, Brady," with a red heart and another that featured Brady's head photoshopped onto the body of Jesus.

The Brady mania infiltrated the "Mac Attack Corner," a section in the lower bowl that had been dedicated to cheering for Patriots rookie quarterback (and Brady's successor) Mac Jones. On Sunday, however, their banner hung perpendicular to one that read, "Brady's Corner #12."

"It was awesome," Brady said of the overwhelmingly friendly welcome.

Once the game kicked off, the crowd's allegiances shifted a bit. Fans booed when the Buccaneers took the field for their opening drive — and again whenever the referees made a call in Tampa Bay's favor. Many in the lower bowl stayed on their feet for the duration of the game, making their presence known at every opportunity.

The Patriots and Buccaneers did their best to simmer the hype surrounding Sunday's matchup. In the first quarter, when Brady surpassed Drew Brees to set the record for most career passing yards in NFL history, the moment was barely acknowledged.

"I didn't even know he broke the record," Fournette said. "I'm not going to lie."

Brady said he felt normal during the game

The trademark intensity of Tom Brady was on full display in a familiar setting at Foxborough, just in an unfamiliar Tampa Bay uniform.

("He's always poised, it's hard to get into his head," Brown said), but there were moments where Brady's emotions surfaced.

In the second quarter, he did not appreciate when outside linebacker Matt Judon sacked him for a loss of 8 yards and lingered on the tackle. Early in the fourth quarter, when Brady scrambled to convert on a third and 6 to keep Tampa's drive alive at its 42-yard line, he couldn't help but smile. Two plays later, when the Buccaneers had to burn their first timeout of the half, he furiously butted his hands together.

Brady was also uncharacteristically inaccurate, completing just 51.2 percent of his passes. In the first half, he recorded 10 off-target throws, which already exceeded his season-high.

But the final image for Brady was one of rejoice.

After Folk missed his 56-yard attempt that sealed Tampa's victory, Brady clutched offensive coordinator Byron Leftwich in celebration.

"I think it's very, very special for him," Arians said. "You know, he kept it inside all week and he's probably letting it out right now."

The smiles and hugs continued after the game. At midfield, Brady greeted a number of former teammates and coaches, starting with linebacker Kyle Van Noy, safety Devin McCourty, center David Andrews, quarterback Brian Hoyer, special teamer Matthew Slater, wide receivers coach Troy Brown, and offensive coordinator Josh McDaniels.

"There is a whole crew," Brady said. "These are the people that I've shared my life with. I'm very grateful for everything they've kind of contributed to my life. Very blessed."

The "Brady! Brady! Brady!" chants from fans returned one last time when he ran off the field and into the locker room.

After Brady finished speaking to the media, he began to make his way out, with the record-setting football and a 64-ounce stainless steel water bottle tucked in his camo duffel bag. En route, he stopped for a couple of last hugs, including one with longtime Patriots videographer Jimmy Dee.

Around 1 a.m., Brady ducked behind a black curtain to the team buses. Trainer and business partner Alex Guerrero trailed right behind him.

Might Sunday mark the last time Brady visits Gillette? He hinted that won't be the case.

"I don't know what the future holds," he said. "Obviously, there could be an opportunity to come back here. We'll see. I feel like I'll always be a part of this community. I'll be up here quite a bit when it's all said and done." ■

THE TOP OF THE MOUNTAIN

Tom Brady Goes Down as the Greatest Athlete in the Storied History of Boston Sports

By Dan Shaughnessy • February 1, 2022

Old-timers (like myself) still carry a torch for the celebrated likes of Bill Russell, Ted Williams, and Bobby Orr. But the truth is that Tom Brady clinched the trophy three years ago when he won his sixth Super Bowl for the Patriots at the age of 41.

Brady, who announced his retirement Tuesday morning, goes down as the greatest athlete in the long, storied history of Boston sports.

Russell forever will be our most prodigious winner: 11 championships in 13 seasons. Teddy Ballgame was the greatest hitter who ever lived. Orr is the best to ever lace up skates.

But Tom Brady is Boston's Zeus ... A-No. 1 ... Top of the List ... King of the Hill ... Capo di Tutti Capi of all who played sports for New England teams.

When the first reports (only slightly premature) of Brady hanging up his cleats broke Saturday afternoon in the middle of a major New England blizzard, a 32-year-old Boston sports lifer from Saugus named Jared Carrabis tweeted, "David Ortiz got voted into the Baseball Hall of Fame and Tom Brady retired from the NFL within four days of each other. That officially closes the book on my childhood."

Brady was the best player in the most important sport of the 21st century, and his career framed the fan experience in Boston in the new millennium. New England was in a 16-year cham-

pionship drought when Brady & Co. pulled off a Super Bowl upset for the ages in New Orleans 20 years ago.

That victory broke the dam and kick-started a championship surge never seen in any other American city. New England's teams won 12 titles between 2002 and 2019, bookended by Brady's first and last for the Patriots. In a stretch of six years and four months, the Patriots, Red Sox, Celtics, and Bruins all won championships. No American municipality had ever experienced anything like it. The feat is unlikely to ever be matched.

Carrabis, who grew up to be a media star at Barstool Sports, represents a generation of young, spoiled New England fans who came of age when Brady and Bill Belichick got things going in Foxborough. I have three adult children who were born in the 1980s (I remember a pack of middle schoolers running around the neighborhood in boxer shorts on a cold February evening after Adam Vinatieri split the uprights in the Superdome) and I spent considerable time reminding them it wasn't always like this around here.

The 21st century is the High Renaissance of Boston sports, and Brady was our Michelangelo. He changed our image and our expectations as we went from Loserville to Title Town.

After what Brady and Friends did to the Rams in Super Bowl XXXVI, we came to expect sudden victory instead of crushing, last-second defeat. Tom Brady paved the way for the Red Sox miracle of 2004, for Kevin Garnett & Co. showing us that "anything's possible," and for Tim Thomas standing on his head in Vancouver in 2011.

In an era of salary caps and commissioner-driven parity, Brady drove the bus for two Patriot dynasties: three Super Bowl championships in four years between 2002 and 2005, then three more Super Bowl wins and four appearances over five seasons from 2015-19.

As a Patriot, Brady appeared in nine Super Bowls, and won 16 division titles, 30 of 41 playoff games, and three league MVPs. And that's without even getting into his post-Patriot career, when he won another Super Bowl and almost won an MVP at the age of 44.

Brady won his last Patriot championship 17 years after his first one. He won in a century when pro football was far more popular than any other sport. He became the greatest football player of all time playing for a Patriot team that emerged as more popular than the Bruins, Celtics, or Red Sox ever were.

And now it's over. Tom Brady has met the death that awaits all athletes. He has decided to retire from football.

His numbers speak for themselves.

Boston's other sports gods speak for Brady.

"Boston's had a lot of great ones," Carl Yastrzemski told me in 2018. "Larry, Ted, Russell, Bobby Orr. Don't forget Big Papi. But right now, because of all the Super Bowls that he's won, I've got to go with Tom Brady. Without a doubt."

"You could feel it when the Patriots were behind [28-3] in the Super Bowl," Orr said. "You just knew it wasn't over. Look at the last drives, and Tommy executes them. I think Bill Belichick's a genius, but Brady's the guy that steers it and runs the ship."

Orr added that same year, "Tommy will go down as the greatest athlete in Boston history. Look at what he has done. It's just unbelievable. There is no argument."

Who are we to argue with No. 4? ∎

Tom Brady rode off into the sunset for good following the 2022 season, completing an unparalleled 23 years of elite football in the NFL.

'I WOULDN'T CHANGE A THING'

An Emotional Tom Brady Bids Farewell to the NFL — 'For Good' This Time

By Ben Volin • February 1, 2023

With a sense of self-awareness and a slight quiver in his voice, Tom Brady announced his retirement from the NFL Wednesday morning in a 51-second video posted to social media.

The announcement came a year to the day after Brady first retired, a career move that lasted only 40 days as he ultimately returned to the Buccaneers for his 23rd NFL season — three with Tampa Bay and 20 with the Patriots.

This time, though, is "for good," Brady said in a brief but emotional video shot on the beach after sunrise. Brady also posted to his Instagram account a collection of photos from his early days as a backup in Foxborough through his final years with the Buccaneers.

It was a marked difference from his first retirement, which included a leaked report two days earlier and a lengthy letter from Brady that caused commotion locally by not mentioning the Patriots.

"I won't be long-winded," Brady said this time. "You only get one super-emotional retirement essay, and I used mine up last year, so I really thank you guys so much, to every single one of you for supporting me — my family, my friends, teammates, my competitors. I could go on forever, there's too many. Thank you guys for allowing me to live my absolute dream. I wouldn't change a thing. Love you all."

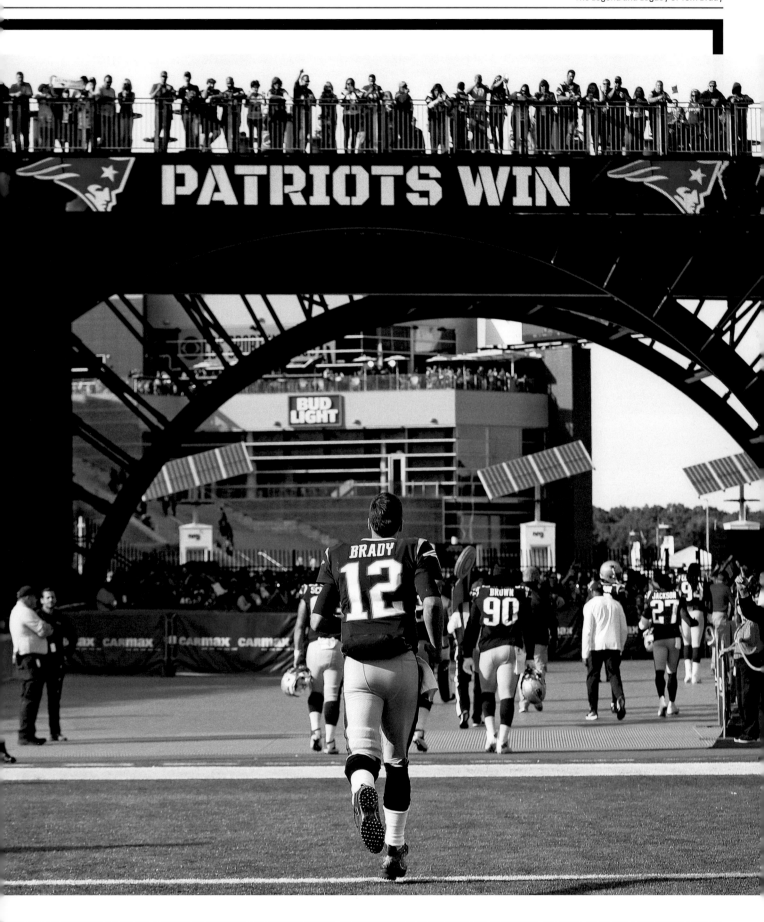

Brady didn't state his reasons for retiring, and his announcement seemed to take many across the NFL by surprise. Though he was 45 — the oldest quarterback to start a game in the NFL — Brady still played relatively well in 2022 and looked to have several options to play again in 2023, whether it be with the Buccaneers, 49ers, Raiders, Jets or another team.

His father, Tom Brady Sr., said by phone Wednesday that his son told him about a week ago that he would be retiring.

"We're not shocked by any means," Brady Sr. said from the family's home in northern California. "He has played football for 32 years out of his 45, living his dream for three-fourths of his life. It's been a wonderful ride. He's very secure in his decision. It's about time."

For many observers, Brady's retirement won't be official until the 2023 NFL season kicks off in September. When Brady announced his retirement on Feb. 1 last year, it was just the beginning of a complex plan to join the Dolphins front office as an executive and limited owner, with the possibility of un-retiring to play quarterback for them.

Those plans were scuttled when Brian Flores filed an employment lawsuit against the Dolphins just hours after Brady's announcement. Brady ultimately came out of retirement March 13 to return with the Buccaneers.

But his 2022 season was a tumultuous one, and his frustrations were visible.

Injuries and coaching issues led to the Buccaneers having the 25th-ranked scoring offense and to Brady having the first losing season of his career (8-9).

Off the field, Brady's marriage to supermodel Gisele Bundchen ended in divorce after 13 years, and he took multiple extended absences from the Buccaneers to deal with it.

"This has been a hard year," Brady Sr. said. "I'm really happy for Tommy from the standpoint that he's going to be able to spend more time with his kids. He's going out on his own terms, and he's in good health. He's taken a lot of hits over the years — a lot of sacks, a lot of knockdowns. I am thrilled that he won't get knocked down again."

Tampa Bay quarterbacks coach Clyde Christensen, who retired last week, told the Tampa Bay Times that Brady lost 15 pounds during the season.

"To watch Tom have to leave training camp for 11 days to take care of some personal problems, it was heartbreaking stuff," Christensen said. "I have an unbelievable respect for what Tom did this year. Off-the-charts amount of respect for him just managing things."

After the Buccaneers were knocked out of the playoffs by the Cowboys last month, Brady was asked on his podcast by radio host Jim Gray about his plans.

"If I knew what I was going to [expletive] do I would've already [expletive] done it," he told Gray. "I'm taking it a day at a time."

While many believe Brady can still be a good — if not great — quarterback, he walks away with nothing to prove. He accomplished his stated goal of playing until he was 45. And after 21 full seasons as a starter — he was a backup in his 2000 rookie season and missed practically the entire 2008 season with a torn ACL — Brady owns just about every quarterback record in NFL history.

He has the most Super Bowl wins (seven) and appearances (10). He has the most wins in the regular season (251) and postseason (35). He owns the records for pass attempts, completions, yards, and touchdowns. Brady won three MVPs, won five Super Bowl MVPs, was named to 15 Pro Bowls, and was named to the NFL's All-Decade Team for the 2000s and 2010s. He won Comeback Player of the Year in 2009.

He was remarkably durable, missing only those 15 games in '08 because of his knee and four games in 2016 to serve a suspension for his role in the "Deflategate" episode. Even in 2022, one of his worst statistical seasons of his career, Brady set NFL records for pass attempts (733) and completions (490).

Beyond the numbers, Brady authored an improbable career worthy of Hollywood, and led the Patriots to a 20-year dynasty that is unrivaled in the NFL.

Legend has it that Brady, a sixth-round pick out of Michigan in 2000 (No. 199 overall), told Patriots owner Robert Kraft in his rookie training camp, "I'm the best decision this organization has ever made."

It proved prophetic. Brady began his career as the fourth-string quarterback, became a starter only after a devastating injury to Drew Bledsoe, and by the end of his second season was a Super Bowl champion and international sensation.

"I am so proud of Tommy. He has accomplished everything there is to achieve in this game, and so much more," Patriots owner Robert Kraft said in a statement released by the team. "No player in NFL history has done it as well for as long as Tom Brady. He is the fiercest competitor I have ever known and the ultimate champion.

"He led the Patriots to two decades of unprecedented dominance. He is truly the greatest of all time. Words cannot adequately express the gratitude my family, the New England Patriots and our fans have for everything he has done.

"It's been a blessing for me to watch him grow, first as a young professional on the field, but most importantly, as a person off it. He is one of the most loving, caring and passionate players I have ever known and I will always consider him a part of our family."

Brady won three Super Bowls in his first four seasons as a starter to cement himself in NFL lore, but he was only getting started. In 2007 came the first 16-0 regular season in NFL history. Brady led a second wave of Patriots championships with three more Super Bowl victories (plus a loss) from 2014-18.

Patriots coach Bill Belichick also released a statement through the team: "Tom Brady was the ultimate winner. He entered the NFL with little to no fanfare and leaves as the most successful player in league history. His relentless pursuit of excellence drove him on a daily basis. His work ethic and desire to win were both motivational and inspirational to teammates and coaches alike.

"Tom was a true professional who carried himself with class and integrity throughout his career. I thank Tom for the positive impact he had on me and on the Patriots and congratulate him on his amazing career."

In his final years, Brady's rigorous training methods helped him break barriers for aging athletes. He had more playoff wins after turning 37 (17) than any other quarterback has over his entire career. He is the only quarterback to win a Super Bowl after age 40, and he won two. He started 112 games after turning 40, 85 more than anyone else.

In his final act of greatness, Brady left New England in 2020 for Tampa Bay, the NFL's losingest organization, and promptly won his seventh Super Bowl.

"Tom's impact on our franchise these past three years has been immense and we are appreciative of the time we had with him," the Buccaneers owners said in a statement. "He set an exceptional standard that elevated our entire organization to new heights and created some of the most iconic moments in our history."

Brady did not announce what he has planned next, but he has many options. He has a standing deal with Fox Sports to be its lead NFL commentator, a deal reportedly worth $375 million over 10 years, and he could be part of the network's Super Bowl coverage next week in Arizona.

Brady has several business ventures, including TB12 fitness, Brady Brand clothing, autograph.io NFTs, and a production company called Religion of Sports.

Assuming he stays retired, Brady will be eligible for the Pro Football Hall of Fame Class of 2028.

By retiring, Brady is saying goodbye to his childhood dream of playing for the 49ers, who need a quarterback in the aftermath of Brock Purdy's serious elbow injury.

Brady Sr. said he expects his son to live in South Florida and be near his family there.

"We would've enjoyed him playing in San Francisco, but we're much happier with his decision doing this than playing for the 49ers," Brady Sr. said. "I'm just so proud of the guy. He's a heck of a good guy. That's a father talking, but I firmly believe there's no father who has been given a better son than I have. It's been a wonderful ride." ■

Although Tom Brady moved on from the Patriots in 2020 and initially retired in 2022, the timing of his retirement in early 2023 had a sense of finality to it.

THIS TIME, WE BELIEVE HIM

Tom Brady is Done, and the Moment is Right

By Dan Shaughnessy • February 1, 2023

Tom Brady has retired.

Again.

This time, for sure.

I know we went through this last year. And then Tom un-retired 40 days after he retired. He came back and played another season, and we know there are still plenty of owners and coaches who would hire Brady to come back from this retirement.

But this time I believe him. That short, stunning Twitter video that interrupted our breakfast Wednesday looked genuine. Sincere. Heartfelt. Tom presented as a gaunt superstar in distress, resolving a midlife crisis that's been eating at him while he has stopped eating. Tom looked very much like a man who needs to shut it down.

It troubles me that Brady chose to retire on the same date, in the same manner, two years in a row. Last year it was Tuesday morning, Feb. 1. This year it was Wednesday morning, Feb. 1. Could this be some weird, day-before-Groundhog Day punking?

No.

I believe him this time. There is not going to be another Sinatra-esque, Brett Favre-like "one more time!" coming from the Brady camp between now and the start of the 2023 NFL season. In the spirit of Tom and "Tommy," we won't get fooled again.

Brady is really done. And it won't surprise me if he winds up being part of Fox's Super Bowl coverage for the Chiefs-Eagles game a week from

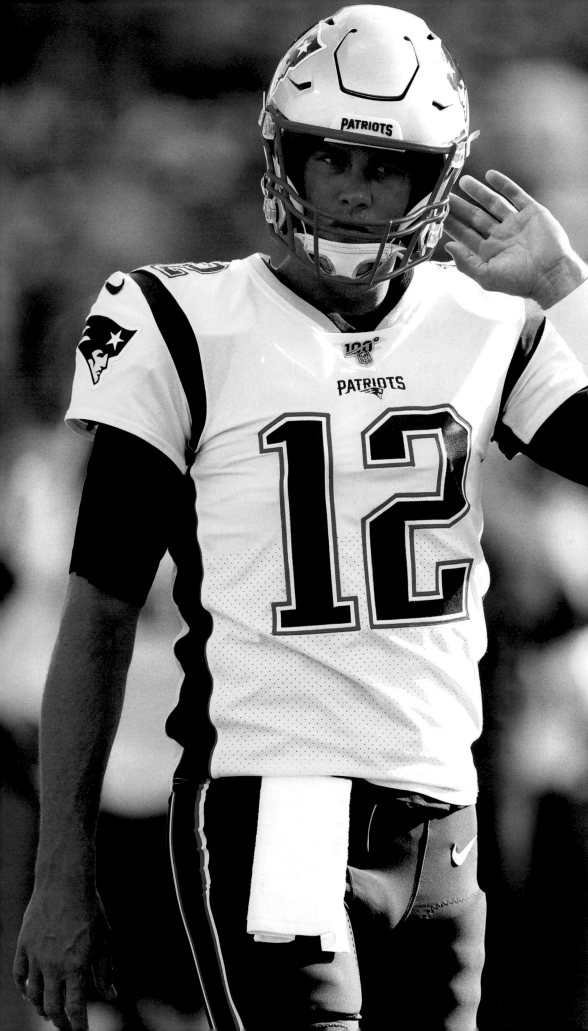

The joy that Tom Brady and the Patriots brought fans for 20 years will be hard to replicate, but always appreciated by the dedicated fan base.

Sunday. Tom has a billion-dollar contract with Fox, so why not step into that new role when he has so much to say?

He knows what it's like to beat Patrick Mahomes in an AFC Championship game. He knows what it's like to face Andy Reid in a Super Bowl, and he knows what it's like to lose a Super Bowl to the Eagles. Maybe an appearance in the booth will bring home the reality that Brady is finally done playing.

There is no reason for him to do any more on the field.

We all thought he was crazy when he said he was going to play until he was 45. And then he went out and did it.

He left New England abruptly at the beginning of a pandemic that is still going and went to Tampa, where he carried the losingest franchise in pro sports history to a Super Bowl victory in his very first season.

That should have been the end right there. Instead, we got two years of petulance and broken tablets. Brady made faces at teammates, got his coach fired, took sabbaticals, and increasingly got rid of the ball too quickly to avoid getting hit. We saw him make sad playoff exits in his final two superfluous seasons.

Poor Tom chucked the ball 66 times in his final game, a bad playoff beating on "Monday Night Football" at the hands of the Cowboys. The sorry Bucs finished 8-10. It wasn't Willie Mays-in-the-1973-World Series-bad, but it was not the way we wanted to see Tom finish.

More riches and attention awaited if Brady wanted to enjoy 2023 courtships, but did he really want to end his career with the godforsaken New York Jets after establishing himself as the greatest quarterback of all time?

No. Why keep going? He could only get hurt or do more damage to an image that was pretty perfect in almost all the days when he won championships for the New England Patriots.

That's the Tom Brady we celebrate today.

Foxborough folks should get started on the statue at Patriot Place right now. We all know Tom is on the New England Mount Rushmore with Bill Russell, Ted Williams, and Bobby Orr. It can be argued that we had the greatest player ever in each of the four major American team sports.

Brady is the certified GOAT because of what he did here. He transformed a sketchy franchise that was ever-ready to be mocked into the NFL's most powerful and feared brand. Brady and Bill Belichick were the 21st century Russell and Red Auerbach, and New England was blessed to have him all those years. Together, Tom and Bill won six Super Bowls and went to three more.

I'll always wish it ended for Tom and Bill when they won that last one, the 13-3 grinder over the Rams in Atlanta in 2019. That was the last time it was really good for Tom and the Patriots.

After that, we watched the slow bleed toward the end of Brady's career.

And now it's really over.

In the words of John Updike, Brady has "met the little death that awaits all athletes."

And he's free to start living again. ∎

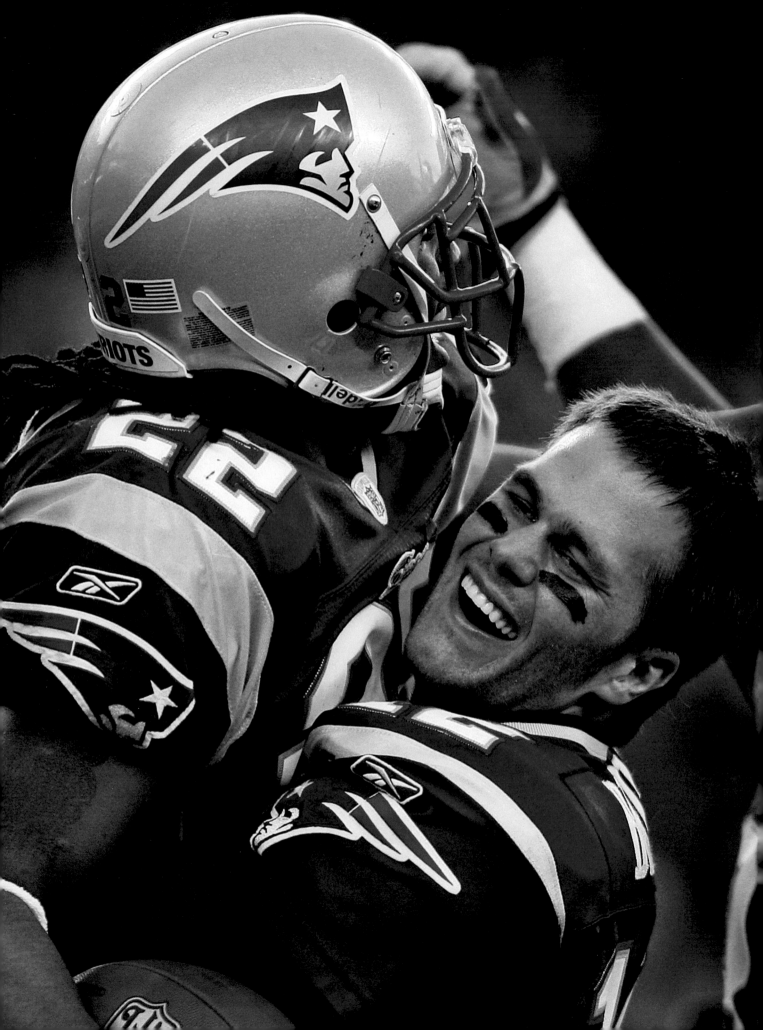

Tom Brady may have seemed larger than life at times, but he consistently made sacrifices for the team throughout his career and served as the ultimate team leader.

THE ULTIMATE TEAM PLAYER

Celebrate Tom Brady Not Just for Individual Achievement but for What He Meant to His Teams

By Tara Sullivan • February 1, 2023

There are retirements, and then there are seismic shifts to the NFL landscape.

There are announcements from athletes that are met with some fanfare and a few farewells, and then there are decisions that stop the league in its tracks.

There are careers that deserve to be honored for their accomplishments and glory, and then there are careers that demand everyone stop and take notice, honoring not just that solo journey of triumph but the collective impact it had on others.

Tom Brady had one of those careers.

And now, it's over. For real this time.

With a short yet clearly emotional video posted Wednesday morning, Brady confirmed that he is finally ready to leave the game, these few heartfelt words serving as a perfect replacement for last year's lengthy emotional essay that never actually included the word "retirement" and was retracted after six confusing weeks:

"Good morning, guys. I'll get to the point right away: I'm retiring. For good."

After a third season in Tampa, after 20 amazing years in New England, Brady made the call, walking away at age 45 just as he'd always told us he would.

"I know the process was a pretty big deal last time," he said, "so when I woke up this morning, I figured I'd just press 'record' and let you guys know first. It won't be long-winded. You

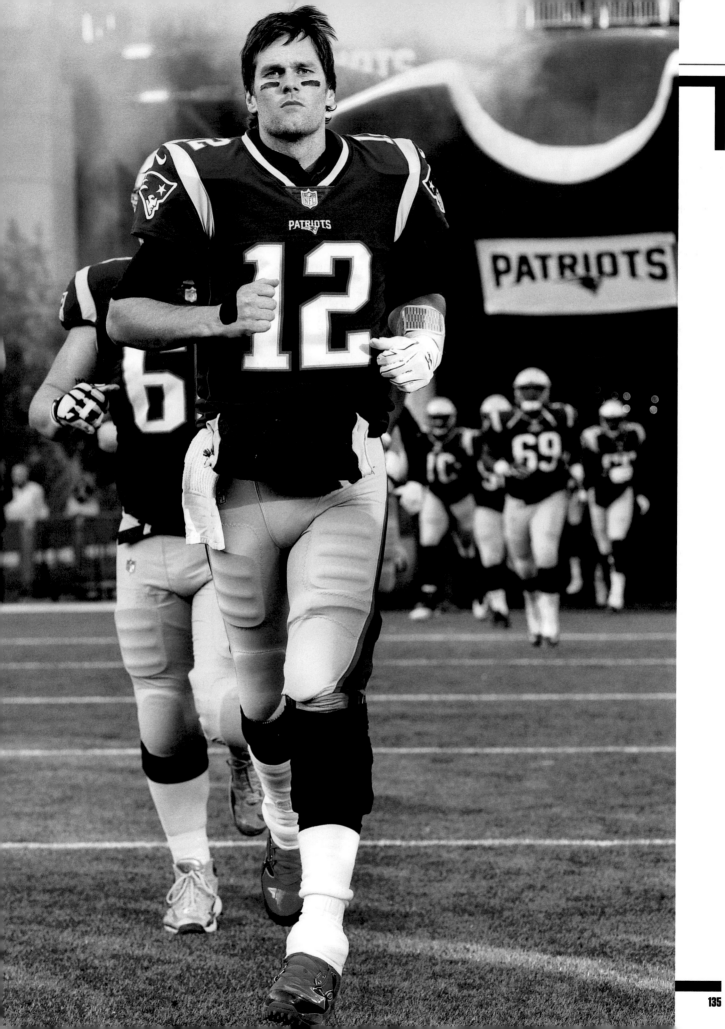

From humble beginnings to surprising early Super Bowl glory to two decades of excellence, Tom Brady's accomplishments are unlikely to ever be matched in the NFL.

only get one super emotional retirement essay, and I used mine up last year, so I really thank you guys so much, to every single one of you for supporting me."

With the wind blowing around him, Brady's voice thickened as he wrapped it up.

"My family, my friends, my teammates, my competitors, I could go on forever, there's too many. Thank you guys for allowing me to live my absolute dream, I wouldn't change a thing. Love you all."

He walks away as the best of all time, even if he wasn't always at his best this past season. But the occasional sideline tirades, the unfamiliar duck-and-cover throws, the sunken, tired eyes on a perpetually boyish face, all of it is forgotten now, eclipsed by the memories of one of the greatest NFL success stories of all time.

The 199th pick of the 2000 draft leaves a legacy defined not simply by seven Super Bowl titles, five Super Bowl MVP awards, three league MVP trophies, 15 Pro Bowl nods, and a pile of statistical records that no one will ever match.

In the ultimate team sport, Brady proved himself the ultimate team player, using his own approach and skill set to elevate those around him, never demanding from anyone what he wouldn't give himself, but never settling for less than what was necessary for success. In New England, pairing with a like-minded and similarly focused coach in Bill Belichick, the two of them set a standard that many have tried to emulate but none has ever replicated.

A few years back, when Brady was still with the Patriots and Tom Coughlin was general manager of the Jacksonville Jaguars, the teams combined for some training camp practices. Coughlin, who'd famously bested Brady in two Super Bowls with the Giants, couldn't help but marvel at Brady's unceasing effort.

During a two-minute drill, Brady threw a ball that didn't get out of bounds. The receiver did not get the ball back, but there was Brady, sprinting outside the numbers, grabbing the ball, sprinting back to the huddle, setting the ball down, and clocking it.

"If you're standing there watching it as a receiver, you just got the greatest lesson of all time," Coughlin told me last year, after the initial Brady retirement. "To me, what the man brings to the table, I will say he's the greatest of all time, but that's not what I talk about. To me he is the greatest person to set the expectation level of the entire franchise at the highest level you can imagine.

"When a player was drafted by the New England Patriots or was a free agent and went to the New England Patriots, they knew when they stepped into that building that the level of expectation for championships is through the roof because this man demonstrated it year in and year out.

"His accomplishments speak for themselves, and you can take all the stats to call him the greatest of all time. But he's the greatest of all time for me because of what he brought to the building. When he made the commitment, he made it 100 percent."

Football has always separated itself from its sporting brethren because of its game-planning challenge, because its outcomes can be decided as much by what is done in the run-up to the game as in the game itself. What goes on in the mind can be as vital to success as what can be done with the body. Brady was his generation's biggest game-planning challenge, daring opponents to outsmart him, demanding teammates keep up with him.

We've seen the last of it now, the thrilling fourth-quarter comebacks, the methodical, back-breaking drives, the quick dump-offs in the flat or the soaring, full-flighted throws downfield.

What a ride. The best one ever. ∎

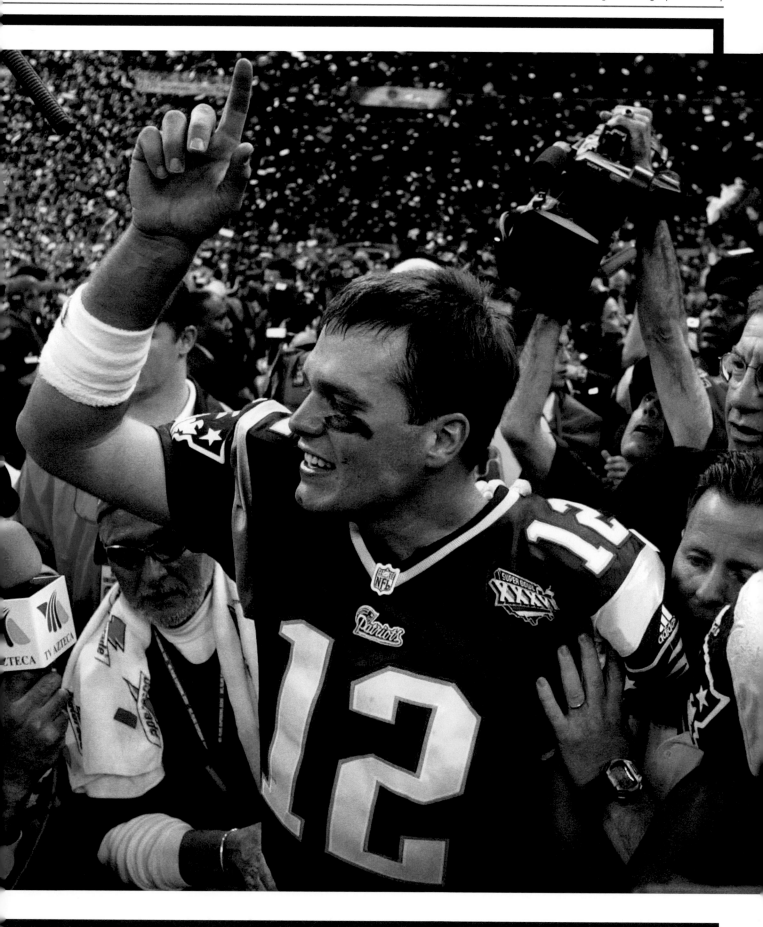

Tom Brady set the bar high with his regular season passing yards record, one that will be tough to catch even in the modern passing era of the NFL.

TOM BRADY'S RECORD-BREAKING NFL CAREER, BY THE NUMBERS

By John Hancock, Daigo Fujiwara and Ryan Huddle • February 1, 2023

Tom Brady's on-field success looms large in the annals of NFL history. And even though he's says he's now retired from the league "for good," the records he set will be incredibly difficult to eclipse. His 737 total touchdown passes are 129 more than No. 2 Drew Brees. His 35 postseason wins are more than double No. 2 Joe Montana's 16. Brady by himself has won more playoff games as a starting quarterback than 27 of the NFL's 32 franchises. Below, view some of the Patriots great's numbers and records, many of which could stand the test of time.

Brady's passing dominance

Any way you slice it, Brady is miles ahead of other quarterbacks when it comes to the passing game — and he was especially dominant during playoff runs, with nearly double the playoff passing yards of Peyton Manning.

NFL ALL-TIME LEADERS: REGULAR SEASON PASSING YARDS

Player	Regular season passing yards	Years	Team(s)
Tom Brady	89,214	2000-2022	New England, Tampa Bay (2)
Drew Brees	80,358	2001-2020	San Diego, New Orleans (2)
Peyton Manning	71,940	1998-2015	Indianapolis, Denver (2)
Brett Favre	71,838	1991-2010	Atlanta, Green Bay, NY Jets, Minnesota (4)
Ben Roethlisberger	64,088	2004-2021	Pittsburgh
Philip Rivers	63,440	2004-2020	San Diego/LA, Indianapolis (2)
Matt Ryan	62,792	2008-2022	Atlanta, Indianapolis (2)
Dan Marino	61,361	1983-1999	Miami
Aaron Rodgers	59,055	2005-2022	Green Bay
Eli Manning	57,023	2004-2019	NY Giants

Source: Pro-Football-Reference.com • As of Feb. 1, 2023

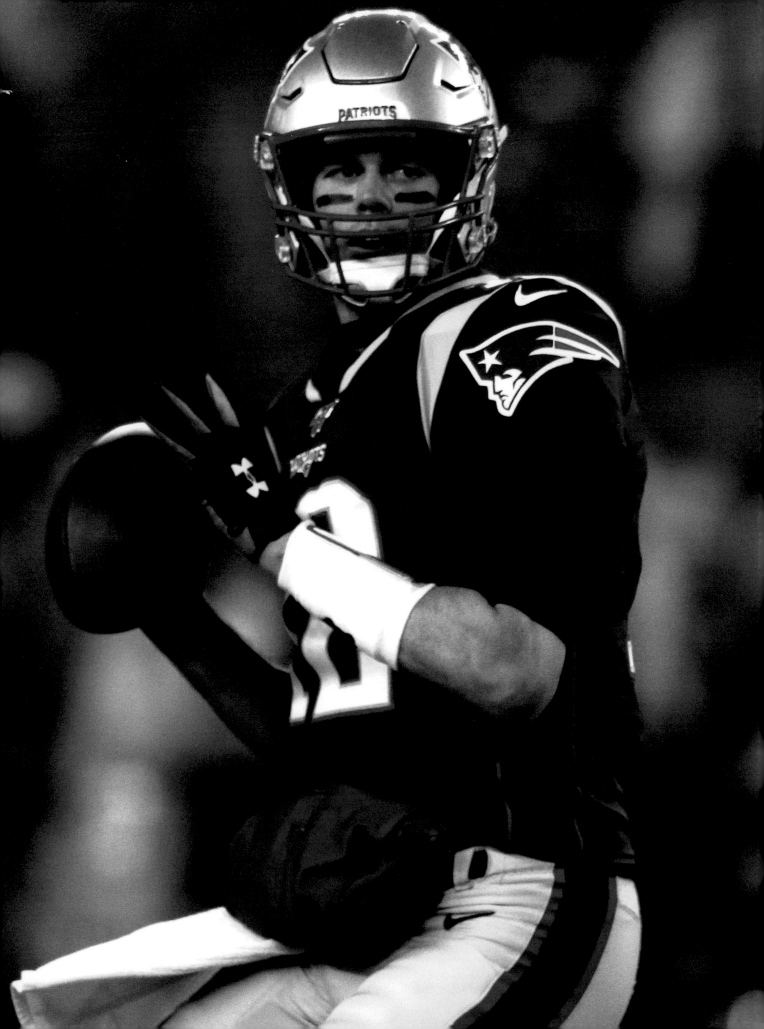

Tom Brady's postseason passing success is unprecedented both from stats and Super Bowls perspectives.

NFL ALL-TIME LEADERS: PLAYOFF PASSING YARDS

Rank	Player	Playoff passing yards	Years	Team(s)
1	Tom Brady	13,400	2000-2022	New England, Tampa Bay (2)
2	Peyton Manning	7339	1998-2015	Indianapolis, Denver (2)
3	Ben Roethlisberger	5972	2004-2021	Pittsburgh
4	Aaron Rodgers	5894	2005-2021	Green Bay
5	Brett Favre	5855	1991-2010	Atlanta, Green Bay, NY Jets, Minnesota (4)
6	Joe Montana	5772	1979-1994	San Francisco, Kansas City (2)
7	Drew Brees	5366	2001-2020	San Diego, New Orleans (2)
8	John Elway	4964	1983-1998	Denver
9	Dan Marino	4510	1983-1999	Miami
10	Kurt Warner	3952	1998-2009	St. Louis, Arizona (2)

Source: Pro-Football-Reference.com • As of Feb. 1, 2023

NFL ALL-TIME LEADERS: REGULAR SEASON TOUCHDOWN PASSES

Rank	Player	Regular season touchdown passes	Years	Teams
1	Tom Brady	649	2000-2022	New England, Tampa Bay (2)
2	Drew Brees	571	2001-2020	San Diego, New Orleans (2)
3	Peyton Manning	539	1998-2015	Indianapolis, Denver (2)
4	Brett Favre	508	1991-2010	Atlanta, Green Bay, NY Jets, Minnesota (4)
5	Aaron Rodgers	475	2005-2022	Green Bay
6	Philip Rivers	421	2004-2020	San Diego/LA, Indianapolis (2)
7	Dan Marino	420	1983-1999	Miami
8	Ben Roethlisberger	418	2004-2021	Pittsburgh
9	Matt Ryan	381	2008-2022	Atlanta, Indianapolis (2)
10	Eli Manning	366	2004-2019	NY Giants

Source: Pro-Football-Reference.com • As of Feb. 1, 2023

NFL ALL-TIME LEADERS: PLAYOFF TOUCHDOWN PASSES

Rank	Player	Playoff touchdown passes	Years	Teams
1	Tom Brady	88	2000-2022	New England, Tampa Bay (2)
2	Aaron Rodgers	45	2005-2022	Green Bay
2	Joe Montana	45	1979-1994	San Francisco, Kansas City (2)
4	Brett Favre	44	1991-2010	Atlanta, Green Bay, NY Jets, Minnesota (4)
5	Peyton Manning	40	1998-2015	Indianapolis, Denver (2)
6	Drew Brees	37	2001-2020	San Diego, New Orleans (2)
7	Ben Roethlisberger	36	2004-2021	Pittsburgh
8	Dan Marino	32	1983-1999	Miami
8	Patrick Mahomes*	32	2017-2022	Kansas City
9	Kurt Warner	31	1998-2009	St. Louis, Arizona (2)

Source: Pro-Football-Reference.com • As of Feb. 1, 2023. * Not including Superbowl LVII

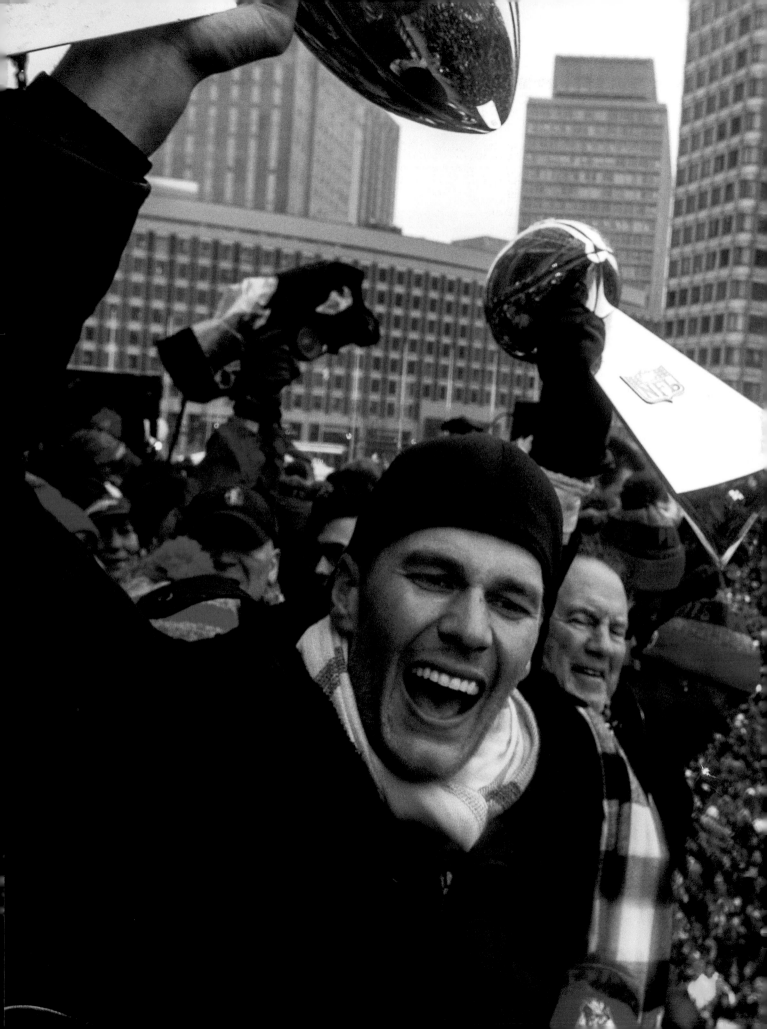

The legendary snow-covered, 16-13 overtime win by the Patriots over the Raiders in the 2002 playoffs was a sign of things to come for Tom Brady's playoff dominance.

TOM BRADY'S 14 CAREER 400-YEARD REGULAR SEASON PASSING GAMES

Team	Date	Win / Lose	Passing yards	Passes	Passing Att	Passing Cmp%
Patriots vs. Dolphins	9/12/11	W 38-24	517	32	48	66.67%
Patriots vs. Bills	9/20/15	W 40-32	466	38	59	64.41%
Patriots vs. Saints	9/17/17	W 36-20	447	30	39	76.92%
Patriots vs. 49ers	12/16/12	L 34-41	443	36	65	55.38%
Buccaneers vs. Panthers	1/1/23	W 30-24	432	34	45	75.60%
Buccaneers vs. Rams	9/26/21	L 24-34	432	41	55	74.55%
Patriots vs. Steelers	11/3/13	W 55-31	432	23	33	69.70%
Patriots vs. Chargers	9/18/11	W 35-21	423	31	40	77.50%
Patriots vs. Browns	12/8/13	W 27-26	418	32	52	61.54%
Buccaneers vs. Dolphins	10/10/21	W 45-17	411	30	41	73.17%
Buccaneers vs. Jets	1/2/22	W 28-24	410	34	50	68%
Patriots vs. Chiefs	9/22/02	W 41-38	410	39	54	72.22%
Patriots vs. Browns	10/9/16	W 33-13	406	28	40	70%
Patriots vs. Ravens	12/12/16	W 30-23	406	25	38	65.79%

Source: Pro football reference As of Feb. 1, 2023

Playoff supremacy

Brady will be perhaps best remembered for his seven Super Bowl wins and ability to lead his team on touchdown drives in critical playoff situations. His 14 postseason game-winning drives are unmatched.

NFL ALL-TIME LEADERS: SUPER BOWL WINS BY A QUARTERBACK

Rank	Wins	Player	Record	Team(s)	Super Bowl appearances
1	7	Tom Brady	7–3	New England, Tampa Bay	XXXVI, XXXVIII, XXXIX, XLII, XLVI, XLIX, LI, LII, LIII, LV
2	4	Terry Bradshaw	4–0	Pittsburgh	IX, X, XIII, XIV
2	4	Joe Montana	4–0	San Francisco	XVI, XIX, XXIII, XXIV
4	3	Troy Aikman	3–0	Dallas	XXVII, XXVIII, XXX
5	2	John Elway	2–3	Denver	XXI, XXII, XXIV, XXXII, XXXIII
5	2	Roger Staubach	2–2	Dallas	VI, X, XII, XIII
5	2	Peyton Manning	2–2	Indianapolis, Denver	XLI, XLIV, XLVIII, 50
5	2	Bob Griese	2–1	Miami	VI, VII, VIII
5	2	Ben Roethlisberger	2–1	Pittsburgh	XL, XLIII, XLV
5	2	Bart Starr	2–0	Green Bay	I, II
5	2	Jim Plunkett	2–0	Oakland/Los Angeles	XV, XVIII
5	2	Eli Manning	2–0	NY Giants	XLII, XLVI

Source: Pro-Football-Reference.com

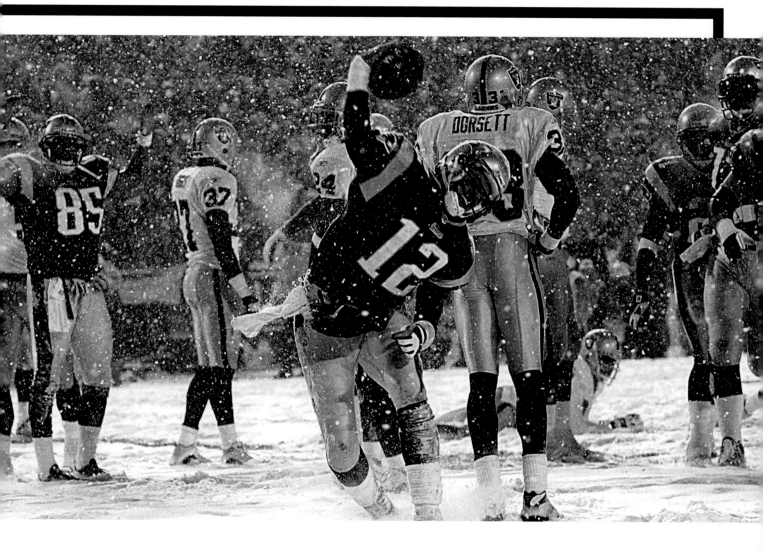

NFL ALL-TIME LEADERS: GAME-WINNING POSTSEASON DRIVES

Rank	Player	Game-winning drives in postseason	Years	Teams
1	Tom Brady	14	2000-2021	New England, Tampa Bay (2)
2	John Elway	6	1983-1998	Denver
3	Joe Montana	5	1979-1994	San Francisco, Kansas City (2)
3	Eli Manning	5	2004-2019	NY Giants
5	Terry Bradshaw	4	1970-1983	Pittsburgh
5	Dan Marino	4	1983-1999	Miami
5	Ben Roethlisberger	4	2004-2021	Pittsburgh
5	Russell Wilson	4	2012-2021	Seattle
9	Drew Brees	3	2001-2020	San Diego, New Orleans (2)
9	Dan Fouts	3	1973-1987	San Diego
9	Ken Stabler	3	1970-1984	Oakland, Houston (2)
9	Kurt Warner	3	1998-2009	St. Louis, Arizona (2)
9	Patrick Mahomes	3	2017-2022	Kansas City
9	Matthew Stafford	3	2009-2022	Detroit, Los Angeles Rams (2)

Source: Pro-Football-Reference.com · As of Feb. 1, 2023

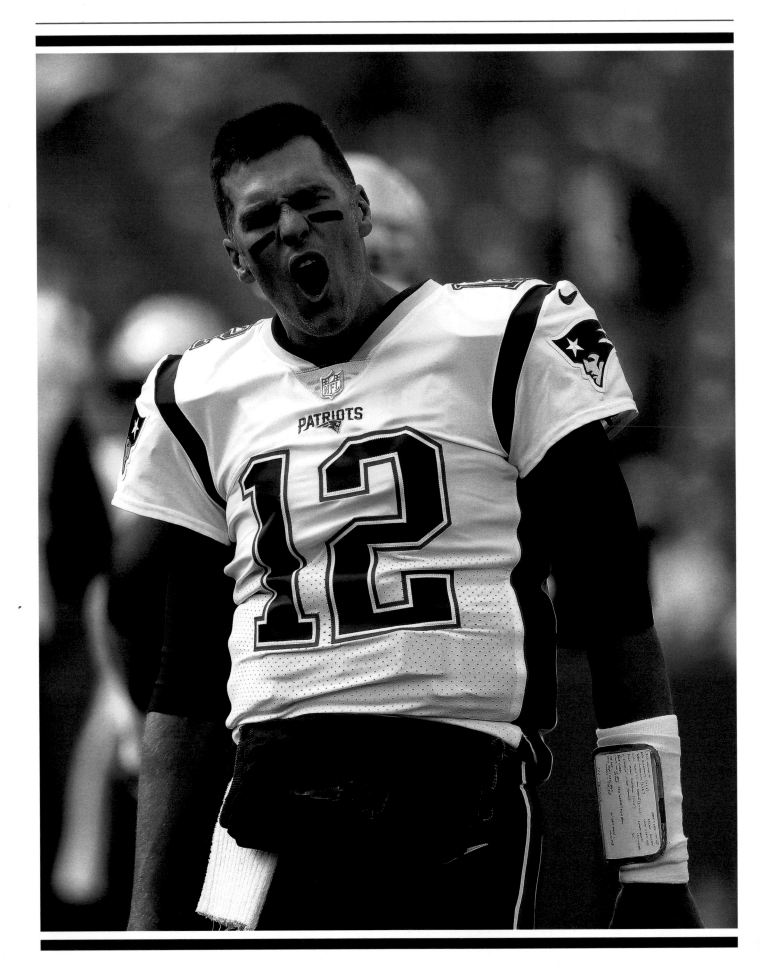